Therapeutic Presence

of related interest

A Multi-Modal Approach to Creative Art Therapy
Arthur Robbins
ISBN 1 85302 262 4

Poiesis
The Language of Psychology and the Speech of the Soul
Stephen K. Levine
Foreword by Paolo Knill
ISBN 1 85302 488 0

What Do You See?
Phenomenology of Therapeutic Art Expression
Mala Betensky
Foreword by Judith A. Rubin
ISBN 1 85302 261 6

Arts Approaches to Conflict
Edited by Marian Liebmann
ISBN 1 85302 293 4

Art Therapy – The Person-Centred Way
Art and the Development of the Person (2nd edition)
Liesl Silverstone
Foreword by Brian Thorne
ISBN 1 85302 481 3

Mutative Metaphors in Psychotherapy
The Aeolian Mode
Murray Cox and Alice Theilgaard
Forewords by Philip Brockbank and Malcolm Pines
ISBN 1 85302 459 7

Art Therapy and Dramatherapy
Masks of the Soul
Sue Jennings and Åse Minde
ISBN 1 85302 027 3 hb
ISBN 1 85302 181 4 pb

Reflections on Therapeutic Storymaking
The Use of Stories in Groups
Alida Gersie
ISBN 1 85302 272 1

Arts Therapies and Clients with Eating Disorders
Fragile Board
Edited by Ditty Dokter
ISBN 1 85302 256 X

Tapestry of Cultural Issues in Art Therapy
Edited Anna Hiscox and Abby Calisch
ISBN 1 85302 576 3

Therapeutic Presence
Bridging Expression and Form

Edited by Arthur Robbins

Jessica Kingsley Publishers
London and Philadelphia

First published in the United Kingdom in 1998 by
Jessica Kingsley Publishers Ltd
116 Pentonville Road
London N1 9JB, England
and
1900 Frost Road, Suite 101
Bristol, PA 19007, U S A

Copyright © 1998 Jessica Kingsley Publishers

Library of Congress Cataloguing in Publication Data
A CIP catalogue record for this book is available from the Library of Congress

British Library Cataloguing in Publication Data
Robbins, Arthur
Therapeutic presence: bridging expression
and form
1. Art therapy 2. Psychotherapy 3. Therapist and patient
I. Robbins, Arthur, 1928-
615.8'5156

ISBN 1 85302 559 3

Printed and Bound in Great Britain by
Athenæum Press, Gateshead, Tyne and Wear

Contents

PART VI A Final Note

Acknowledgements

This text is dedicated to the students and mental health professionals that I have had the pleasure of teaching as well as supervising during the four decades of my therapeutic career. They have also participated as my teachers, who have both challenged and confronted me with the notion that growing as a professional is a lifetime process. Their spirit and vitality have been a constant source of professional inspiration.

I want to express my deep sense of appreciation to my wife, Sandy, who has been my teacher as well as mate in helping me understand the depth and complexity of holding and caring that is so much part of any treatment relationship. I also want to give credit to my teachers in the Psychoanalytic Institute, Hans Herman, Jule Nydes and Max Hertzman, who have provided me with a discipline and grounding that has permitted me to roam professionally in many different directions.

I also owe a deep sense of appreciation to my typist, Jennifer Vesper, who has that wonderful knack of staying with me in spite of my racing mind and run on sentences. Finally, I want to thank Elaine Brand and Rebecca Graziano for their editorial assistance in giving my writing further articulation while still preserving the essence of my thinking.

Preface

In order to understand an experience, I must first feel its contours, touch the very texture of its existence, and take the substance of the interaction into my body. I realize that this is not a universal technique. Some people first experience cognitively and then allow the sensory and affective part of this engagement to take hold of them. Others connect visually to an image in order to understand the nature of their interaction with the environment. Still others attune themselves to the melody or song that offers them an intimate connection to the world.

Whatever the technique, all of us attempt to transform sensation, cognition, and affect into meaning. This ability calls for the interpretation of affect and cognitive engagement. It requires an openness to encounters with the expressive contours of one's environment. Combined, these techniques help shape and give meaning to our existence. In the therapeutic workplace, the interaction between patient and therapist is built upon these cognitive, affective, and expressive experiences. This text will focus on that interaction.

As a fledgling psychotherapist, my notions of therapeutic presence were driven by a focused attention to my patient's communications and a concerted effort to make empathic contact. In many respects, this approach seemed appropriate to the everyday problems and issues that were presented by my patients. Yet, upon reflection, I wondered why I felt so tired at the end of a day and, in fact, emotionally burdened. I mused to myself that perhaps more personal psychotherapy was in order.

In spite of the emphasis on countertransference fantasies and thoughts, the affect content of the therapeutic interaction, particularly on the analyst's part, was never developed in my early stages of training. I entered the National Psychological Association Psychoanalytic Training Programme, founded by Theodore Reik, whose text *Listening With the Third Ear* became an inspiration for my future therapeutic endeavors. During a later stage of my professional development, my exposure to object relations theory offered me a far more complex understanding of the countertransference presence of projective identifications and inductions. With this framework as an

important guidepost, countertransference work became a major part of my professional investment and work.

In 1988, I published a text entitled *Between Therapists: The Processing of Transference and Countertransference Material*. There, I included a statement which became a critical foundation for my further study. It focused the continued work that will be presented in this text. In *Between Therapists*, I wrote:

> Being a psychoanalytic therapist creates an ongoing and grueling emotional balancing act. In order to be effective therapists, we must maintain an appropriate objective emotional distance from our patients while, at the same time, we transmit an essence of humanity as we touch our patients' raw emotional nerves. We also try to be openly receptive to our patient's communications, offering ourselves as 'containers' for such intensely powerful affects as abandonment, rage, loss and love. This state of containment requires an emotional centring of ourselves, and demands that we put aside the stresses of our personal daily lives when we enter the office and confine our patient's confidential struggle to a very private section of our psyche. (p.13)

I wanted to learn more about this emotional centring of therapists. It is the shifting from inside to outside, self to other, affect to cognition that became the very essence of what I call therapeutic presence. In this therapeutic workspace, we contain the deep projections of our patients and offer an empathic mirror that becomes a cornerstone for a new internalized self/object identification. In this space, patients make unconscious contracts with us. They offer us their pathology for containment. We, in turn, process this material as it makes contact with many of our past conflicts and identifications. We organize this material and offer a mirror that reflects not only this containment but a more adequate picture of where each patient's self/object lives.

In the process, we are often overwhelmed by our patient's affects. As fierce marauders, they invade the very essence of our therapeutic presence. When this happens, we open ourselves up to defensively acting out in order to master the countertransference trauma. In short, the container/therapist springs a leak that can spill out in any number of directions. Here, in this space where we live on the edge of preconsciousness and consciousness, we are open to an internal process that is set off by our patients. Our job, then, is to regain our therapeutic presence. This is no small task. The mere

acknowledgement of an induced affect or fantasy does not seem sufficient for regaining our therapeutic presence.

Upon further reflection on my own career, I suspect that my initial therapeutic efforts were comparable to some form of enablement with patients. I was empathically present to my patient, but was unavailable to my own cognitive and emotional transference process. Given this framework, the development of a therapeutic presence required an emotional and cognitive balancing act that demands considerable creative effort and emotional coping ability. With this full engagement with our patients, therapy has far more energy, play and spirit. The psychic working of this process, of moving back and forth to different levels of consciousness, became the foundation of my work as both a therapist and teacher.

Within this context, there is a good deal of interchangeability between therapeutic presence, the creative process, and expression. The choice of modality by both therapist and patient will, hopefully, permit a creative expression of a self that can find mirroring and containment in a therapeutic engagement. In creative expression, there is a synthesis of primary and secondary process, a shifting in different levels of consciousness, and an organization of verbal and non-verbal communication. The choice of a particular modality by both patient and therapist can only serve as a bridge to further exploration of the true nature of the self/object process. However, since the therapeutic workspace is transitional in nature, a modality cannot serve as a substitute for the deep connection that is made between therapist and patient.

If treatment is to proceed, both therapeutic parties must work towards being present with one another. Therapeutic presence, best described as an ego state, has several specific qualities. First, it is a dual level of consciousness, of being one but yet separate with any given patient. Next, it manages linear and non-linear time, which exist simultaneously. In this state of therapeutic presence, both parties shape and reshape non-verbal and verbal expression. It is a state of emotional and cognitive presence.

When *Expressive Therapy: A Creative Arts Approach To Depth-Oriented Treatment* was published in 1980 it was a pioneering effort. The new professionals of that time, faced with the inevitable growing pains of shaping their own professional identities, found the notion of expressive therapy at odds with their particular parameters and definitions of treatment. The intermeshing of expressive therapy principles with a variety of therapeutic approaches often created confusion and certainly raised many questions. It is now 1996, and much research and study has been accomplished to further the initial effort of *Expressive Therapy*. Nonetheless, much of the original

edition still seems very relevant to this new text. I quote from the preface to the first edition:

> A good therapy session contains many of the characteristics of a work of art. Both share a multiplicity of psychic levels and a release of energy that radiates along the axis of form and content. Therapeutic communication, like art, has both a sender and a receiver and is defined by psychic dimensions that parallel the formal parameters through which art is expressed. In any one session, we can detect in patient–therapist communications both verbal and non-verbal cues that can be examined within the artistic parameters of sight, sound, and motion; that is, in rhythm, pitch, and timbre; in colour, texture, and form; and in muscular tension, energy and spatial relation. These elements of therapeutic composition will have their own principles and will require the utmost skill in therapeutic management. This complex field of energy will become transformed during the process of treatment as the perceptual fields of both patient and therapist go through the process of differentiation and fusion, much as the perceptual field of the artist ebbs and flows. The expressive therapist relates and responds to this complex matrix and develops the tools to contain and organize communications that may resist reduction to the linear logic of words. Moreover, the expressive therapist must have the talent to create metaphorical interventions that bridge fantasy, dreams, and play with the world of reality. (p.13)

Therapeutic presence calls for an openness and awareness of the intersubjective space between therapist and patient. This space is a field of energy bounded by polarities of positive and negative valences and both therapist and patient constantly discover new orders. Therapists need to maintain a sensitivity to defence s, developmental stages, and the processing of transference and countertransference material. Paramount to this stance is an awareness of the sensory perceptual communications that are inextricably bound up with the therapeutic dialogue in both verbal and non-verbal contact. Therapists who become receptive to these subtle cues, as well as to the playful, mirroring, and meditative interaction, will find successful and meaningful interactions with patients. Therapeutic presence requires a sensitivity to the concepts of centring and grounding. It also embodies the spatial and temporal characteristics of the frame, as well as the container, that are organic pieces of this Gestalt. In addition, it incorporates an experience of energy that may open, shut down, or disrupt the field of therapeutic contact.

This stance can be applied to therapeutic modalities ranging from psychoanalysis to creative arts therapy. The particular methodology – such as dance, art, or music – will certainly affect the nature of processing. Further, each particular modality has a built-in transference and countertransference impact that is influenced by the style of the therapist and the characterological issues of the patient. This mix of stance with methodology thus becomes a complex field of contact that demands recognition and understanding.

Though representing a depth perspective, therapeutic presence does not require a long-term approach to treatment. In today's world, therapists are increasingly called upon to work with short-term treatment populations. The challenge for the therapist is to bring a sense of openness and sophistication, as well as discipline, to a highly fluid and changing therapeutic field of contact. Simple treatment plans do not easily conform to the overpowering demands of today's therapeutic workplace. Instead, successful therapists call on a complex framework to match the instability and changing nature of their work loads. The full use of one's creative energies may well provide the only solution to overwhelming therapeutic situations that defy neat cognitive ordering. To neglect or underutilize a therapist's creative resources will inevitably lead to a buildup of countertransference resistance in one's work. The interplay of therapy and creativity, shaped and reshaped within a therapeutic framework, may well hold the key to professional survival.

So it is that the therapeutic presence of this revised framework has become the focal point of this revised text. This approach merges the therapeutic and creative, combining the healing perspective with an analytic search for meaning. It is also a deeply artistic approach to treatment.

Arthur Robbins

PART I

Introduction

Introduction to Therapeutic Presence

Arthur Robbins

The Parameters of Therapeutic Presence

Any discussion of therapeutic presence requires understanding of the by-products of primary process communications. Fantasies, dreams, art, and play, the organizers of our primary process, contain the raw affects of our inner experiences. According to Susan Langer (1942), creative manifestations originating in part in the unconscious utilize visual and auditory images presented simultaneously, rather than successively in time, and thus through association acquire inner relationship and meaning. Discursive symbolism, on the other hand, is the language of conscious rational thinking presented consecutively in time, according to the conventions of grammar and syntax. Working towards being present with a patient, the therapist uses verbal metaphor to create or discover bridges to link non-discursive and discursive communications.

In his landmark text, *Affect Regulation and the Origins of the Self* (1994), Allen N. Schore amasses an impressive amount of research data demonstrating the parallels in the neurological development of the infant that accompany the emotional bonding of mother and child. The primary caretaker actually facilitates a growth and stabilization of interconnections located in the frontal cortex and right hemisphere of the brain. The patterns of these connections are imprinted in the neurological organization of the child, and go hand in hand with the expressive transactions that are occurring between mother and child. In such manner, the representation of the mother's expressive facial image leads to a neurological imprint system. Similarly, during the second year of the child's development, the exploration of the outside world that begins to occur may be accompanied by the mother's expression of disapproval or disgust. This, in turn, mobilizes a fear reaction

in the child that is set forth through the parasympathetic nervous system. Therefore, in place of excitement, we potentially have fear, and in place of the sympathetic nervous system, we now have the parasympathetic system kicking in. This, in turn, affects neurological development. Thus, affect regulation by the mother, with its accompanying visual and auditory stimulation, can have enormous impact in frontal cortex development.

Schore reports analogous findings regarding the therapeutic relationship. To quote Schore (1994, p.437):

> The patient therapist relationship acts as a growth-promoting environment that supports the experience-dependent maturation of the right brain, especially those areas that have connections with the subcortical nimbic structures that mediate emotional arousal. Structural change, an outcome of long-term psychological treatment, specifically involves the rewiring of the connections of the right frontalimbic cortex and the consequent replacement of toxic with more internal representations of the self. These events allow for the emergence of a system that can efficiently mediate psychobiological transition between the various internal states.

The implications for therapists are extraordinary. As therapists, we attempt to repair the primary process communication of mother and child through our particular modality. The quality or resonance becomes particularly relevant and significant if we are to repair not only a psychic representation but a neurological one as well. Perhaps, as therapists, we have resorted too early to an interpretive psychoanalytic mode at the expense of repairing this self/object internalization, a process that must occur in long-term treatment. Yet there are implications for short-term treatment as well. Regardless of our goals and the limitations of our institutions, it well may be that primary process communication and creative arts imagery are the expressive mode that makes the most good sense for a broad range of patient populations.[1]

Expressive reflections such as gestures, postures, styles of movement, tones, and inflections of voice are all like fantasies, dreams, art, and play: fueled by drive and muscular tension, they outwardly shape and form these inner representations of primary process. Primary process serves to promote self-continuity and identity (Noy, 1968); it is potentially available through conscious regulation of the ego as perceived in productions of the mind and

1. The foregoing paragraphs are distilled from the introduction to *Expressive Therapy: A Creative Arts Approach to Depth-Oriented Treatment* (1981), Human Sciences Press Inc., New York.

bodily expressions. On the other hand, secondary process communication gives us feedback and validation for our perceptions, and is used for all functions aimed at encountering reality. Both primary and secondary processes vary in level of organization and integration and are manifested through different cognitive ego states. We will attempt to demonstrate in future chapters how primary and secondary processes are expressed through different cognitive modes, one being a holistic orientation that is essentially spatial and non-linear, as contrasted to a shaping mode that is more synthesizing and analytic.

Thus, if we are to be present with our patients, we must be open and receptive to both primary and secondary modes of communication process. To achieve these goals, much work must be done to enlarge our capacity to shift ego states. We must be comfortable with a holistic, intuitive and receptive orientation that is essentially spatial, while always being ready at any moment to shift to a more synthesizing mode in which the choice of words gives structure and definition to non-verbal flow. This ability to synthesize and articulate the multiplicity of levels in the patient–therapist dyad goes to the heart of what I describe as therapeutic presence.

Although not necessarily a dancer, artist or musician, a therapist is sensitive to movement, vision and sound and can play with his or her patient within this multilevel orientation. The expressive perceptual mode becomes a frame or container in which the therapist can meet and organize patient communications. But whether a therapist who is fully present with a patient actually paints, moves or sings with the patient is not particularly relevant, for the choice of modality depends upon considerations ranging from characterological resistance to the patient's lifestyle to a sensitivity to a given mode of expression. Thus it is quite possible to work with patients through a variety of visual metaphors even though they might be quite resistant to painting or drawing in a treatment relationship. Yet it is equally true that many patients, given the opportunity to work in an expressive modality, feel far less threatened and more open and indeed more therapeutically present with their therapist than in a more traditional verbal mode of expression.

The therapist who is cognitively, emotionally and therapeutically present works within a humanistic orientation. At the same time, the therapist does not discard the valuable constructs of psychoanalysis or other therapies. In this light, the process of therapy takes place in a fluctuating energy field of positive and negative vectors associated with projected, introjective identifications. The therapeutic work place is characterized by an openness to this everchanging energy field that is communicated through verbal as well as non-verbal imagery, physicalization and affect mood states. In treatment, this

complex field of energy ebbs and flows, going through a process of gestalt organizations as figure and ground. The changing developmental and transference issues of each case will determine what moves into the forefront or what shifts into the background. How therapists respond to the spontaneous reorganization of their own inner fields, or their everchanging gestalt, and how they utilize their own conscious and pre-conscious symbolism is the essence of being therapeutically present with patients. The therapeutic stance, which can help therapists to become more available to this process, has a number of aspects that can best be described as cognitive ego states. The following section describes the experience, parameters, and characteristics of being in the ego state of a therapeutic stance called presence.

The Expressive Therapeutic Stance

The initial contact is vital in setting the scene for the therapeutic relationship that may follow. The phone rings, and I listen to the subtle inflections of the voice on the other end. At the same time, I pay attention to what my own body is telling me. Do I feel tense? If so, where in my body does the tension lodge? I quickly feel the image and affect that lie just beneath this tension. Am I immediately engaged? Or, instead, is it hard for me to listen to this patient? Perhaps there is a whisper, or a loud booming voice which does something to my ears. Or maybe a message is merely left on my machine with no return telephone number. All these threads are woven into a fabric that soon tells a story. The method of referral – by whom and where – is another thread in the fabric. Sometimes similar patients come from similar sources. I keep on listening to my gut to determine the patient's impact on me. Am I interested, bored, enthusiastic, or does everything slip out of my head before it even registers? When the patient actually arrives, I take in how he or she walks, dresses and moves, and how much space the patient takes up in the therapy room. Does she immediately find the chair? Does he wait for an invitation to sit down? In all this process, I try to steer clear of any particular theoretical framework or diagnosis. I constantly struggle to avoid the pitfalls of premature closure, or pegging somebody in one hole or another. 'Keep it open,' I say to myself; let it unfold, and see how the dialogue moves.

Dual Levels of Consciousness

I try to be open to my patient while remaining fairly separate and clear, as I listen to the patient's story. This openness can be described as a state of just being, or being very present. In a sense, I become one with my patient,

though this should not be confused with a fusion state. I am being present, in the presence of my patient. In so doing, I temporarily suspend my boundaries and let the full force of the patient enter my inside. Yet at the same time, I am separating out my feelings and giving them shape and form. I watch for the telltale signs of overstructuring the material or becoming too lost in identifying with the conflicts of the patient. During this moving back and forth, from a more holistic, interacting stance to a more cognitive, separate one, a rhythm slowly develops between the patient and myself. I try to sense the flow and pattern of this rhythm. Do I have trouble moving with it? Possibly I am either too removed, or else too involved inside my patient's emotional state. Sometimes I am unable to feel any rhythm, nor can I create a transitional space where we can meet. The transitional space becomes a meeting room where two minds join one another, engaged as well as finding their separateness, creating for one another a field of forces. In this space we both strive to discover our presence, fueled by the energy that emanates from our mutual centres. This struggle ultimately creates forces of resonance, dissonance and the possibility of reshaping our energy.

The Ground

Entering this state of dual levels of consciousness can only be accomplished from a grounded position. I refer to being grounded in reality, as certainly as my two feet are solidly planted on the floor beneath me. I attend to whether my patients have a structural cohesiveness to their therapeutic story. Are they relating to an external reality? Sometimes patients wander off, seemingly floating up to outer space. At such times, an indefinable balance in me must pull them back to the concrete and specifics of their real life situation. This grounded position becomes an essential ingredient for functioning within a therapeutic workspace.

The Centre

It is likewise essential for me as a therapist to find and use my centre in relating to the patient. As the process unfolds, I try to listen to my centre. This is the most authentic place that I can engage with another. It is the essence of myself and the source of my energy; it is that place deep inside the solar plexus of my body; it is what some call the soul. I try to address my patients from this deep place, while remaining aware of my therapeutic position. Authenticity or 'being real' should not mean being oblivious to the therapeutic stance and why we are there. Of course this is more easily said than done, and often I speak from my head or from a tension place that I

cannot locate. I realize that I am not always making contact with my therapeutic centre, or even aware when I move away from it. This source, or soul, or basic self is the most fundamental organizing force that I possess. If I were to be seen as a work of art, the centre is the aesthetic magnet to which the eyes are drawn; it is where sensations flow in and out of my perceptual network. This most central force contains no words, but fuels enormous power to my vision. Yet I must and I do find the words to express the experience of relating from my centre. Only when I am in a centred place can I offer the patient a structure that truly makes sense out of our interaction. I confess that a good deal of what I offer emanates from a decentred place that does little for the patient, and tends to create a false structure which, happily, soon is discarded or collapses! It may be a necessary phase of our relationship, as I am captured by introjections or projections, that I lose my centre and seek to regain it as part of the process.

The Paradoxical State of the Expressive Therapist

There are many paradoxes inherent in the stance of the expressive therapist. I am centred, grounded and open, yet equally focused with my energy. This openness on the one hand, and directedness on the other, are equal parts of the therapeutic engagement. I am not trying to direct the flow of communication, but I certainly hold out possibilities that come from the central organizing place inside of me. The paradoxical state of an expressive therapist, then, is being both focused yet open, offering possibilities but not overly structuring or pushing for one direction or another. I throw out my preconceptions of theory and diagnosis, yet I bring a body of experience and knowledge that is my discipline and art. For artistry to flourish, it must occur within a discipline, but only where the practitioner is also able to flow with the material. I must be able to move figuratively from inside to outside, hovering somewhere between the patient and myself, organizing material into form, and allowing the communication to have its own chaotic energy that will eventually find its direction.

The Frame

I bring to the patient a frame of therapy that represents the boundaries of my professional experience and knowledge as well as the limits of my time, space, energy and, to some extent, financial resources. This is the external reality that I live by, and I am very clear about not allowing assaults on my body and invasion or exploitation of my time and space. Within that frame,

I can roam in many different directions, but the frame is always available to mark off the boundaries of a therapeutic container.

Life Versus Death

Although openness is necessary in the therapeutic dialogue, to say that I bring no values of my own into the dialogue would misrepresent what I believe being a therapist is all about. I am deeply invested in life and see myself as offering hope that there is indeed a continuity with the past, holding meaning, purpose and belief. I also accept that some patients will present a disbelief in anything, a lack of meaning, or a state of emptiness and pointlessness and therefore an identification with death. I do not propose to convert or transform patients. I do hope to open up to them the possibilities of life that I stand for, and to allow my values to filter into treatment despite maintaining a 'neutral' stance. One of my beliefs is that life is deeply connected with a libidinous self that offers energy and meaning. In many respects I see therapy as a struggle between life and death forces. A therapeutic dialogue is replete with the dialectic of movement and lack of movement; acceptance and growth and lack of growth; respect that patients cannot be pushed forward or backward; and recognition of where they must be in order to survive. In therapy I offer hope and identification with connection and care. Care does not mean rescuing but witnessing and offering possibilities against the forces of hopelessness.

The Dialectic Among Being, Meaning and Becoming

Therapy involves not just a state of being, however, but also a journey towards meaning, and there exists a dialectic between these states. On the one hand, I hold out to patients an ability to accept who and what they are, to be able to live with and even love their defences, while also making a profound contact with their very existence. For some patients, an exploration of their core existence may be experienced as walking into a pit of nothingness, being lost in empty space, and encountering the dread of no boundaries. My job, wherever possible, is to be alive therapeutically for the patient, while encountering his or her darkest part. This being, which results in a profound spiritual connection, is an essential aspect of healing. On the other hand, the therapeutic healing contact also embodies a working towards meaning by shaping and forming energy. It is the very essence of treatment to give shape and form to the symbols and images that emanate from one's centre. To then translate these symbols into a meaningful identification, and use them to create an engagement with the world, is a most gratifying piece

of treatment for both patient and therapist. We aim for this ideal and at times accomplish it, but in many instances we leave our patients with only partial success in making the inside reality an outside one.

Process

Throughout the above paragraphs, it is implicit that therapy revolves around process. It is the movement in dialogue from inside to outside, from closed space to open space, from oscillating downwards to upwards, from different affect states, and to different polarities. This energy field, composed of positive and negative vectors or directions, fills the transitional space where therapist and patient relate. This space is ruled by sensation and perception, by images and fantasies, and the push and pull of these various opposing forces then becomes the focus of treatment. Often hidden polarities are projected to us as therapists, and our task is to contain and mirror these hidden opposites to create a dialectic for the patient to encounter. This dialectic becomes the therapeutic workspace. As we focus on this resolving of opposing forces, defences and resistance are often encountered. Some patients are too embodied in their inside life, while others are connected only to the outside reality. Some hide behind merger, others survive through withdrawal or denial. The object of processing is to enable the differentiation (and sometimes dedifferentiation) of self and others. Along the way, there may be times when the inside becomes clearer at the cost of the outside, and times when the process is reversed, and still other times when one simply becomes lost in an inner psychic mess. The process of building, destroying and rebuilding is intrinsic to depth-oriented treatment. These stages are repeated as developmental changes occur, and thus similar struggles may be re-encountered throughout life – during infancy, adolescence, young adulthood, middle age and even old age.

The Container

As we move into the field of sensation, perception and cognition, I am clear as to the boundaries of my container, and I struggle to deal with the affects that are introduced in the therapeutic space. I contain a myriad of projections and send out a few of my own in this very intimate, intersubjective relationship. Occasionally it is very difficult to differentiate clearly what belongs to whom, for indeed the container is often serving as the contained. We are both mirroring back and impacting our mutual projections and introjections. I experience these projections by giving them shape and definition, as well as by connecting them with my own past experiences. I

also try to accept them in a profound way as well as to comprehend the resistance to truly understanding this encounter. In many respects, I attempt to give perspective and image to the variety of affects and sensations that I am challenged to hold. My container can be flexible, rigid, soft or pliable, but it is always meant to offer perspective and reflection. In short, my container can take in toxicity and mirror back understanding and acceptance. I hold the variety of affects and projections that bounce in and touch the deepest part of me. Sometimes my container leaks and many of my affects spill over in the therapeutic exchange. On other occasions, I rigidly hold onto myself for dear life, knowing that this is not really containment but basically control and restriction of my imaginative ability to play.

The Mirror

How can the very essence of ourselves knowingly be held, unless we can somehow see the figure being held? If we are to be contained, we certainly need to be seen. The figure must always emerge from within the container, for if we are completely enclosed, then it is impossible for us to really be seen. Thus as I hold and contain, I am also attempting to see the essence of the patient emerging out of the container. This process of mirroring is far from superficial; indeed, we may contain as well as mirror very complex polarities, not to mention the dark side of the patient. Our mirroring may include defences as well as the struggle for self and other. Mirroring, therefore, becomes a complex, creative interchange between patient and therapist. At times, the therapist is mirrored back, and so we see reflections of ourselves mirroring the patient in this therapeutic process.

The Body as an Organizer

Body communication encompasses the subtle cues derived from how we sit, talk and shift back and forth in our non-verbal movement with the patient. Moving from inside to outside, or self to other, my body experiences varieties of form and formlessness, and I attempt to give meaning and acceptance to these experiences. Most important, I am sensitive to my body and what it is telling me, for I open up my boundaries and I sense in my own voice, posture and gestural cues the hidden affects that lie behind these somatic tensions. Furthermore, as I take the patient's body force inside me, the images and affects that are associated with his or her bodily tensions slowly seep into my awareness. As a consequence I acquire some very basic information regarding the patient's history, defences and transference projections. In fact, there are often moments in treatment where it is virtually impossible for me

to take the patient inside of me, as too many deep wounds and areas of anxiety are touched. I note this, and attempt in due time to release the flow of therapeutic process for both patient and myself. Thus within this bodily container lie affects that may be warring or being introjected in the very tissues of my somatic existence. I am sometimes aware of a subtle mirroring that goes on in our postures and body stance. These subtle, non-verbal communications are so swift that my response is highly reactive, jumping way ahead of my cognitive understanding of this process. These body tensions are important cues to me as they are on the edge of revealing important affect states. The stab in my heart, the headache, the slump in my shoulders all tell a story. I listen to this symbolic speech with its own metaphors and unique language. Thus my body responses can help to organize the flow of information in the therapeutic process.

The Therapeutic Workspace

The therapeutic workspace can be viewed as a field governed by polarities – or opposing forces – of sensations, perceptions and affects. These forces have a direction, or vector, and are experienced in different shapes as well as images. In this field, both parties – patient and therapist – potentially can be inundated with sensations and affects that gyrate in and out of conscious-ness. It is equally possible for one or both parties to be detached or frightened from joining into the field. Ideally, the flow of this field becomes the focus of treatment. When the flow stops, our skill in regenerating the flow is one of the artistic challenges of the therapeutic workspace.

Working Within the Polarities

The vectors of hate and love, of inside and outside, indeed the whole spectrum of opposing forces become the fulcrum of engagement, or the means by which engagement can occur. We try not to be allied with one polarity or another but to allow an opening for both ends of a force to come into consciousness. In this way, a dialectic between the two opposing aspects can be identified and encountered. Thus if we are experiencing mainly love in a particular therapeutic workspace, then I search for that place inside of me that holds the underlying hate. If I am listening to all outside material, then I constantly search for the inside of this patient's life. My job is not to inflict a polarity onto a patient, but to discover in myself, while holding and mirroring, an inner experience that the patient may utilize in any manner that is helpful. I do not try to override or overcompensate the imbalances. I simply hold out the possibility that there is space and room for new

resonances within existing affect sensations and cognitions. This potential rebalancing of the therapeutic workspace is analogous to what is commonly called an 'action interpretation'. The very act of projecting a presence into the therapeutic workspace becomes an opportunity for transformation. For as I hold these projections and introjections, I am attempting at the same time to contain and mirror them with new meaning and new balances for the patient to perceive at his or her own level of readiness.

Again, I cannot overemphasize the need to accept where the patient must live, even joining as I discover my separateness. At the same time I offer new possibilities and try to create a climate conducive to making new integrations. I simply try to sense the direction and nature of the energy: whether it is from deep inside, all from the outside, overbalanced with hate, full of sensuousness or lacking in form and shape. These are the ingredients that I allow myself to hear, see and kinesthetically feel in order to play with the dialectic. Often I am aware of a shifting from one polarity to another, from one end or extreme to another, and I respond to a rhythm in the flow of our connections and disconnections. At times, I am aware of either being excessively preoccupied with a patient's outside or inside, or feeling the variety of rhythm in this movement. Each patient seems to have a particular stamp of rhythm. The intensity of this rhythm may vary from extreme, complex, profound involvement to a shallow flatness with little movement of energy or form. My own rhythm will be deeply enmeshed with the patient's, as we both resonate self and other as part of our mutual interaction. On other occasions, we may be in a state of dissonance and barely connect with one another as our mutual fragments search for a frame that can hold and contain our emptiness and pieces.

A Short Review

As therapists, we work from a centred and grounded position, connecting with our patients in an intersubjective place characterized by a dual level of consciousness, open yet separate. Therapist and patient respond to verbal and non-verbal cues that exist in the space between them. This space is governed by a number of polarities, often pushing and pulling against one another. I focus my energy on the barriers that block the shared space, and try to facilitate a living and dynamic interaction. Since the sensory cues have their own direction, they may either clash and splatter chaotically, or work in harmony and provide order, so integral to therapeutic and creative interaction. In addition, some elements of our interaction may continue throughout, whereas others may be of temporary duration, or may occur at different times in our multiple levels of awareness.

Although I relate on several levels of consciousness, ranging from pragmatic to spiritual, I may at the same time be aware of a heightened sense of my own body. In this intersubjective connection, affects may spill into one another. I offer a container to receive and organize projections and introjections, defences and adaptations, and the many affects that are part of the therapeutic workspace. As the therapeutic interaction develops and changes, my container also changes in form, volume and perspective. As affects and images arise out of this container, I must first identify and express them in symbolic form. After I regain my own separateness, I must translate these symbols into a language or framework that the patient can use in the effort to differentiate self and others. These images will facilitate a mirroring and a resonance that it is hoped will generate a transformation of energy and form. With this transformation, ultimately a new balancing of inside and outside, of form and energy, will evolve out of this therapeutic dialogue.

Defences

In the therapeutic workplace, the degree of movement can range from free-flowing to rigid, with attendant deadness or lack of flow. The therapeutic experience can span the spectrum from chaotic to harmonious. Consequently, various defences may emerge, depending on the level of consciousness on which the parties communicate. In the therapeutic container, I am constantly experiencing the impact of defences and how they interfere with the flow of material. In fact, we may shift the method of communication in order to lower the defences and increase the flow of contact. This shift is not the result of conscious technique, but rather arises spontaneously as required by a subtle, unconscious message. When there is such a shift, and a flow of energy, there is life in the engagement with a libidinal energy that is continuously being transformed. I respect the various protections that build up and recede in the background and are modified by therapeutic modalities. I suspect that different kinds of transference and countertransference response can be reinforced by different therapeutic modalities, ranging from the magical influence of a healer, to the temporal in music, to the safe and connecting cognitive impact of an analytic perspective. Defences are viewed as something that we respect and honour, but in fact, much self-hate is lodged in the defences. Thus, part of therapy is helping patients recognize, respect and care about their defences, as well as become aware of how they operate as an important life survival mechanism.

The Relationship Between Confrontation and Acceptance

We now encounter another paradoxical dimension of the expressive thera-peutic stance. Although we accept the adaptive nature of a patient's defences, there is also room to play and counter these defences by offering new balances, ambiguities, and surprises that unlock the energy and facilitate the flow. Just because we accept where a patient must be in therapy, we do not preclude a playful confrontation. When and how to confront a patient has much to do with the inner resources of both the patient and the therapist. The more we encounter vulnerability – a fragility and disconnection from the centre of oneself – the more we shore up the defences and recognize their life survival impact. The more a patient feels out of touch with the centre, or feels deeply wounded and guarded about the centre, the more we respect his or her defences. We help to enforce the control and power exercised by the patient. The paradox exists in that the more reinforcement of control there is, the greater the potential there is to give up control. How we confront and play with defences becomes part of our artistry. We may match hardness with softness, or play with toughness and straightforward-ness, or use surprise and ambiguity. In short, we are constantly knocking the patient off defences and creating anxiety. Consequently, I am but a mirror of a patient's defences and will reflect them back in one form or another. This playing with ambiguity and creation of anxiety makes possible new shifts of figure and ground. I believe, however, that there is optimal anxiety, but there is also the possibility of overwhelming the patient with enormous dread and fear of catastrophe to which we must be constantly on guard and sensitive. We also must take a risk at times, in order to open up the space and offer the potential of hope and change. Navigating this pathway is another artistic challenge in the work of an expressive therapist.

The Relationship Between an Expressive Stance and an Expressive Modality

Throughout this text, the reader will encounter a number of therapeutic vignettes that illustrate particular expressive modalities or methodologies. Through the sheer dint of their training and talent, therapists will rely on one or more modalities of their choosing, either alone or in combination. In each instance, the modality becomes a personal expression for both partici-pants – as much a potentially limiting tool or place to hide as it is a place to make contact. Often it is both. Each modality has enormous impact on the transference and countertransference. When we shift from one modality to another, we must consider the implications of the shift on the level of consciousness, which ultimately affects the kind of processing to be enacted.

In a modality shift, as previously noted, different defences emerge as well as different self/object relationships. We must also be alert to spot when material is being processed through on only one level of consciousness and not another. Thus we may see a splitting off or a dissociation resulting from the excessive use of a particular modality. In the end, we must observe whether processing leads to more differentiation or less. There is a complex interplay between methodology, the level of consciousness that each modality calls forth, and the mutual characterological issues of both patient and therapist. All these influence the shaping and reshaping of therapeutic space. The decision as to which modality is most effective is a pragmatic one. Does the processing move the treatment ahead? Patients will bring to treatment a readiness to respond to different therapeutic modalities. Some have a highly cognitive style and are extremely distant and disconnected from a sensory-perceptual mode. This may be equally true of a particular therapist, and so the right matching may well be required for therapy to proceed. In other situations, we may need to call upon allied therapists to work with us either on a short-term or long-term basis.

The Relationship Between Play and Character Style for the Expressive Therapist
As therapists, we play very differently from each other and with each particular type of patient. By play, I am referring to the Winnecottian notion of play, which implies making an imaginative contact with our patient. It does not necessarily imply having fun. Our playful contact, however, must be guided by an internally developed and disciplined use of our personality in making contact with others. Some of us may be more laid back than others in our therapeutic interaction. Some may rely more on form, and others may plunge into a more chaotic type of relatedness. The point is that there is no one ideal expressive therapeutic form. All of us as therapeutic artists must generate a style that emanates from the flexible but disciplined use of our own character and defences, and which ultimately comes from deep inside of us. We cannot imitate our supervisors or teachers; the best we can do is learn from them and eventually evolve a style of therapeutic contact that is authentic and all ours. This becomes a lifelong process of development and practice.

Summary
An expressive therapeutic stance can be adopted within all therapeutic art forms. Putting it another way, therapists of differing backgrounds and modality identifications can all utilize this stance. However, use of the art

form of a given modality does not automatically make one an expressive therapist. We could easily envision an art or dance therapist working from a behavioural or cognitive framework, where the end goal is either bringing the unconscious into consciousness or producing behavioural change in a patient. What is central for an expressive therapist is the merger of the creative and the therapeutic. Within the creative workspace we can go to move, dance and sing with the particular inflections, intonations and body movements that are part of the field of therapeutic contact. A cognitive insight may be a product of therapeutic movement, but the most important outcome is a rebalancing and reorganization of one's perceptual, cognitive network, ultimately affecting our sense of self and other. An expressive therapeutic stance, therefore, can cross over into many modalities, but the one basic constant must be therapeutic artistry. Obviously, the nature of a particular modality will affect the type of processing that goes on between therapist and patient. Also, the wider our range of receptiveness to the complexities of the therapeutic field, the more complex our processing can be. It should be noted, however, that use of this expressive therapeutic stance does not necessarily mean we are engaged in long-term treatment. It is a stance that can be useful even in a single session, where the institutional goals are very limited. In sum it is our guidepost for therapeutic survival as we call upon our creative energies to meet the many challenges in working with different institutional populations.

The Raw Outline of Our Thesis

As a basic theoretical foundation for this text, Billie Pivnick provides a review of the literature regarding the notion of transitional phenomena. In this framework, therapeutic presence is enhanced by respecting the developmental limitations as well as adaptations of our patients. Winnicott offers the therapist a map that gives overall perspective to the development of inner and outer space. He views development at the very start of life in which the mother by nearly total adaptation affords her infant the illusion that her breast is part of the infant:

> From birth, therefore, the human being is concerned with the problem of the relationship between what is objectively perceived and subjectively conceived of, and in the solution of this problem there is no help for the human being who has not been started off well enough by the mother. The intermediate area to which I'm referring is the area that is allowed to the infant between primary creativity and objective perception based on reality testing. This transitional phenomenon

represents the early stages of the use of illusion without which there is no meaning for the human being in the idea of a relationship with an object that is perceived by others as external to that being. (Winnicott, 1971, p.63)

Presence, then, encompasses inner and outer reality and is part of that intermediate space that is neither inside nor outside but somewhere between. It is in this area that therapeutic work takes place.

Psychotherapy takes place in the overlap of two areas of playing, that of the patient and that of the therapist. Psychotherapy has to do with two people playing together. The corollary of this is when playing is not possible then the work by the therapist is directed towards bringing the patient from a state of not being able to play into a state of being able to play. (Winnicott, 1971, p.63)

I would modify the above description of therapy by substituting the concept of therapeutic presence for playing. Viewed from this perspective, psychotherapy takes place when the two parties in therapy are present. When one party is not present, the work of treatment is directed towards both parties attempting to become present with one another. When this occurs, there are possibilities for change and movement as well as processing.

Four therapeutic frames of processing will be presented in this text. Each model offers an organization of psychic reality that impacts differently on our experience of therapeutic presence. I suspect that each therapist selects a particular therapeutic frame as a creative expression of individual temperamental and characterological organizations. One's own deeply personal expression thus becomes a creative way of working with people.

Sandra Robbins, a healer, invites the patient to join her in an altered state of consciousness. In this process she works first from a very grounded and centred position where self is not abandoned but put aside. She then commits herself to move into a no-boundary position while the grounded self is available if and when she needs an anchor to move into a new, unexplored territory of consciousness. At the same time, she remains keenly aware of the here and now existence of her patient and does not invite the participant to be part of the fusion state. She has a profound respect for her patients' capabilities and readiness to explore the spiritual part of themselves.

By contrast, Melissa Robbins' therapeutic presence appears heavily grounded in a cognitive behavioural model. She is focused, goal-directed and presents a fairly clear and firm structure to her patients. With the boundedness that is so much a part of her goal-directed approach, she blends a social and emotional acuity. She is not disengaged from her countertrans-

ference for she believes that when she does lose her centre, her structure for her patients often misses the mark. She knows all too well that a form cannot be a superimposed artifact but must arise out of felt interaction with her patients.

Michael Robbins creates a therapeutic presence that appears to be an amalgamation of both a psychoanalytic and a spiritual approach to his patients. The artist and the poet, as well as the healer in Michael Robbins, combine self with a basic structure that originates from systems theory. These elements come together in a unique interwoven fabric that is part of his therapeutic presence.

Arthur Robbins, in the chapter entitled 'The Therapist as Nanny', combines a deficit and psychoanalytic model utilizing both ego and self psychology. In the case example, during the later stages of therapy, issues of separation and abandonment as well as the integration of drives are all part of the treatment dialogue. Within the psychoanalytic perspective, an important theoretical premise is the existence of the unconscious. The work with character resistances in order to release primary process material, and the holding environment that creates the potential for the projection of deep transference and introjections, are all part of the material of psychoanalytic processing. Yet in the earlier phase of therapy, the form that exists in psychoanalytic treatment is basically non-verbal. We see transient identification with the therapist, as well as mirroring and resonating that is largely empathic in nature. Later, through interpretation of character resistances, deep aggressive and sexual drives find a place in the patient's ego function. As treatment progresses, interpretation along with a resonant and holding relationship become part of the non-verbal and verbal matrix that is so much a part of psychoanalytic processing.

The subtle interplay of inductions and countertransference and the harnessing of the associative affects are all basic cornerstones of psychoanalytic processing. How we share, communicate, and explore a multiplicity of feelings with our patients, and how we use imagery to overcome barriers and fears, makes treatment more than simple linear communication. In fact, therapy can be seen as a time of creation, when fear can be transformed into an act of self-affirmation. The literature of countertransference is rich and extensive, and no attempt will be made to review it here. However, we may note that Searles, in particular, offers us a container in which to utilize countertransferential material (Searles, 1955). The countertransference field for engagement is highlighted by the projections of introjects. Our goal is to help facilitate an integration of self object representations. The Spotnitz-Nelson group (1969) and Lacan (1953) speak of the non-rational counter-

transference components of therapists' communications. The chapter entitled 'Affect and Therapeutic Presence as a Diagnostic Indicator' will explore the complicated interventions that must be integrated within a diagnostic frame.

Turning now to the expressive therapeutic mode section, we will see a number of unique and creative uses of particular modalities. Benedikte Barth Scheiby combines music therapy with a psychoanalytic perspective. She makes profound connections with her patients, while at the same time exploring the relationship of transference and countertransference that is transmitted through sound and voice. Vivien Marcow Speiser presents an overview of the meaning of ritual and its use in expressive therapy. In more traditional verbal therapy, there is little room for the use of ritual except outside the context of the relationship. Here, Marcow Speiser makes an important case for the processing and honouring of significant psychic events through the framework of ritual.

Why we choose a particular expressive mode speaks deeply about our own temperaments and characterological adaptations in life. Felisa Weiss offers a very moving portrayal, involving the creation of a puppet play, of some of the dynamics that contributed to her decision to become a puppet therapist. Here we see how our own particular relationships become an important adaptation in working with patients. Sarah Griffin Banker adds significantly to the employment of expressive modes with the use of fairy tales in furnishing structure for therapeutic engagement. Here, when a group of therapists is presented with a fairy tale, it seems to touch some very deep unconscious themes regarding betrayal, abandonment and adaptation. The group's individual unconscious elaborations jointly result in an extraordinarily profound and emotional experience. Finally, this section closes with an integration of the attributes and benefits of utilizing art and movement within one framework.

The notion of therapeutic presence offers the therapist a certain latitude in employing different modalities. In the chapter on art and movement, we see that Robbins, with little training in movement therapy, plays with a variety of movement and body communications that become profoundly engaging in the treatment dialogue.

Body, music or movement therapies involve us in tapping into some very deep, visceral expressions that are connected with powerful affect states. Maintaining a structure to process this material becomes extraordinarily important. Often the material creates imagery far removed from conscious awareness. Respecting defences – so that patients are not overwhelmed – becomes an vital part of creating a firm and safe holding structure. The use of each expressive mode encompasses a very complicated structure. We may

well see different levels of consciousness expressed through multiple levels of containment – that is, the art form itself alongside the transference/countertransference relationship.

All therapists can make use of the notion of therapeutic presence. What we are presenting here is an orientation or approach to therapy, rather than a series of techniques or tools. Underlying this approach is a value system that prizes the inherent worth of creative expression. Such expression brings excitement and joy that originates in our innermost selves and is manifested in our outer behaviour. In the process of this therapy, both patients and therapists – like artists in the process of artistic creation – may from time to time suffer the pain of birth, death and regeneration. The creativity of patients is released as they are deeply present in encountering their life crises and challenges, and the patient, like the artist, will become free to its fullest dimension. We have given you the raw content of our thesis, and now you as reader can join us as we give shape and direction to our material.

References

Lacan, J. (1966) *Fonction et Champ au la Parole et du Language en Psychanalyse.* Paris: Du Seui.

Langer, S. (1992) *Philosophy in a New Key.* Cambridge MA: Harvard University Press.

Nelson, M., Nelson, B., Sherman, M. and Stream, H. (1968) 'Roles and paradigms.' *Psychotherapy.* New York: Grune and Stratton.

Noy (1968) 'The development of music ability.' *The Psychoanalytic Study of the Child, 23,* 332–347.

Racker, H. (1957) *The Meaning and Uses of Countertransference.* New York: International Universities Press.

Schore, A. (1994) *Affect Regulation and the Origins of the Self.* Hillsdale, NJ: Lawrence Erlbaum.

Searles, H. (1955) *Collected Papers on Schizophrenia.* New York: International Universities Press.

Spotnitz, H. (1969) *Modern Psychoanalysis of the Schizophrenic Patient.* New York: Grune and Stratton.

Winnicott, D.W. (1971) *Playing and Reality.* New York: Basic Books.

Theoretical and Developmental Issues

Wriggles, Squiggles and Words:
From Expression to Meaning
in Early Childhood and Psychotherapy

Billie A. Pivnick

With children, Winnicott plays the Squiggle Game in which each partner takes a turn drawing a scribble, which is then modified by the other... The spontaneous movement of a hand which allows itself to be guided by the drive, a hand which does not act but rather expresses itself, traces a more or less insignificant and formless line, submitting it to the scrutiny of the other, who, deliberately, transforms it into a meaningful shape. What else do we do in the analysis of difficult cases?... Meaning is not discovered, it is created. It is a potential meaning... To actualize it means to call it into existence, not out of nothing (for there is no spontaneous generation), but out of the meaning of two discourses, and by way of that object which is the analyst, in order to construct the analytic object [a symbolic expression that is co-created in the potential space between analyst and patient]. (Green, 1993, p.219)

Therapy and the Developmental Perspective

Ever since Freud posited that a 'talking cure' could remediate psychopathology, therapists have been trying to ascertain the mutative factors in the psychotherapeutic process. Psychoanalysts have variously conceptualized these factors as 'making the unconscious conscious', 'where id was there shall ego be', 'gaining of insight', increased self-awareness, the establishment, restoration, or increase of the patient's capacity to relate to self and others without distortions in reality testing or defects in affect regulation.

From a developmental perspective, Margaret Mabler (Mahler, Pine and Bergman, 1975) considered the 'principle conditions for mental health' to be the 'attained and continuing ability of the child to retain or restore his self-esteem in the context of relative libidinal object constancy' (p.118), meaning that the patient could use an image of the absent caregiver for self-comforting even when not in the the other's presence. Until recently, such an 'ego psychological' conception of good self-esteem regulation, together with adaptive functioning in the areas of 'love' and 'work', were thought to be suitable outcomes of psychotherapy.

The process designed to accomplish these goals has always been essentially a relational one: patient and therapist traditionally talk and listen to one another, investigating the personal meanings of the patient's current dilemmas and life history as they unfold within the relationship with the therapist. Although Loewenstein (1956) has stated, 'The essential factor in the investigative and therapeutic function of psychoanalysis is based upon the use of speech between patient and analyst,' he also cautioned that it was not communication in itself that produced good outcomes, rather 'what is being communicated…, what leads to communication, and what psychic processes and changes occur as a result of this communication…and of its contents' (p.467).

Newer psychoanalytic models of therapeutic process emphasize the intersubjectivity of patient and therapist to a much greater extent, because they are based on object-relational and self-psychological theories which consider the genesis of psychopathology to be a result of inadequacies in the earliest relational context – that of child and mother – which create poorly internalized, differentiated, or integrated images of self with other (Lichtenberg, Lachmann and Fosshage, 1992; Stolorow, Atwood and Brandschaft, 1994). Because each relational constellation is thought to have an affective charge, and some affects are uncomfortable, they can be defensively dissociated, leading to integrative failures which affect self-cohesion as well as self-esteem and ego functioning (Hamilton, 1996). Remediating pathology thought to result from faulty integration of self and other has required the deployment of new techniques, including interventions that are primarily interactional and non-verbal in nature, as well as attention to a finer grained understanding of preverbal developmental processes and their relationship to later functioning. Successful outcomes of therapy in this tradition involve increased self-cohesion, better self/object relatedness, regulation of affects through transmuting internalizations and self-soothing, and the development of a bounded, private, continuous, self-stabilizing self (Lichtenberg *et al.*, 1992).

Although most psychoanalysts can agree that a main focus of the treatment is the relationship of the patient to the analyst and significant others, there is an ongoing debate as to whether psychoanalysis is best conceived as a psychology of the individual or one of interpersonal relations (Greenberg and Mitchell, 1983). According to Rycroft (1956a), Freud himself linked these two perspectives in 1923 when he stated that 'ego is that part of id which has been modified by the direct influence of the external world' (p.25). In other words, the ego's development is intimately related to the establishment of object relations.

Psychoanalytic Developmental Theory

Part of the confusion generated by psychoanalytic developmental theory is that it is in reality at least four theories. I will summarize the assumptions of each, drawing heavily on the work of Fred Pine (1990). The 'drive theory' model of psychoanalysis portrays development in terms of the child's attempts to master conflicting urges, seen as emanating from the child's own body, occurring in epigenetic sequence, but organized and ultimately transformed through defensive activity. In this model, the individual is seen as made up of his or her historical urge-battles. Although the urges are seen as biologically based, they come to achieve form through mental representations, most importantly wishes and fantasies. Because of Freud's conception of these urges as instinctually-derived motivators, he called them drives. The two salient drives were sex and aggression. Defensive prohibition of expression of driven action was made possible by identification with the parents' attempts to control the child's urges, but sometimes resulted in symptomatic behaviour and uncomfortable feelings like guilt and shame anxiety.

Another model of psychoanalysis is that of 'ego psychology'. This model is closely linked to drive theory, but as elaborated first by Anna Freud (1936) and systematized by Heinz Hartmann (1939), development is seen not just as the unfolding of the drives, but as a matter of adaptation to the average expectable environment. Drawn from Freud's structural theory (id, ego, superego), the ego functions and defences are felt to be equally if not more important than instinctual pressures in understanding psychopathology, to the degree the ego mediates between the inner world of feelings and fantasies and the demands of the outer world. Ego capacities are thought to develop over time through learning. As outlined by Bellak, Hurvich and Gediman (1973), the main ego functions are thought to include: reality testing; judgment; sense of reality of the world and of the self; regulation/control of drives, affects, and impulses; object relations; thought processes; adaptive

regression in service of the ego; defensive functioning; stimulus barrier; autonomous functioning; synthetic-integrative functioning; and mastery competence. However, disruptive environment or excessive conflict may lead to problematic development (i.e. developmental fixations or arrests), which manifest as 'ego defects'. Examples of ego defects include affect flooding or intolerance; unreliable delay or control of impulses; failure to maintain self-esteem in the context of libidinal object constancy.

A third influential psychoanalytic model is called 'object relations' theory. In this paradigm, the primary impetus for human behaviour is object seeking (Fairbairn, 1954), with drives operating in service of that search (cf. Klein, 1946; Winnicott, 1965), or, more commonly, with affects seen as more relevant components of motivation (Basch, 1988). The individual is conceived as enacting an internal dramatic scenario, derived from early childhood, kept within in the form of memory, and in which the individual enacts any number of roles. The internal scripts are like templates which stamp even new experiences, so that no new relationships are ever truly new. However, what gets laid down in memory is what the child experienced rather than objective 'truth'. Therefore, the memories are coloured and shaped by the emotions and wishful fantasies that the child originally experienced. In addition, the child is motivated to repeat the early family drama in service of attachment (gaining more security) and/or in service of mastery (achieving a sense of competence).

This theory is a departure from the traditional Freudian conception of object relations in that the drive subserves object seeking, rather than the object serving as the means for consummating the drive. It is an extension, nevertheless, of Freudian ideas about identification as a means of replacing lost object ties with an inner relationship, about dyadic versus triangular relations within the early family (preoedipal versus oedipal configurations), and of the significance of transference through which the patient enacts the early historical object relations with the analyst.

'Self' theory represents a fourth model of psychoanalytic thought. Although primarily associated with the work of Heinz Kohut (1971, 1977), many contemporary analytic thinkers give great emphasis to the role of the self as an organizer of subjective phenomena that is more accurately descriptive of the patient's real experience than are the heuristic concepts of 'ego' or 'object-representation', for instance. In this model, subjective states of the person are what is addressed in therapy, as well as how a person organizes conflicting states of mind and how they manage transitions between states. Emphasized are issues of differentiation between self and other (boundaries); authenticity versus false compliance; a sense of agency in living life free of

inner coercion; affective tone as reflected in a sense of wholeness and cohesion versus discontinuity and instability.

In clinical practice the latter two theories about development are often interwoven to inform a variation on traditional analysis of impulse and defence , called relational or intersubjective therapy (Stolorow *et al.*, 1994). in fact, the unit for analysis is not the individual patient, but the interactional field within which a person develops and tries to form ties and define him or herself (Mitchell, 1988). Mental structures are seen as relational configurations; the achievement of self-regulation is seen as a function of competent management of systems relating. Affectivity is followed closely for its vitality, which is seen to reflect the earliest interactions between child and caregiver and seen to contribute to mutual regulation. The genesis of symptoms in this model is thought to arise from relational contexts in which some crucial emotional experience of the child cannot be integrated or 'claimed' by the child because the caregiver has not been able to attune empathically enough. The child experiences the affect state as threatening to the tie with the caregiver, and may dissociate it. Cleansed of the offending emotional states, the child tries to embody a fantasized ideal (to the caregiver) state; falling short of this ideal causes shame and self-hatred. The walled off affect-state in question, then, constitutes the dynamic unconscious. Through mirroring (Kohut, 1977), affective attunement (Stern, 1985), enactments, and creation of potential space (Winnicott, 1974), it is hoped that those early interactive derailments can be repaired (Lichtenberg *et al.*, 1992).

Psychoanalytic developmental models hold certain common assumptions, despite differences accorded to the importance of drives, ego, or self. Points on which most clinicians agree include: Successful functioning is assumed to be the result of meeting a sequence of unfolding developmental tasks germane to a hierarchy of adaptive challenges (Gedo, 1979; Grand *et al.*, 1988; Schore, 1994). Meeting these challenges requires integrating newly emerging biological and emotional functions so that successive reorganizations create new psychic structures which include and subsume all former organizations of behaviour (Sroufe, 1979). Since failures of integration result in emotional dysregulation (Schore, 1994) and symptomatic behaviour, therapy is also aimed at removing the blocks to developmental progression. The epigenetic sequence can then continue to unfold, creating the possibility for successively higher levels of intrapsychic integration (Freedman, 1985).

Therapeutic Stance and the Developmental Perspective

Freud's original psychoanalytic methods and principles were derived largely from patients who had internalized self and object representations and were capable of symbolic functioning. Indeed, according to Langs (1978) the ability to adapt favourably to the classical therapeutic frame seems to imply some achievement of self- and object-constancy. Nevertheless, the extensive agreement that persons emotionally arrested at earlier developmental levels will experience and communicate to their therapist in ways quite different from persons who have achieved more differentiated representations of self and others (Balint, 1979; Horner, 1984; Pine, 1979, 1984, 1985) has produced a number of modifications of the classical technique (Kernberg, 1984; Kohut, 1971; Searles, 1985). As Hedges (1983) explains, 'Persons whose growth is arrested at earlier phases of development lack the freedom and richness which comes through considering and accepting the psychological separateness of others' (p.10). He argues that a different 'listening' perspective is required for each level of developmental arrest.

In its broadest context, then, psychoanalytic psychotherapy has been viewed as a process 'in which a therapist listens to the self and object experiences presented through the introspections and interactions of the person in treatment' (Hedges, 1983, p.13). In this model, therapeutic progress presumably is related to the therapist's skill in listening to the thoughts, images, symbols, enactments, and engagements of the patient. The more attuned is the therapist to the developmental level of the patient's conflicts or arrests, the more the therapeutic experience is liable to recreate the original context of relatedness in which the patient's difficulties emerged. To the extent that these difficulties can be enacted or verbalized, symbolized and understood, the patient's separation–individuation process can continue to unfold. However, to the degree that the patient's difficulties are enacted, signalled, somatized and dissociated, different 'looking' perspectives are also necessitated.

Creative Attunement

Many of the patients who find their way to expressive therapists do so because they sense a disparity between what they express – behaviourally or verbally – and what they feel or think or mean. They may live as if on the surface with no sense of inner core; or they may be comfortable only with their inner experience, with a sense of others as alien, even antagonistic. They hunger for authenticity, for meaning, for connection; yet they flee from contact. Diagnostically, such a patient is often considered to have a disorder

of the self. However, what we actually see are insufficiently integrated selves. Paradoxically, what is in need of repair are the rifts between public and private selves, and even within their outer and inner worlds.

Disorders of the self manifest as maladaptive patterns of perceiving, relating to, and thinking about the environment and oneself in a wide variety of social and personal contexts. These patterns, like personality traits, endure throughout much of adult life, but unlike normal character traits, cause significant impairment of social or occupational functioning or create severe subjective distress. Enduring personality patterns of this sort are thought to originate out of a need to protect the psyche from excessive narcissistic vulnerability. By this it is meant that behavioural, affective, perceptual, and cognitive processes are altered in order to screen out threats to a sense of existence as a self with boundaries, unitary status, continuity over time, and capable of connecting with others to get a variety of psychological needs met. To simplify still further, people defend against experiences of disintegration, disorganization, discontinuity and disconnectedness, because the anxiety induced by those experiences is that of falling apart or falling forever, and this feeling is nearly intolerable.

The 'self' is an abstraction used to describe a representation of our sense of identity. Therefore, it is a mental phenomenon, but it has continuity in time and a location in space – usually synonymous with our spatial representation of our body (Jacobson, 1964). Furthermore, many feelings, urges, and impulses are connected in our inner experience to our sense of self, so it does not feel like an abstraction. As the vulnerability being defended against is generally a narcissistic one, the inner experience of the individual is of having a problem with his or her basic sense of self and/or self-esteem. Although few patients (or even professionals) can define narcissism, they know when their sense of continuity or of being whole feels shaky.

Since the self is a mental representation, it is one aspect of psychic structure. The self-representation – like object representations and like symbols – can be used to bind impulses and to delay discharge of tension in action (Beres and Joseph, 1970). Like a word or object representation, though, it takes time to develop, and does not fully function in an adult way until at least adolescence, when cognitive developments permit sufficient awareness of abstract concepts so that introspection can begin. However, many aspects of self-experience emerge earlier in development, including self-awareness (I am different from you), self-cohesion (I am a unit), and self-in-relation-to-others (I do things to and with others and they do things to and with me; I am proud of who I am in relation to others and in relation to my own abilities and wishes). To these senses of self can also be added

self as private (I can hold a secret, therefore have an inner space; I can provide self-solace) and self as a member of a particular culture.

Paradoxically, disorders in self experience do not arise in developmental experiences occurring strictly to the self. Rather, they usually occur in relation to the primary caregiver of earliest childhood, whose needs may have inhibited an adequate mirroring or letting go experience, and so either kept the child from differentiating a distinctive sense of self or propelled the child prematurely into a sense of self which did not include a sense of being in loving relation to another person.

Although much has been written about the diagnosis and treatment of self disorders, little attention has been paid to the disorder of symbolic expression which results from poor self and object differentiation. There are, however, a few notable exceptions to this pattern: Joyce McDougall, Henry Krystal, Norbert Freedman, Stanley Grand, D.W.Winnicott, Russell Meares. From their work we can learn much about what happens to the link between mind and body when developmental integration gets derailed.

From McDougall and Krystal we know that when the fusional identity with the mother cannot be relinquished – often because the mother cannot let go herself, or because of defensive regression – there will be no need to create psychic objects to compensate the child for his or her pain. Consider, for instance, the rituals, movements, and objects which baby uses to get him or herself to sleep when left to his or her own devices by a good enough mother. Such a mother lets a child cope on her own with the inevitable demands of reality that the child sleep (and thus be separated from the mother). If she does not permit these brief frustrations, she prevents an important link between physical sensation and mental representation (which is at the sensorimotor level in early infancy) from taking place. Thus, not only does the child fail to learn to soothe herself when need be, but an image of the self as capable of self-soothing is not developed. Without symbolic self-soothing, the child is forced to rely on others in a compulsive, addictive fashion – as need gratifiers instead of separate and distinct individuals. When others are unavailable for frustration relief, defensive 'splitting' is used to protect good feelings from contamination by bad feelings. The 'good', gratifying mother is experienced as a different person from the 'bad', depriving mother, just as the 'good', satisfied self-feelings are seen as incompatible with the 'bad', 'angry' self-feelings. Instead, the 'good' mother is felt to be a unit with the 'good' baby; the 'bad' mother to be connected to the 'bad' baby.

Thus, whenever we see splitting, we can assume that there has been a failure of synthesis (Freedman, 1980), and presume an incomplete experience

of self. This integrative failure takes place at many developmental levels – at the sensorimotor level, in the representational world, and in the integration of affects. These failures also produce disruptions in the deployment of symbolic words and gestures.

Dance therapists see illustrations of this splitting in the patient whose body does not feel to be adequately bounded or connected: she moves stiffly and minimally as if she might shatter at any second. They also see it in the patient who seems to have bodily integrity, but no clear sense of psychological existence, continuity, or cohesion, and is able to mimic or be mirrored, but is not able to initiate or contrast, or who cannot move with a group without losing a connection to her feeling self. They also see splitting at work in the patient who moves, moves, moves, but cannot connect her gestures to words or images.

Without a sense of bodily cohesion, one's reality sense about one's boundaries and physical being is distorted such that a part of one's body can be felt to be disconnected from the rest of oneself. Without self-cohesion, one's loving feelings and angry moods cannot be felt to coexist in one's own personality. Rather, one set of these ambivalent feelings are usually projected onto others (who are experienced as persecutors or deserters, or alternately as the most perfectly loving beings on earth). Without self-cohesion, there can be no mutuality, no collaborative, reciprocal relationships because these require seeing the other person as other – separate from the self, and also just as hampered by the complexities of ambivalence and reality as oneself (i.e. not all bad, not all good, but one with whom one can negotiate, play, work, have loving sex – in short, with whom one not only can but must communicate).

Expressive therapists heal splits, integrate body and mind, and help the patient to be able to function and to connect. That the arts are like play makes them ideal modalities for use in evolving increasingly connected and cohesive psychic existence, because 'the field of play is where, to a large extent, a sense of self is generated' (Meares, 1993, p.5). In play, the child has a particular way of being with another person, a particular way of using language, and a particular form of absorption in activity that is remarkably similar to the state of an adult lost in thought.

Meares (1993) has elaborated a theory of play which links play disruptions with self-pathology. Based largely on the work of Winnicott (1974), his formulation is nevertheless original in its illustration of the links between early developmental events and later therapeutic process, particularly in relation to the formation of the inner world. Play in earliest childhood, when a sense of self develops, takes place in the presence of another (Piaget, 1959;

Winnicott, 1965). The sense of self develops through the child's interaction with the nurturing environment: the mother and what she provides. Ironically, the self, which is private, grows in public. The inner world, on the other hand, is created partly of experiences with physical things, such as toys and bodies.

In play there is a partial overlap between the child's experience and the mother's experience. Prototypical of the type of play experience that is important to the development of the potential for shared reality is this description by Piaget (1959) of a typical child during play:

> What he says does not seem to him to be addressed to himself but is enveloped with the feelings of a presence, so that to speak of himself or to speak to his mother appears to him to be the same thing. His activity is thus bathed in an atmosphere of communion... This atmosphere excludes all consciousness of egocentrism. But, on the other hand we cannot but be struck by the soliloquistic character of these same remarks. The child does not ask questions and expects no answer, neither does he attempt to give any definite information to his mother who is present. He does not ask himself whether she is listening or not. He speaks from himself just as an adult does when he speaks within himself. (p.243)

Meares labels this young child at play the 'embryonic self', the self before a sense of privacy is achieved, where thoughts are mingled with, or even in things. Indeed, thought cannot exist without them. For the young child things are the vehicles for a certain kind of thinking, comparable to the flux of an adult's inner life. Thus, the play space is the precursor of the inner space of an adult.

If normal development of the self through play is disrupted, because of insufficient attunement or constant impingement, the play space will feel broken up. There will develop a sense of self with discontinuities, or even discontinuous selves characterized by disparate states of mind, or even a feeling of no 'real me'. The first sense of self (both inner and outer, illusory and real, though destined eventually to become the inner life) will feel creative and full of the possibility of intersubjectivity and intimacy; this state of mind will be characterized by calm, and accompanied by threads of thought and meaning that generate potential. The other sense of self (destined to become the social self) will feel to be oriented only to the real, the mundane, the adaptive tasks of the social world: the state of the mind will be alert, vigilant to the outside world, and to the other's demands.

The task of the therapist is to establish, with his or her presence, the field of play – a mode of being together that makes the integration between alert social adaptation and quiet being alone in the presence of an other into a more unified sense of self, a self that is both communicating and not communicating. Until that integration is achieved, these discrete senses of self may even feel as if in different play spaces, to the degree that things and others are experienced discontinuously, too. It may even feel to the therapist as if these are two different patients, in two different playrooms, one illusory and one real:

A 29 year old female patient, who sought treatment for chronic, recurring depressive episodes, with a history, during adolescence, of treatment by orthopedic brace for spinal scoliosis, was experiencing severe anxiety in anticipation of her therapist's upcoming August vacation and anger over feeling abandoned on the Fourth of July. When the therapist commented 'It's as if you can't imagine that I can keep you in mind when we're not together,' the patient responded, 'You think of me when you're not here? That's Bullshit!' In a subsequent session she said, 'The problem with this session going well is that now I feel so close to you, like you understand me, and now I don't want to leave.' When the therapist tried to explore with her what would keep her from keeping an image of the therapist-understanding-her with her when she left the office, she said, 'I wouldn't dare take you with me! I'd feel so shameful! You'd hate who I am out there: I'm such a phony. I'm nothing like I am in here! You know what it's like? When I'm in here I get all relaxed and it's like my body is all curved over (demonstrating a sort of fetal posture). When I go out it's like I have to put on that brace, and I feel so ugly and nasty, and I imagine you would find me ugly and nasty, too.' In an attempt to bridge the world of inner and outer, the therapist said: 'You can't imagine that I would understand your need for your defences.' And, later, in order to help her explore the issues between self and other, the therapist also commented: 'So you must imagine that I'm totally different outside of here, too. No wonder you think I couldn't possibly be interested in you when I'm on vacation.' The patient said: 'But I've actually seen you outside of here, and you're the same. You're always the same. It's me, I guess, who can't bear the thought of you-understanding-me when I'm not here. I don't want to do it myself. I want you to be there.'

As the arts can be play without words, they are ideally suited to this work of creating an inner world that is not so disparate from the socially adaptive mode of being. But as illustrated above, a therapist working in a verbal modality can help create the same type of experience, if attuned to the phenomenology of a patient who lacks integration in ways that are thought to be characteristic of self-experience before a sense of a fully bounded self comes into existence. This requires a knowledge of how the personality is rooted in, indeed grows out of, bodily experience of a certain sort. For this, an understanding of preverbal development is essential.

The Developmental Process

Development of a person is an interaction between biologically-based maturation and experientially-based learning. Two modes of increasing competency are central to growth: that of biopsychosocial *adaptation*, or the enhancement of externally-oriented survival-related capacities; and that of the *awareness* of the experiencing person that is either adapting or not adapting. The personality is made up of characteristic ways of handling the external and internal milieus, and the tensions between their sometimes competing claims.

Under the category of biopsychosocial adaptation is included *maturation of neurobiological processes*, which are, in turn, dependent on provision of care by the environment if they are to unfold (Schore, 1994). The interaction between the brain and the environment proceeds according to stages: different emerging brain structures produce a sequence of infant behaviours, which elicit the appropriate attuning, stimulating, or regulating interventions from the mother; different caregiver responses are predictably produced as well, since they are necessary for the stimulating and regulating of certain types of infant behaviour. Behaviours which unfold in this way include affects and movements, which are tied to sensations and ways of processing those sensate experiences. The organization of the dyadic behaviours into a stable style of *attachment* helps the child learn to balance a sense of security with a sense of efficacy (Aber and Slade, 1987; Bowlby, 1979).

Other competencies in the sphere of biopsychosocial adaptation include a hierarchically-organized *personality structure* which expresses and regulates expression of affects and motivations as they emerge out of attachment experiences (Freud, A. 1936, 1965; Freud, S. 1923; Gedo and Goldberg, 1973). Such a personality organization is essential to the efficient processing of information and to the survival of the infant as a separate, viable human being. Another competency in this sphere, related to organismic viability and integrity, is that of *relationship*: the capacity to form, sustain, and enjoy human

connection as a group member (Fairbairn, 1954; Sullivan, 1953; Winnicott, 1974). Subserving these capacities is competency in cognitive and *symbolic processing*, involving perceptual processes, artistic sensibilities, and creativity as well as language and thought (Deri, 1984; Dissanayake, 1992; Freedman, 1985; Vygotsky, 1978).

The dimension of the experiencing self is both a product of sensory and motor experiences which ensure survival and a part of the appraisal process necessary to rapid information-processing and judgment. So although subjective awareness and the so-called inner world are more generally the province of psychology and the arts, and thus thought to be expendable luxuries, it is now thought by some that by enhancing subjective experience through the arts and through better psychological awareness and management, we increase our intelligence and thus our adaptability (see, for instance, Dissanayake, 1992; Goleman, 1996; Hanna, 1979). In any case, the development of a separate, subjective sense of self, or as Winnicott (1974) would describe it, 'inner psychic reality', also proceeds through stages.

Depiction of those stages is problematic, however. It is difficult for the following reasons: one, there is at least one stage theory for every theorist. Two, theorists are divided not just by their differing observations and inferences, but also by different scientific allegiances. Thus, for every event observed, there is a cognitive orientation, a neurobiological basis, a socioemotional explanation of various persuasions, and at least ten psychoanalytic hypotheses. Furthermore, the language of each discipline is formidable in its complexity and in its resistance to easy translation.

Conceptualizations of the Developmental Process

Illustrative of this problem is how to fit together the accounts of cognitive psychology with those of psychoanalysis. Both seem to contain a certain truth. However, if one reads either a sufficient number of psychoanalytic accounts of development, or wades through enough cognitive studies of laboratory-induced phenomena, one naturally develops an appreciation for the simple, the descriptive, the observable, the self-evident. Nevertheless, doing therapy with patients who have suffered integrative failures requires both a metatheory which accounts for intrapsychic structuring and a methodology which permits one to move between objective and subjective reality.

The metatheory and methodology of psychoanalysis are rich in description of psychic reality, but limited in language that describes the actions which constitute the processes of structuralization, affective experience, and defensive operations. In fact, the delineation of the developmental progression of affective life in early childhood has become obscured by the

complexity and strangeness of some of the concepts involved in describing infant experience. Descriptions like 'bizarre life-maintaining mechanisms of a secondary autistic nature', 'unconditional hallucinatory omnipotence', 'quasi-coenesthetically acquired patterns of reception in the service of an important "pleasure motivation", 'primal undifferentiated matrix…cathected with primordial undifferentiated drive energy', 'primal cavity experiences', and 'omnipotent symbiotic dual unity' (Mahler, Pine and Bergman, 1975) make an empathic understanding of early development difficult.

As Schafer (1976) has pointed out, the biologically-based Freudian metatheory is also problematic because it is analogous to the 'archaic bodily language of infancy' (p.5). This bodily language tends to concretize processes as things with location and mass. At the same time it is relatively lacking in terms that describe the child as acting with a sense of agency; rather, he or she is considered to be passively experiencing propulsive drive forces which initiate action. Emotions are described as traits one has, rather than as kinds of felt behaviours or as processes of appraisal. Schafer argues that even more modern psychoanalytic theorists, such as Jacobson (1964) and Kohut (1971), are replacing Freudian materialistic/energic concepts of psychic structure with self and identity constructs that are equally reified. Rather than considering 'self' as a type of mental representation, modern writers often treat this concept as a space, place, or substance.

Cognitive theories of the self, on the other hand, suffer not from a paucity of behavioural descriptions, but from a lack of resonance with one's private experience. Although studies of cognitive competencies, symbol formation abilities, and intellectual capacity clearly delineate the sequence of growth in the child's capacities to represent him or herself mentally, these studies tend to neglect the affective components of the cognitive experiences; that is, describing the facts of self-knowledge or self-recognition or self-aware-ness does not do justice to the experience of being a self, because these competencies are not possessed by people, but organized by people in relation to other important people and events.

Psychoanalyst Roy Schafer (1976) suggests replacing traditional Freu-dian concepts with alternative formulations based on 'action language'. Following Schafer's guidelines means that any delineation of emotional development in relation to evolving psychic structure requires attention of phenomenological (emotional) experience through the observation of ac-tions. By actions, what is meant are: 'all private psychological activity that can be made public through gesture and speech…as well as all initially public activity…that has some goal-directed or symbolic properties' (Schafter, 1976, pp.9–10). Thus, attending to actions or behaviours of a certain sort,

permits one to observe, describe, work with private (i.e. intrapsychic) experience as well as delineating or modifying public (i.e. interpersonal) interaction. It can also serve to place cognitive achievements in the context of an affectional relationship.

The self can be reconceptualized as 'a way of pointing' (Schafter, 1976, p.271). Emotions, too, can be rendered differently: as modes of action. Since one no longer speaks of 'an emotion' but of 'doing an emotion action or doing an action in an emotion mode', both emotions and self experience are rendered visible. These emotive actions do not simply signal one's acting emotionally, but constitute aspects of acting emotionally. So any change in the action implies a change in the emotion. Emotion then can be treated as a process (a 'how') or as a dynamic (a 'thus'), rather than as a thing (an 'it').

Translation of intrapsychic structure and emotion into action language thus permits one to work therapeutically with patients using both symbols and emotions-in-action: artistic creation, authentic movement, symptomatic arts, therapeutic play. Out of these active engagements can come the mutual creation of a symbolic bridging of inner and outer reality.

To do so, however, requires an understanding of developmental theory from the point of view now just of action and its inhibition (drive and defence : conflict theory and ego psychology) but of affect and its regulation (interpersonal process, activation contours, experiential states of intersubjectivity: object relations and self-psychology theory). In addition, since, in this model, physiological state is now inextricably linked to intrapsychic experience, an understanding of the unfolding of neurobiological competencies is essential.

The Art of Knowing: An Integrative View of Biopsychosocial Development

Each person moves, thinks, feels, and speaks in a unique way, based on the image of him or herself and the image of the world that he or she has built up through experience (Feldenkrais, 1977). Everything known by us has been taken in by our bodily senses. For everything seen, touched, heard, smelt, or felt there is a perception, which is made up of both an 'exteroception' – a recognition of something produced outside the organism – and a 'proprioception' – a recognition of something produced within the organism. In other words, every sensation also involves a motoric response. Our core knowledge is built up on the foundation of these sensorimotor impressions (Freud, 1990; Piaget and Inhelder, 1969) which are differentiated, integrated, organized, and balanced (Hartmann, 1964) or assimilated, accommodated, schematized, and equilibrated (Piaget, 1962).

The internal processes through which we acquire, transform, and store perceptual information is called cognition (Zajonc, 1984, p.241). Cognitive processing involves mental activity, which in turn reflects the transformation of a sensory impression into a neural pattern of relative synaptic strengths. These patterns of neural firings are called representations. Since the same stimulus can be processed in a number of different ways (e.g. how it smells, how it looks, how it makes the perceiver feel, and so forth), a stimulus is often represented in many different processing 'modules' – pathways in the brain – which are interconnected by associational networks to other percepts (Gazzaniga, 1985). For example, think of the self- and object-representational unit.

When events are processed in the brain's cortex, they are also compared and stored. In other words, information is evaluated and given meaning (Le Doux, 1986). Appraisal of a stimulus event's significance is important to survival. Comparison with either inherited (genetically encoded) or learned (in the form of knowledge) information helps us decide which of the multitude of impinging stimuli require action. This appraisal process is felt by the perceiver, proprioceptively-speaking, as emotion. Each processing module, or representation, then, is also interconnected with an affective experience, creating the self-affect-object unit of object-relational theory.

Thus, emotion has the adaptive function of making us care. Such caring facilitates behavioural control and social communication. According to Ellen Dissanayake (1992), who had developed a 'species-centred' theory of aesthetics, art conveys more than the usual emotional and cognitive interconnections. In making us care, art not only reinforces individual survival skills, but organizes cultural bonding and affiliation, which subserve group survival.

Information processing within the brain structure is organized spatially and temporally. One important axis is the vertical connection between the limbic system and the cortex. The vertical axis is made up of two main ascending and descending pathways, which together comprise the autonomic nervous system. These two pathways are called the sympathetic – underlying 'fight or flight' reactions – and the parasympathetic – underlying the so-called 'conservation-withdrawal' response. Another axis is the horizontal connection between the right and left hemispheres, constituted by the corpus callossum. Typically, the left brain is thought to handle information through temporal processing, analysis, sequential ('logical') thought, abstraction, and language. Its counterpart, the right brain, is thought to operate more 'intuitively' or holistically, due to its reliance on visuospatial processing, emotion, imagery, and analogical thought.

Information can be processed in each hemisphere independently and as a result much of remembering, feeling, and acting-on-need can be 'computed' without contact with the language and cognitive systems that are thought to subserve private, conscious experience. Indeed, what we hold to be conscious experience may turn out to be just verbally-encoded memories that are associated with interpretations given by the left hemisphere to our behaviours or imagistically-represented memories, while the unconscious may be located in the non-verbal, nontemporal, right hemisphere (Gazzaniga, 1985; Schore, 1994).

Even within the right hemisphere, the emotionally-toned, perceptual-motor memory structures (representations) are connected in various associative networks on the basis of their different sensory and emotional features, including their emotional relevance to the self and social surround. Elements like intensity, contour, shape, temporal beat, rhythm, and duration are features of the environment that even preverbal infants have the inborn capacity to match across sensory modes (Stern, 1985). This cross-modal matching process is not restricted to infancy, though. It can be illustrated by the comments of a seven-year-old child, who, upon viewing the newly cleaned brown-on-brown Trinity Church in downtown Manhattan, was heard to observe, 'It smells like a chocolate donut with chocolate frosting.'

Association networks that bridge right and left hemisphere probably account for the power of analogy and metaphor for evoking internal feeling states and for describing the psychological aspects of people (for example, 'He's yellow.' 'She's a stinking liar.' 'He's so remote.' (Dissanayake, 1992)). According to Bowerman (1980), the earliest sentences constructed by young children concern 'being' and 'activity': descriptions of 'that, there, more, no more, and all gone' reflect concern with the existence/nonexistence and disappearance/recurrence of objects and events. Most metaphors have similar features in that they are orientational (concerned with size, location, etc.), ontological (concerned with existence), or rooted in activity ('get a hold on yourself'), and use visual, auditory, tactile, kinesthetic, thermal, and olfactory terms.

In Dissanayake's view, it is more than coincidence that the building blocks of aesthetic experience are rooted in spatial and temporal qualities. We are innately predisposed to process information through spatial organization, a certain quality of thinking which involves contrasting opposites and comparing new information with prototypes, through cross-sensory-modal matching, through patterning experiences in time (inferring qualities like permanence and changeableness, sequence and duration), through amplification and patterning of 'innate affects'. Sensitivity to changes in size, shape,

rhythm, relationship to gravity, and so forth, involves learning how to produce optimal stimulation levels, which confer biological advantages. High arousal states, for example, facilitate exploration, attachment, and the survival mechanism of fight-flight activation. Low arousal states facilitate the survival mechanism of conservation-withdrawal, which is useful in tempering high arousal states in social situations, in modulating heart rate and metabolism for tissue repair, and in facilitating the more inward focused cognition necessary to symbolic representation.

Although these predispositions are inborn, they require environmental stimulation for optimal development, and they unfold in a timed sequence (Schore, 1994). First the different senses achieve maturity, with the maturation (in sequence) of olfactory/gustatory (smell/taste), somesthetic/thermal (kinesthetic/touch), visual, and auditory modes; simultaneously the infant learns to co-process information across sensory systems, enabling him or her to recognize equivalence, detect invariant features, and respond to changes in intensity over time. This permits the amodal abstraction necessary not just for translation from one mode to another, but for the formation of internal cognitive representations. (Think of the 'chocolate' church, for example: if it tastes good, it must feel good, and make you feel good.) The neural encoding of such 'activation contours' is done partly on the basis of the similarity of affective charges or arousal levels, which are registered in the brain as temporal patterns of changes in the density of neural firing.

In fact, sensory stimulation and cross-modal matching are activities carried out not just by an infant, but by a mother–infant pair, as part of the attachment or bonding process. The ultimate reference for the match between sensory experiences is the internal feeling state, not the external stimulus event, and that feeling state is generated in the context of a highly affectively-charged relationship. Some researchers even posit that during the first months of an infant's life, her mother is essentially 'downloading' a programme from her brain to her infant's brain for use in arousal activation, encoding, regulating, and decoding (Schore, 1996).

Thus, it can be said that meanings emerge in the context of interpersonal relationship, and that this earliest of relationships imprints or programmes the brain to react to certain categories of events as did the mother and child (Schore, 1994). Understanding the earliest mother–infant relationship, therefore, is essential to understanding the process of meaning-giving.

This unique dyadic relationship, however, is not unidimensional; the interaction between mother and infant is formed and changes over time both in response to the dispositions of each partner and in response to the special organization their relationship attains. Furthermore, how the relationship is

organized changes with the infant's age and stage of development. At every stage, the baby has physical experiences and expressions (organized in relation to gravity, space and time), which get mirrored, matched, contrasted, or held by the caregiver and thereby given a value, dimension, and an acceptable intensity range.

Different theorists understand and highlight different non-verbal dimensions and modes of interaction they make possible. All see a trajectory of increasingly complex organization and interaction, with more differentiated, articulated modes which either work together or are at odds with one another and come to define what we call personality. All theorists attempt to account for both biopsychosocial adaptation and the development of a subjective sense of self, and further make an effort to integrate these two complementary tasks.

Images of the Developmental Interplay of Adaptation and Awareness

Picture an infant at birth: a mass of wrigglings and jigglings, cries, sighs, and open eyes. 'See me, feel me, touch me,' in the words of Peter Townsend's 'Tommy'. The infant is felt to be irresistible to the mother, who can't wait to see, touch, count, examine, cradle, smile, and coo to her baby. Concerns about hunger and warmth also intrude on the powerful moment where both invite each other in, deeply or shyly, but with looking so charged that the moment can never be forgotten. The infant's movements propel the mother into action: more holding, perhaps swaddling, as a way to contain the spastic arms and legs. Propping of the head is automatic as is the wish to be body to body close, every inch contained, but no, let him have some freedom, he's fussing about being too closely held. The tension between the two, the communication through bodily empathy, is palpable, then calm. Playing first, then feeding.

Such a newborn infant not only cannot come to exist without the mother and father, but cannot continue to exist without maximum amounts of environmental stimulation, holding, handling, and soothing, usually provided by the mother. Therefore, crucial to an understanding of early development is the 'fact of dependence' (Winnicott, 1960). Winnicott even goes so far as to say, 'There is no such thing as a baby'. You cannot describe an infant without reference to someone else. A baby cannot exist alone, but is essentially part of a partnership. Thus, environmental provision in the form of 'good enough mothering' is essential.

This dependence, according to Winnicott (1965), has three stages: the stage of absolute dependence, where the infant has minimal control over what is provided; the stage of relative dependence, in which the infant

becomes more aware of his or her need for mother's ministrations, and learns that a gesture, cry, smile, and reach get results (as do hiccups); the third stage, that of movement towards independence, involves the infant beginning to take over aspects of his/her own care, which is accomplished through memory and development of confidence in the environment.

Meanwhile, back at the (less theoretical) ranch, baby will smile and even stick his tongue out at mum by two months, in imitation of her silliest antics. She, of course, has just been imitating him, which is the only way to produce this miraculous behaviour: catch him already at it. She and he have their eyes fixed on one another, with mother imitating his expressions, selectively. Although this maternal reflection is often called 'mirroring' it is actually something different, because she gives him back something of herself along with something of him. Usually, that something includes shameless adoration. The joy is in her face.

'What does the baby see when he or she looks at the mother's face?... What the baby sees is himself or herself. In other words, the mother is looking at the baby and what she looks like is related to what she sees there' (Winnicott, 1974, p.131). So she not only mirrors the affective state expressed on baby's face, she responds in a way that gives his emotions form. Trevarthan (1983) calls this 'primary intersubjectivity' a 'protoconversation', with affects as the words. The precision of the synchrony between mother and baby led him and others (e.g. Bernstein and Singer, 1982; Stern, 1977) to consider this type of interaction a dance. When experimenters (Murray and Trevarthan, 1985) tried showing a 6–12 week old baby an even slightly time-lagged version of her mother (on videotape), the infant was distressed and turned away. By two months, then, the mother and baby have created a shared structure of activity, regulated by gaze, synchronous movement, and coordinated intonations (Jaffe and Feldstein, 1970). Of course, affects are more than just the gestures of this choreography or the language of this earliest dialogue; they are also the stuff of later intimacy. For what we see here is 'self object' experience, par excellence.

The mother finds herself going to sleep at night with his face on her mind, and wonders if he is having the same experience. Her being is full of him. She knows his shape, his weight, his rhythms, his preference for accelerating when excited or decelerating when anxious, for hollowing away or bulging into her, his lightness when straining up, his heaviness when tiredly giving in to gravity. Does he know me that way? she ponders. Sometimes she feels as if the two of them are one. Other times, her mind drifts, her eyes wander, and she catches a glance at him in a similarly 'spacy' or dreamy state. At those times, she breathes deeply, contented and relaxed,

attending to nothing in particular, but bathed in a sea of coenesthetic satisfaction. I hope he feels as deeply peaceful as I do now, she muses.

> It is only when alone (that is to say, in the presence of someone) that the infant can discover his own personal life… The infant is able to become unintegrated, to flounder, to be in a state in which there is no orientation, to be able to exist for a time without being either a reactor to an external impingement or an active person with a direction of interest or movement. The stage is set… In the course of time there arrives a sensation or an impulse [that] will feel real and be a truly personal experience. It will now be seen why it is important that there is someone available…although present without making demands, the impulse having arrived, the…experience can be fruitful and the object [recipient of the impulse] can be a part or whole of the attendant person, namely the mother. It is only under these conditions that the infant can have the experience which will feel real. A large number of such experiences forms the basis for a life that has reality instead of futility. The individual who has developed the capacity to be alone is constantly able to rediscover the personal impulse. (Winnicott, 1965, p.34)

Back at the ranch the infant and mother are continuing to have lots of playful moments. Baby shakes his legs on the changing table, mum shakes her head in response. Wow, hair flies, baby cracks up with laughter. He shakes again; she shakes again. Many times the sequence is repeated. He begins to shake his head in imitation of her. She adds a sound, a 'prrrr', with her lips vibrating while her head and hair shimmy, as well. A crescendo of mutual 'positive affective sharing' (Waters, Wippman and Sroufe, 1979) is reached, with the so-called 'vitality affects' or 'activation contours' (Stern, 1985) – the 'hows' of movement, the dramatic choreography of tension-flow motility (Kestenberg, 1975) revved and reflected. The baby has been 'blasted into a higher orbit' (Stern, 1985), and another unforgettable moment has occurred between the two. This interaction gets repeated numerous times in a day: baby jiggles, mum wiggles, both dissolve in giggles. ('Hey, this is just what I needed,' he feels.)

It is important that the mother not overdo or underestimate the response: the baby has to initiate this relating. If he does, he will come to feel as if the interaction and its attendant good feeling came from himself: 'I created this; the world is under my control.' ('Cool!') Meanwhile, good old mum is saying to herself, 'Let him enjoy this illusion of omnipotence now; he'll be rudely awakened about the limits of his power soon enough'.

The baby begins to get the sense that he created what was there to be found. And thus is built trust, hope, possibility: inner can connect to outer. That silly, but vibrant, maternal head-shake is what Winnicott would call 'object presenting', that part of the maternal provision that facilitates the first relationship. However, woe is to the mum who is too abandoning or engulfing ('impinging') and forces the infant to react in some way. The baby's continuity of being can be interrupted, with resultant trauma and threat of annihilation. With too much misattunement comes the development of vigilance and compliance, which stifle the creativity and spontaneity that makes life feel worth living. In later life the baby/man who had to defend against too much impingement comes to see a therapist because he feels deadened, disconnected, or unreal.

As far as our baby is concerned, he attains a sense of being one existential 'unit' by virtue of being able to bring together his hands at the midline of his body, or by touching (even sucking on) his toes. He soon begins to notice that sucking his toes gives him quite a different internal sensation than sucking on his crib rail or blanket. Eventually, he starts to group these two types of proprioceptive experiences into a 'me' and a 'not me'. Because of cognitive developments he becomes increasingly able to reproduce or repeat experiences that have already happened to him, and can begin to anticipate the positions objects pass through while they are moving. He has been so successful at 'creating' what mum presents that he thinks he alone can cause all events. By four months, he has figured out that a cough will bring mum running.

In fact he thinks this the beginnings of objectivity! Mum, on the other hand, is starting to feel that this little guy is ready for some dosing of disillusionment, so she starts deliberately failing him in small ways. Maternal cunning takes over, and she stays gone for short periods of time when she's expecting him to get himself to sleep at naptime and bedtime. (Then again, hard-hearted though she is, she's attuning to those wails through the baby-monitor.) For baby, however, out of sight, out of mind. This is presenting a bit of a problem for the boy wonder, though. He feels as though he's been dropped and could fall forever. ('Come back, Mum! What I need is a Mummy-monitor'...or a memory-trace.) Resourcefulness is part of his inborn potential, though, and soon he finds a finger, blanket, or toy to suck on, at first accidentally, then on purpose. ('Well, it's not the cigar, but it will substitute. Gotta survive...')

One day, while he's practising the 'vision thing' (tracking and anticipating the position of objects in space), he becomes intrigued by a flash of grey fur streaking by. ('What's that? Reminds me of mum's hair flying by...quick,

indirect, back and forth motion, something dark, soft-looking, that's not smooth or light like mum's and my skin, nor brightly coloured like my clothes; hmm, fun to watch, interesting, changing.') He gets all excited, looking at…the cat. Mum notices he's not looking at her anymore and starts to pay attention with him to the furry creature, pointing and naming it 'cat; kitty cat' over and over, helping him make contact, watching his awe at the soft fur, sharing his delighted state. Soon, he, too (precocious child that he is), starts saying 'ca' and pointing when he sees the cat. And trying to crawl toward it.

Before he successfully coordinates his locomotor abilities, he receives a gift, a toy sheep dog. 'Ca,' he says. This boy has been reading his Piaget! He obviously has created a 'schema', or category, for something soft, on four legs, with moving hairy stuff, to which he is adding this new possession in his mind in an act of cognitive assimilation.

Mum, for her part, is over the top with admiration of his genius. The two of them are in their own high-arousal orbit, but the orbit is now centred more and more around a third element: the world-to-be-manipulated. Unbeknownst to mum, though, his interest in the toys is at least partially motivated by their relationship and his interest in sensing her responses. That sheepish sheep dog, for instance. She's smart enough to have figured out by now that this is his 'transitional object' (popularly thought of as a 'security blanket' – thanks to Linus). After all, he does play with it and laugh at its shaking fur when in his crib, and can't go to sleep without it.

Yet it is only after the head shaking game one day, when he points at her hair and says 'ca', that she realizes that 'ca' is not just cat, it's something more indefinite, like 'soft moving hairy stuff that makes me laugh with delight and reminds me of is part of my Mum, and therefore also part of me'. She also sees suddenly that the dog, while definitely more created by him than by her, partakes of something about her. The magical confluence of all these kinesthetic, affective, and cognitive events is what gives the 'transitional object', and other phenomena like it, the feeling of illusion. ('Ca' is cat, dog, and Mum, and even a little bit me, when I'm delighted and being amplified and admired.) Thus, Winnicott (1971) calls it the first 'not me' possession, at once illusive and real. It exists in an intermediate area of experience, somewhere between thumb-sucking and the teddybear. It is the beginning of a differentiation between an inner and an outer world. The illusory part is contributed by the area of the infant's experiencing.

It is this illusory experience that will form the basis of art, creative living, and religion for the boy when he's an adult. In the meantime, the shaggy dog serves as a defence against anxiety, especially of the sort he has when

separating from his mum at bedtime. It has several important functions: it is his possession; it can be loved ruthlessly; it must never change, except by his doing; it must show it has a life of its own (like give warmth, have texture or movement); it comes neither totally from outside of him nor inside, but both; and it must eventually lose its meaning.

Another thing mum doesn't know is that the reason he can create this quasi-symbolic representation is that she has been 'good enough' at holding and handling him. With too much maternal inadequacy, the internal feeling and 'schema' fail to have enough meaning to manifest in this way. This underscores a key point: it is not the object that is transitional; it is the relationship to the mother.

So back to the playspace...playing takes place in the same 'potential space' as do transitional phenomena. It is neither inside nor outside, but in the overlap of two areas of playing – that of the mother and that of the child. 'Potential space' is seen by Winnicott (1971) as the area of all satisfying experience, dominated by 'creative apperception' and the discovery of meaning: 'It is creative apperception more than anything else that makes the individual feel that life is worth living'. In contrast, 'compliance carries with it a sense of futuility for the individual and is associated with the idea that nothing matters and that life is not worth living'. Furthermore, 'only in playing is communication possible', because only in playing is true mutuality of experience created.

Gradually, then, our child is beginning to take in that there are other minds out there, not just other things. Things he can roll, push, bounce, grab, and fairly predictable actions result. But go try to roll, push, bounce, grab another baby, and boy, does the fur start flying then! ('And what about the time I bit mum instead of the frozen bagel. She got all red and sudden and loud and abrupt and strong, not at all like that soft, funny lady I play with. In fact, I'm not even sure she is the same lady. Nothing like my mum, really. And when she got all huffy and pulled away from me, well, I turned away and got stiff. I didn't even feel like myself; no melting warmth. In fact, I got cold, too, and I started to cry. Then my real mum came back. She hugged me. I wonder what happened? Maybe it wasn't the same me, either. She said 'bad'. Her or me? Maybe it was a bad baby who did that. Yuk. I don't like that new lady, and I don't want her to touch me, either. I better be extra nice to my mum so that bad baby doesn't bite her again.')

By seven to nine months emotional states can be read, matched, aligned with, or attuned to. Alternately, of course, they can be misread, mismatched, misaligned, and misattuned. The permutations and combinations of these social behaviours by mother and infant produce a great number of relation-

ship possibilities: the soap opera of infancy has begun! Who's doing what to whom? and when? and how? Stern (1985) calls this capacity for subjectivity 'the domain of intersubjective relatedness'. Make no mistake, it is built on the language of non-verbal affectivity far more than that of verbal differention. All that cross-modal matching of early infancy now serves the process of psychological inference. ('Does red, abrupt, and withdrawing make me feel hot or cold? How does it make her feel? Is it the same? And if I feel cold, am I bad? Or is she?') For every image of other (mother), there will be a corresponding image of self, joined forever by an affect state. Many of these self-other-affect constellations (known in the object relations business as self- and object-representational units) will be contradictory and nearly impossible to reconcile with one another. In fact, they will be held in separate frames of reference, 'split off' from one another.

Do I need to tell you that the honeymoon is over? It will be months, maybe years, before all this is sorted out. In the meantime, batten down the hatches, the state of relative dependence is becoming permeated with aggression, and there's trouble in River City. Primitive motility, fused with some form of instinctual ('ruthless') love, brings about discovery of, and separation out of, the environmental surround. This bumping up against the world changes the nature of the relationship between baby and mother from that of 'object relating' to that of 'object usage', where object usage is dependent on a view of mother as separate. In order to achieve such a differentiated psychic representation, the baby (subject) must (psychically) destroy the object (mother). Her job is just to survive his greedy or aggressive attacks. Survival, however, is not guaranteed; she has to remain non-retaliatory:

> The subject says to the object, 'I destroyed you,' and the object is there to receive the communication. From now on the subject says, 'Hullo, object!' 'I destroyed you.' 'I love you.' 'You have value for me because of your survival of my destruction of you.' 'While I am loving you, I am all the time destroying you in (unconscious) fantasy...' In these ways, the object develops its own autonomy and life, and if it survives, contributes in to the subject according to its own properties. (Winnicott, 1974, pp.105–6)

The shift to object usage differentiate dream states from waking states, so that dreaming can be used for self-enhancement, and the baby can take on the investigatory functions of a scientist. In its approach to reality, the 'social' or scientific self has to be alert, on guard, ready to fight or flee. He learns how to be competent, how to ward off disabling states of dreaminess. He

learns, language, logic, and reality. Now, lots of this is very satisfying, because he gets better at doing real things, and can generate lots of praise. The problem is that what can be given can also be taken away. ('Whoops. Please don't take away your approval. When you're critical of me, I feel ashamed, and I can't stand that feeling. I see you staring at me with that look on your face, and I feel like falling through the floor. I'll do anything you say, really. You're happy with me? Good. Then I'm happy with me. Just don't go, and don't be mad at me. Look, I'm shaking my hair, just like you!')

In this way, the child switches back and forth between two modes – which constitute two discontinuous spaces, if you will. One is felt as totally real, the other as real and illusory (transitional). Both experiences are fundamental to growth, but one is more delicate than the other. One is high arousal, and subserves reality and survival, exploration and affectivity. The other is low arousal, inhibited, and subserves fantasy, dreaming, relaxation, and the type of cognition necessary for inward focused attention, remembering, and verbal communication. The danger for the child is that if parental attunement is chronically insufficient, the 'potential' play space is never fully created, and he never has a chance to generate a sense of the personal, the private.

In one playroom space, he is 'practising' (Mahler, Pine and Bergman, 1975) social and survival modes. The world is his proverbial oyster, loco-motion his passion, his affect is elated, mum is adoring and enabling. With our new knowledge of developmental neurobiology (Schore, 1994), we can speculate that this playroom is 'run' by the sympathetic branch of the autonomic nervous system. The other playroom, thought to be dominated by parasympathetic arousal, which is facilitated by mum's (second year) switch to socializing and regulating arousal states and the transitions between them. He is 'low-keyed' (Mahler, et al., 1975), reactive to separations with inhibition, moody, ambivalent, shame-prone, self-doubting. He oscillates between shadowing mum and darting away. He wants to be found; he is terrified of being re-engulfed in the dyadic unity. 'Rapprochement' crises around separations, reunions, and slights to his self-esteem are the order of the day. His affect is primarily depressive; his mother is at wit's end, but trying to stay emotionally available, so he can make reparations after his destructive bouts. Interactive repair, after all, is the key to psychic integrity, as it unites the two playroom experiences.

By 18 months a real 'social' self is emerging, and a verbal self (Stern, 1985) is constituting. He can recognize himself in the mirror. He shows this by pointing to himself rather than the mirror to remove rouge that some slightly sadistic experimenter put on his nose (Lewis and Brooks-Gunn, 1979). He has an increased sense of awareness about himself and his

competencies and deficiencies in comparison with others (Kagan, 1981). Self-conscious emotions (like coyness and embarrassment) appear in the second half of the second year (Lewis and Brooks-Gunn, 1979; Lewis, 1992; Sroufe, 1979), with shame the result of a sense of personal exposure, and a sense of 'concern' for others – the outcome of the crisis over destructiveness (Winnicott, 1965).

Our boy is aware of being and feeling small. Mum helps him deal with this by denial in fantasy (A. Freud, 1966): 'You're such a big boy!' Lucky for him, he'll soon be able to evaluate things on his own. If he listened just to that kind of remark, he'd be stuck in the la-la land of grandiose illusion, for sure. Of course, up until now, his mother may as well have been a procession of women – all familiar, but not exactly connected. As he begins to have more of a sense of continuity in his own personal experience, however, his separate experiences of mother get linked to his self-experience, lending them more elements of commonality, more coherence. He's beginning to feel more stable, and he's beginning to believe others have a stable existence whether he can see them or not. He's starting to realize that the same woman who frustrates him at bedtime is the one who comforts him in the middle of the night if he has a nightmare. He can be good and bad: she can be good and bad.

A terrible sense of loss accompanies this realization, though. With the attainment of this more ambivalent 'object relation', and the freedom from instability and constantly shifting moods, he has had to give up the fantasy (and accompanying feeling of bliss) of ecstatic union with head-shaking, all-adoring mum. He mourns by trying to remember (and recreate) the all-wonderful feelings, and by letting himself miss them. He begins to draw pictures – first dots, lines, and circles; then 'tadpole' figures and faces (Gardner, 1980). He increasingly moves to representing feelings about important people (himself, mum, dad, little brother) and his cat, in words and symbols, rather than through sensorimotor action.

Although he feels sad more frequently, he has better control over his arousal. He doesn't get so 'wild' and out-of-control. At ages two and three, the play space still oscillates between the potentially inner zone and the social, external zone. He plays in the presence of the other, first in actual physical proximity, and then increasingly in a more intrapsychic way. His mum watches him plan play sequences, hears him foresee certain events that are not tied to his immediate sense perceptions. In play he can now copy complex behaviours and pretend (use something other than the original object to stand for the object). He can, for instance, substitute an upside

down cup for a drum, and make a toy monkey beat it. This use of pretend helps him master the difference between reality and fantasy.

His improving command of language means he can communicate what he wants, while also keeping hidden thoughts and feelings he does not want exposed. It also means that the parents can use verbal interchanges for socialization of behaviour, and that words as well as actions can be internalized as thought. Mum and dad can actually listen to incipient thought by listening to the speech that accompanies his play. From three or four to seven or so, the child speaks in monologue to himself; by seven this speech goes 'inner' forever (Piaget, 1969; Vygotsky, 1962).

With development comes the possibility of increased 'distance' between the thing being represented and the symbolic vehicle chosen to represent it. The upside down cup can be replaced with a block of a different shape than a real drum; the block can be replaced by a drawing; a drawing replaced by a trial mental action accompanied by a verbal tag; the trial action replaced by a verbal description. There is also more separation between the child wishing to communicate and the person he is playing with, drawing for, talking to. To link all these components – referent, vehicle, addressor, addressee – each essential to the formation of a symbol (Werner and Kaplan, 1963), hierarchical organization is indispensible. Indeed, that (drum roll) is how symbolization builds psychic structure.

Vygotsky (1981) considered all higher mental functions to be internalizations of social relationships. This formulation was shared by Werner and Kaplan, the gurus of symbolization, who believed that the act of reference is a social action: Within a 'primordial sharing situation', child and mother begin to 'contemplate' objects with the Other, by 'exchanging things with the Other, by touching things and looking at them with the Other. Eventually, a special gestural device is formed, pointing at an object, by which the infant invites the Other to contemplate an object as he does himself' (p.43). Soon, however, the child is able not just to refer to a concrete object, but also to represent that object in another medium, such as an auditory, visual or gestural one.

Let us go back to our sadder-but-wiser boy, who has lost the Happy Hair Ranch, and hasn't quite recovered. He has started drawing a series of pictures. First, at age 27 months, is a representation of a boy and a girl (Figure 2.1). The girl is the taller figure at left; the boy is feeling small. It is made up of 'oral dots' and 'anal scribbles', as one might expect at this age. It is accompanied by no description other than the gender labels (reflecting gender differentiation). Take note of the scribbled horizontal line over the upper 'head' section of the boy – we'll come back to it. Figure 2.2, his first

Figure 2.1 Girl and boy

Figure 2.2 A snake with a back and a tail and a mouth and a peach

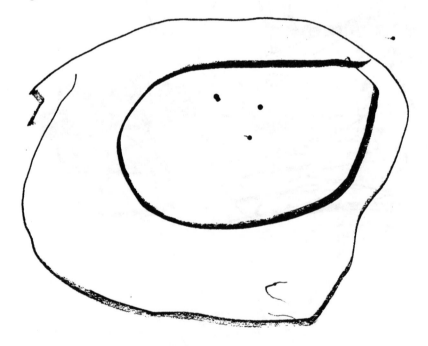

Figure 2.3 An "O", a bird, a bird inside an "O", an Ian

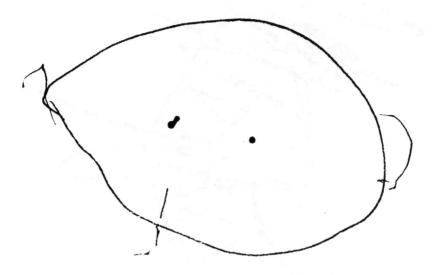

Figure 2.4 My mummy with eyes, a mouth, a hand, another hand

Figure 2.5 My daddy

Figure 2.6 Mummy with two eyes, mouth, nose and hair, then lots of hair

Figure 2.7 Mummy and Ian

Figure 2.8 Ian, eye, eye, mouth, mouth, feet, feet

Figure 2.9 Ian, eye, eye, feet, feet

Figure 2.10 Daddy, Mummy, Ian

line drawing, was done when he was 34 months old. He described it as 'a snake with a back and a tail and a mouth, and a peach'. Figure 2.3, done the same day, was his first self-portrait: 'an "o"; a bird; a bird inside an "o" an Ian (his name), with eyes and mouth; a blue Ian'. Figures 2.4 and 2.5 were also executed the same day. Figure 2.4: 'My mummy, with eyes, a mouth, a hand, another hand.' (Not only did he read Piaget, but he read Freud's description of the 'active' Preoedipal Mother.) Figure 2.5: 'My daddy' (Notice the shape protruding at the bottom).

One month later, Figure 2.6 was created and described. This was done in two stages: first a tadpole, with internal dots and side extensions; then a scribble which covered the figure. He described it as: 'Mummy, with two eyes, a mouth, a nose, arms, and hair'; then, while scribbling more, 'lots of hair.' The next portrait series was created when he was 38 months old. Figures 2.7, 2.8, 2.9, and 2.10 were described as follows: 2.7: 'Mummy and Ian', with 'eyes, two feet, and arms'. 2.8: 'Ian' with 'eye, eye, mouth, mouth, feet, feet.' 2.9: 'Ian' with 'eye, eye, feet, feet'. 2.10: 'Daddy, Mummy, Ian', each with 'two eyes, two feet, two mouths'. Finally, Figure 2.11 was executed later that month: 'Mummy, Daddy (the giant), and Ian'. All were covered

Figure 2.11 Mummy, Daddy (the giant), Ian

with scribbles looking strangely like hair. Returning to Figure 2.1, it's tempting to infer the same process.

The transitional nature of these representations is apparent, as is the touching attempt to evoke the happy feeling of all that shaking going on. The development of alternately merged and then increasingly separate self and object representations is also in progress, as is the messiness of all the feeling involved in the soap opera drama, ending with the entrance of 'Daddy, the giant'. The story of the oedipal triangle, remember, is no soap; it's pure tragedy.

These drawings, however, are also offerings, harbingers of a time to come when, as a more mature child, Ian will be able to engage in a reciprocal relationship, involving choice and interchange rather than ignoring the other's taken-for-granted presence. He will continue to have greater control over whether to reveal or not to reveal aspects of his private, inner world. His offerings will then take on the qualities of secrets, inviting the sharing of a like confidence in exchange. Thus will the acts appropriate to intimate relating be realized out of the potential space between him and a friend. When privacy (shown in the ability to keep a secret) has been attained, the self can be said to have a boundary, and thus to really exist, according to Winnicott (Davis and Wallbridge, 1981). Before that, Winnicott believes it is not self, but ego, that is relating.

The constellation of self-experiences is organized both through symbolization and through feelings about one's self existence, such as security and value. Sullivan (1953), for instance, considers the function of the self-system as the protection of the sense of security (with defences seen as 'security operations'). Mirroring, of course, is essential in helping the child constitute not only self-cohesion, but self-esteem. When a child displays tenderness, and is greeted with contempt, he feels devalued in a deeply, almost bodily, damaging way. He will learn to hide whatever is tender in him. If, on the other hand, his need for tenderness is met, and feelings of value become associated with vulnerability, he will develop a feeling of well-being when with another. According to Meares (1993), 'The experience of well-being arises with another. It comes when the match between the responsiveness of the other and what one feels and knows is so good that it brings with it a muted form of elation. There is a receptivity to, and a harmony with, the sensory environment and things 'get inside' (p.68). This is a bodily experience, with a probable underlying resonance between sensory data and memory patterns encoded neurally in the limbic system.

The path to feelings of effectance, then, depend on a correspondence between one's wishes and their fulfillment, but the feeling of self-worth is a

product of a valuing response to one's personal emotions and ideas. Connectedness with another person can, therefore, be a precursor to acting in competent self-enhancing ways. This is an idea that runs contrary to the prevailing popular notions of self-esteem, which hold that it is a product of achievement. In this model, disconnection with necessarily deflate self-worth, whereas achievement of a sense of connection with another human being will create the emotional 'fit' necessary to feelings a 'lift'. Feeling uplifted restores energy and sufficient mastery motivation to inspire capable action. So self-esteem involves interconnection with responsive (mirroring) others that reverberates with personal expressions and meanings.

Clinical Process: From Expression to Meaning in Therapy

Winnicott masterfully bridged drive, ego, object-relational, and self-psychological formulations of development and therapy. He consistently emphasized the perspective of the experiencing patient, the importance of inner psychic reality to the development of the central self, and was one of the first analysts to embrace a fully intersubjective (i.e. noninterpretive) method for gaining access to and understanding of intersubjective states. One of the techniques he employed for exploration of intersubjective consciousness (making use of transitional phenomena) was a game he used first with children, called 'The Squiggle Game' (Winnicott, 1971), which later informed his modification of adult analytic technique to be less interpretive (Davis and Wallbridge, 1981).

In this game communication was fostered by alternate patient and therapist 'squiggling': Winnicott would draw a line on paper for the child to turn into something, and then the child would make a line or squiggle which he would turn into something, until a 'dialogue' of sorts would emerge, usually out of one or both of their inner worlds. As Andre Green (1993, p.219) observed:

> With children, Winnicott plays the Squiggle Game in which each partner takes a turn drawing a scribble, which is then modified by the other... The spontaneous movement of a hand which allows itself to be guided by the drive, a hand which does not act but rather expresses itself, traces a more or less insignificant and formless line, submitting it to the scrutiny of the other, who, deliberately, transforms it into a meaningful shape. What else do we do in the analysis of difficult cases? ... Meaning is not discovered, it is created. It is a potential meaning... To actualize it means to call it into existence, not out of nothing (for there is no spontaneous generation), but out of the meaning of two

discourses, and by way of that object which is the analyst, in order to construct the analytic object [a symbolic expression that is co-created in the potential space between analyst and patient].

To illustrate how therapeutic presence helps transform play therapy into a modified 'Squiggle Game', partaking of the transitional phenomena of intersubjectivity characteristic of the earliest developmental stages, I will discuss the opening phase (establishment of the therapeutic alliance) in the therapy of a five-year-old electively mute girl.

Ilene was referred for therapy for treatment of her refusal to speak in school or other settings outside her home, despite good verbal facility at home. Her developmental history included difficulties with breastfeeding ('She didn't want anything to do with it'), colic for the first six months, and a series of ear infections at three months of age, which culminated in a three day hospitalization for croup. The mother linked the patient's illness to her return to full-time work when Ilene was three months old. Since that time, the patient had been raised mainly be her great-grandmother, who spoke little English. Significant family history revealed parents who were having marital discord which they dealt with by alternately arguing/undermining one another and being silent/shutting each other out. They slept in separate rooms in the same house in which the patient had a bed in her great-grand-mother's room and aunt's room. This arrangement had been arrived at after a sister had been born 16 months before, and the father blamed the patient for being too noisy, while ejecting her from the parental bed, where she had slept ever since her hospitalization. This history was gathered prior to the first meeting with the patient.

At the first session, the patient refused to enter the playroom alone. Her mother therefore decided to accompany her, but made sarcastic comments such as, 'What's the matter? Do you think I'll never come back?' and 'What's the matter? You don't like the toys?' The therapist chose not to interpret the ambivalence and hostility directly but instead to try to engage the patient in play. She used two hand puppets to mirror the ambivalence: one in an 'open' position, friendly and talkative; the other in a 'closed' position, withdrawn and reluctant. The patient did not talk to the therapist, but played with doll house figures, elaborating dramas (which the mother ventriloquized) which involved people, either dad or baby, being closed out of the bedroom of the doll house, and which greatly amused mother.

In the next session the patient, again accompanied by her mother, came into the room with more deliberation, sat at the small table which was set up with paper and markers. Mother opened a tablet-form book of coloured paper to two side-by-side blank pink pages, and they both began to draw.

The patient cupped her hand around her drawing, attempting to hide it from her mother. Then she began whispering to her mother and showing her the drawing, but excluding the therapist. The therapist reflected her wish to keep a secret. She then showed the therapist her drawing – an open hand. The therapist reminded her of the open–closed game of the session before and asked if she could draw a closed hand? She was hesitant, but persevered, and after several attempts produced a drawing of a closed hand, which she was quite pleased with: a fist.

Meanwhile mum had been working on her own drawing, which was of a mother, daughter, cat, toys, and perhaps a birthday cake. The therapist commented on the mother's drawing: 'Look, the little girl has no hands!' Mother then changed her picture by adding in the little girl's hands. The patient clapped her hands, and jumped up and down in excitement. Subsequent play involved people being ejected from rooms in the doll house and objects, as well as her head, being hidden in block structures she built. The therapist continued to make descriptive, reflective comments through the open and closed puppets. At the end of the session, as Ilene was leaving, she blurted out, 'Mummy's a booby! You're a booby, too!' Thus was the therapeutic alliance forged out of mirroring attunement with her inhibited/prohibited vitality.

Even in these first encounters, a therapeutic 'potential space' was created. It allowed deep communication between this non-verbal patient and the therapist. The first 'squiggle' in this case was the patient's reluctance to enter the playroom, coupled by the mothers devaluing comments about the patient's feelings and the therapist's resources (toys). This was clearly still a merged self and object unit, with hostility/fear as the affect. They needed to be engaged as such. The therapist's response to their 'squiggle' was puppet play – introducing the game 'open–closed' – using a bodily-based 'crossmodal' (using the sense organ of the hand instead of the mouth) reflection of the dyad's ambivalence about how open to the new situation they felt. This was elaborated by them into a game in the doll house where someone was always getting closed out.

The pair's next 'squiggle' was a pair of drawings: the patient enacted keeping a secret from mum, then keeping a secret with mum, which closed out the therapist, while simultaneously producing a drawing of an open hand. The therapist elaborated their 'squiggle' in the form of a suggestion that they again play the open–closed game, this time by a drawing of a closed hand. The patient's willingness to oblige produced a representation of a dissociated part of the self (as seen by object) – the fist. The mother openly offered a drawing of a girl without any hands. Therapeutic comment that

something of the daughter was not represented by the mother permitted interactive repair to take place (as seen in the mother's correction of her drawing). The child then saw herself more fully mirrored and represented, and began to jump for joy, using the formerly missing (split-off) part of her self-representation to vehemently clap. Admiration by the therapist for the efforts of both was, of course, provided.

A symbolic re-enactment of the process through which people or things got projected, ejected and disowned allowed her to claim her anger gradually and safely. Mother, meanwhile, survived her daughter's attacks. The fruits of this work were seen when the patient was able to use words to express her angry feelings at both the mother and therapist. The words, 'you're a booby,' of course, are suffused with oral aggression and evocative of the developmental struggles and trauma over feeding, weaning, and separation.

Potential space was created not just by willingness to take an intersubjective stance, in which the pair's merged state was mirrored and responded to, but also by the introduction of playful mirroring – on a bodily level – of the sensory-motor constellation (open–closed) behind their dual stance (one open–one closed), behind their separate ambivalences (each open and closed), and behind symptomatic expression, through enactment and somatization, of the family conflict over who gets closed out (mouth open in some settings, mouth closed in others).

Play, admiration, and mirroring all contributed to increased vitality, affect amplification, and eventually the achievement of verbally-encoded ambivalent feelings ('Mummy's a booby. You're a booby, too.') Although the sentiment is angry (closed), the wish to communicate the anger through shared meanings (words) betrays the hunger to relate (open).

In summary, the therapeutic challenges posed by patients reflect the level of developmental integration the patients have achieved. The attuned therapist will use an understanding of unfolding developmental dynamics to create the appropriate potential space for the level of developmental difficultly encountered by her patients. In that potential space, she and her patients will playfully transform their affectively-based expressions into vitality, and from vitality into shared meaning.

References

Aber, J.L. and Slade, A. (1987) 'Attachment theory and research: A framework for clinical interventions.' Paper presented at the Regional Scientific Meeting of the Childhood and Adolescence Division for Psychoanalysis of the American Psychological Association. New York City, 10 January.

Baliant, M. (1979 [1968]) *The Basic Fault: Therapeutic Aspects of Regression*. New York: Brunner-Mazel.

Basch, M. (1988) *Understanding Psychotherapy*. New York: Basic Books.

Bellak, L. Hurvich, M. and Gediman, H. (1973) *Ego Functions in Schizophrenics, Neurotics, and Normals*. New York: Wiley.

Beres, D. and Joseph, E.D. (1970) 'The concepts of mental representation in psychoanalysis.' *International Journal of Psychoanalysis 51*, 1, 1–9.

Berstein, P. and Singer, D. (eds) (1982) *The Choreography of Object Relations*. Keene, NH: Antioch.

Bowerman, M. (1980) 'The structure and origin of semantic categories in the language-learning child.' In M. Foster and S. Brandes (eds) *Symbol as Sense: New Approaches to the Analysis of Meaning*. New York: Academic Press.

Bowlby, J. (1979) *The Making and Breaking of Affectional Bonds*. London: Tavistock Publications.

Bucci, W. and Freedman, N. (1978) 'Language and hand: the dimension of referential competence.' *Journal of Personality 46*, 594–622.

Bucci. W. and Freedman, N. (1981) 'The language of depression.' *Bulletin of the Menniger Clinic 45*, 4, 334–358.

Davis, M. and Wallbridge, D. (1981) *Boundary and Space*. New York: Brunner/Mazel.

Deri, S. (1984) *Symbolization and Creativity*. New York: International Universities Press.

Dissanayake, E. (1992) *Homo Aestheticus: Where Art Comes From and Why*. New York: Free Press.

Fairbairn, W.R.D. (1954) *An Object Relations Theory of the Personality*. New York: Basic Books.

Feldenkrais, M. (1977) *Awareness Through Movement*. New York: Harper and Row.

Freedman, N. (1977) 'Hands, words, and mind: on the structuralization of body movements during discourse.' In N. Freedman and S. Grand (eds) *Communicative Structures and Psychic Structures*. New York: Plenum Press.

Freedman, N. (1980) 'On splitting and its resolution.' *Psychoanalysis and Contemporary Thought 3*, 237–266.

Freedman, N. (1985) 'The concept of transformation in psychoanalysis.' *Psychoanalytic Psychology 2*, 4, 317–339.

Freedman, N. (1971) 'The analysis of movement behaviour during the clinical interview.' In A. Siegman and B. Pope (eds) *Studies in Dyadic Communication*. New York: Pergamon Press.

Freedman, N. and Bucci, W. (1981) 'On kinetic filtering in associative monologue.' *Semiotica 34*, 225–249.

Freedman, N. Barroso, F., Bucci, W. and Grand, S. (1978) 'The bodily manifestations of listening.' *Psychoanalysis and Contemporary Thought 1*, 157–194.

Freedman, N. and Steingart, I. (1975) 'Kinesic internalization and language construction.' *Psychoanalysis and Contemporary Science 4*. New York: International Universities Press.

Freud, A. (1936) 'The Ego and Mechanisms of Defence'. In *The Writings of Anna Freud, Vol. 2.* New York: International Universities Press.

Freud, A. (1965) *Normality and Pathology in Childhood.* New York: International Universities Press.

Freud, S. (1900) *The Interpretation of Dreams. S.E. 5,* 509–623.

Freud, S. (1923) *The Ego and the Id. S.E., 19,* 3–66.

Gardner, H. (1980) *Artful Scribbles: The Significance of Children's Drawings.* New York: Basic Books.

Gazzaniga, M. (1985) *The Social Brain.* New York: Basic Books.

Gedo, J. (1979) *Beyond Interpretation.* New York: International Universities Press.

Gedo, J. (1988) *The Mind in Disorder: Psychoanalytic Models of Pathology.* Hillsdale, NJ: The Analytic Press.

Gedo, J. and Goldberg, A. (1973) *Models of the Mind: A Psychoanalytic Theory.* Chicago: University of Chicago Press.

Goleman, D. (1995) *Emotional Intelligence.* New York: Bantam Books.

Grand, S., Freedman, N. Feiner, K. and Kiersky, S. (1988) 'Notes on the progressive and regressive shifts in levels of integrative failure: A preliminary report on the classification of severe psychopathology.' *Psychoanalysis and Contemporary Thought 10.*

Grand, S., Freedman, N. and Steingart, I. (1973) 'A study of the representation of objects in schizophrenia.' *Journal of the American Psychoanalytic Association 21,* 399–434.

Green, A. (1993) 'Analytic play and its relationship to the object.' In D. Goldman (ed) *In One's Bones: The Clinical Genius of Winnicott.* Northvale, NJ: Jason Aronson.

Greenberg, J.R. and Mitchell, S.A. (1983) *Object Relations in Psychoanalytic Theory.* Cambridge, MA: Harvard University Press.

Hamilton, N.G. (1992) *Self and Others: Object Relations Theory in Practice.* Northvale, NJ: Jason Aronson.

Hamilton, N.G. (1996) *The Self and Ego in Psychotherapy.* Northvale, NJ: Jason Aronson.

Hanna, J. (1979) *To Dance is Human: A Theory of Non-verbal Communication.* Austin: University of Texas Press.

Hartmann, H. (1939) *Ego Psychology and the Problem of Adaptation.* New York: International Universities Press.

Hedges, L.E. (1983) *Listening Perspectives in Psychotherapy.* New York: Jason Aronson.

Horner, A. (1984) *Object Relations and the Developing Ego in Therapy.* New York: Jason Aronson.

Jacobson, E. (1964) *The Self and the Object World.* New York: International Universities Press.

Jaffe, J. and Feldstein, S. (1970) *Rhythms of Dialogue.* New York: Academic Press.

Kagan, J. (1981) *The Second Year: The Emergence of Self-awareness.* Cambridge, MA: Harvard University Press.

Kernberg, O. (1975) *Borderline Conditions and Pathological Narcissism.* New York: Jason Aronson.

Kernberg, O. (1984) *Severe Personality Disorders: Psychotherapeutic Strategies*. New Haven, CT: Yale University Press.

Kestenberg, J. (1975) *Children and Parents*. New York: Jason Aronson.

Klein, M. (1946) 'Notes on some schizoid mechanisms.' *International Journal of Psychoanalysis 27*, 99–110.

Kohut, H. (1971) *The Analysis of the Self*. New York: International Universities Press.

Kohut, H. (1977) *The Restoration of the Self*. New York: International Universities Press.

Krystal, H. (1978) 'Self representation and the capacity for self care.' *Annual of Psychoanalysis 6*, 206–246.

Langs, R. (1978) *The Listening Process*. New York: Jason Aronson.

Le Doux, J. (1986) 'The neurobiology of emotion.' In J. Le Doux and W. Hirst (eds) *Mind and Brain: Dialogues in Cognitive Neuroscience*. New York: Cambridge University Press.

Lee, B., Wertsch, J.V. and Stone, A. (1983) 'Towards a Vygotskian theory of the self.' In B. Lee and G. Noam (eds) *Developmental Approaches to the Self*. New York: Plenum Press.

Lewis, M. (1992) *Shame: The Exposed Self*. New York: Free Press.

Lewis, M. and Brooks-Gunn, J. (1979)*Social Cognition and the Acquisition of Self*. New York: Plenum.

Lichtenberg, J., Lachmann, F. and Fosshage, J. (1992) *Self and Motivational Systems: Toward a Theory of Psychoanalytic Technique*. Hillsdale, NJ: The Analytic Press.

Loewald, H. (1960) 'On the therapeutic action of psychoanalysis.' *International Journal of Psychoanalysis 41*, 16–33.

Loewenstein, R.M. (1956) 'Some remarks on the role of the speech in psychoanalytic technique.' *International Journal of Psychoanalysis 37*, 460–468.

Mahler, M., Pine, F. and Bergman, A. (1975) *The Psychological Birth of the Human Infant: Symbiosis and Individuation*. New York: Jason Aronson.

Meares, R. (1993) *The Metaphor of Play: Disruption and Restoration in the Borderline Experience*. Northvale, NJ: Jason Aronson.

Mitchell, S. (1988) *Relational Concepts in Psychoanalysis*. Cambridge, MA: Harvard University Press.

Modell, A. (1976) '"The holding environment" and the therapeutic action of psychoanalysis.' *Journal of American Psychoanalytic Association 26*, 285–308.

Murray, L. and Trevarthan, C. (1985) 'Emotional regulation of interactions between two-month-olds and their mothers.' In T. Field and N. Fox (eds) *Social Perception in Infants*. Norwood, NJ: Ablex.

Piaget, J. (1959) *The Language and Thought of the Child*. London: Routledge and Kegan Paul.

Piaget, J. (1962) *Play, Dreams and Imitation in Childhood*. New York: Norton.

Piaget, J. and Inhelder, B. (1969) *The Psychology of the Child*. New York: Basic Books.

Pine, F. (1979) 'On the Pathology of the Separation – Individuation Process as Manifested in Later Clinical Work: An Attempt at Delineation.' *International Journal of Psychoanalysis, 60*, 225–242.

Pine, F. (1985) *Developmental Theory and Clinical Process.* New Haven: Yale University Press.

Pine, F. (1990) *Drive, Ego, Object, and Self.* New York: Basic Books.

Rycroft, C. (1956a) 'The nature and function of the analyst's communication to the patient.' *International Journal of Psychoanalysis 37,* 469–475.

Rycroft, C. (1956b) 'Symbolism and its relationship to the primary and secondary processes.' *International Journal of Psychoanalysis 37,* 138–146.

Schafer, R. (1976) *A New Language for Psychoanalysis.* New Haven, CT: Yale University Press.

Schore, A. (1994) *Affect Regulation and the Origins of the Self: the Neurobiology of Emotional Development.* Hillsdale, NJ: Lawrence Erlbaum.

Schore, A. (1996) 'Interdisciplinary development research as a source of clinical models'. Paper presented at conference, Perspectives on Early Development, sponsored by the Institute for Psychoanalytic Training and Research, NYC, March.

Searles, H. (1985) 'Separation and loss in psychoanalytic therapy with borderline patients: further remarks.' *The American Journal of Psychoanalysis 45,* 1, 9–27.

Sroufe, A. (1979) 'Socioemotional development.' In J. Osofsky (ed) *Handbook of Infant Development.* New York: Wiley.

Steingart, I. and Freedman, N. (1975) 'The organization of body-focussed kinetic behaviour and language construction in schizophrenia and depressed states.' *Psychoanalysis and Contemporary Science 4,* 423–450.

Stern, D. (1977) *The First Relationship: Infant and Mother.* Cambridge, MA: Harvard University Press.

Stern, D. (1985) *The Interpersonal World of the Infant.* New York: Basic Books.

Stolorow, R., Atwood, G. and Brandschaft, B. (eds) (1994) *The Intersubjective Perspective.* Northvale, NJ: Jason Aronson.

Sullivan, H.S. (1953) *The Interpersonal Theory of Psychiatry.* New York: Norton.

Trevarthan, C. (1983) 'Emotions in infancy: regulators of contacts and relationships with persons.' In K. Scherer and P. Ekman (eds) *Approaches to Emotion.* Hillsdale, NJ: Erlbaum.

Vygotsky, L.S. (1962 [1934]) *Thought and Language.* (E. Hanfmann and G. Vakar, eds and trans.) Cambridge, MA: MIT Press.

Vygotsky, L.S. (1978) *Mind in Society: The Development of Higher Psychological Processes.* (M. Cole, V. John-Steiner, S. Scribner and E. Souberman eds.) Cambridge, MA: Harvard University Press.

Vygotsky, L.S. (1981) 'The genesis of higher mental functions.' In J. Wertsch (ed) *The Concept of Activity in Soviet Psychology.* Armonk, NY: M.E. Sharpe.

Waters, E., Wippman, J. and Sroufe, L.A. (1979) 'Attachment, positive affect, and competence in the peer group: two studies in construct validation.' *Child Development 50,* 821–829.

Werner, H. and Kaplan, B. (1963) *Symbol Formation: An Organismic-developmental Approach to Language and the Expression of Thought.* New York: John Wiley and Sons.

Winnicott (1971) *Playing and Reality.* New York: Basic Books.

Winnicott, D.W. (1965) *The Maturational Processes and the Facilitating Environment: Studies in the Theory of Emotional Development.* New York: International Universities Press.

Winnicott, D.W. (1971) *Therapeutic Consultations in Child Psychiatry.* New York: Basic Books.

Winnicott, D.W. (1974) *Playing and Reality,* 2nd edn. New York: Penguin Books.

Winnicott, D.W. (1975) *Through Paediatrics to Psychoanalysis.* New York: Basic Books.

Zajonc, R. (1984) 'The interaction of affect and cognition.' In K. Scherer and P. Ekman (eds) *Approaches to Emotion.* Hillsdale, NJ: Erlbaum.

Therapeutic Presence Within
a Countertransference Context

Affect and Therapeutic Presence as a Diagnostic Indicator

Arthur Robbins

The concept of diagnosis originated in a medical setting. Generally in medicine, a diagnosis is arrived at, based on symptoms, lab reports, and other data, and then a form of treatment is prescribed. This traditional notion of diagnosis is often applied to psychotherapy, with a variety of diagnostic categories suggesting a course of treatment or a particular therapeutic intervention. From another perspective, however, we can see that in psychotherapy the process need not follow such a linear progression. Instead, one can view diagnosis and treatment as inextricably bound together. Even as treatment is ongoing, based on the ebb and flow of transference and countertransference, resistance and defence, and emerging self and object representations, a parallel process of diagnostic thinking is also ongoing, which in turn interfaces with treatment.

Thus diagnostic thinking moves and changes as we enter different phases of therapy. For the therapist, however, diagnostic thinking poses a paradox. On the one hand, we approach each case and indeed each session with fresh eyes, giving up preconceived notions of how the case will evolve. Yet as part of our discipline, diagnostic material accumulates in the psychic background, being organized in reflection of our therapeutic experiences. Our task therefore is twofold. We attempt to be open to new and unexpected possibilities that occur in the treatment process. At the same time, we bring to therapy a discipline that holds a fund of information, based on past experiences and training, and which serves as an organizer for understanding our experiences in the therapeutic workspace. We are constantly checking our impressions against a framework, one that neither binds nor encloses us

but which can be used to support and validate, or sometimes question, our impressions.

In expressive therapy, the particular qualities of the therapeutic space lend important cues regarding the nature of both treatment and diagnosis. Naturally you bring all the tools at your disposal into therapy – your training and experience above all. Yet you also bring yourself, and it is essential to learn to trust your own affects, your own inner experience of what it feels like to be with the patient, because this is another significant source of information to use in formulating a diagnosis and course of treatment. In bringing your past experience to a particular present countertransference situation, your own reactions can provide a guidepost as to what is happening with the patient. In fact, bringing your own personal artistry into play is the essence of expressive therapy. Therefore, in this chapter I am emphasizing the role of countertransference in diagnosis.

From an object relations point of view, therapeutic space is inhabited by generations of family relationships, sometimes known as self and object representations. These representations and images interact, each carrying a multitude of defences and particular textures and forms. Patient representations often invade, take over from, and respond to the therapist's internal representations, thereby creating a unique therapeutic dance. Yet along with this subjective interplay, there does exist an objective psychic structure with characteristic defences and object relations. Different patients, representing a variety of characterological styles, are prone to create characteristic transference and countertransference relationships, tending to override any singular therapeutic intersubjective bias. This chapter will explore a variety of intersubjective spaces that are prototypical of a particular diagnostic constellation. What I propose to offer is a framework for diagnosis, sorting out our perceptual, sensory and cognitive affects as they apply to diagnostic thinking in the therapeutic workspace. I reiterate that these formulations are intended as a guidepost and not as an explicit recipe book, nor are they meant to be all-inclusive or cover every diagnostic category. Clinical supervisory examples of the following framework can be found in the author's text, *Between Therapists: The Processing of Transference / Countertransference Material* (1989).

The Autistic Position

From an object relations perspective, the four major positions that evolve out of the early maternal holding environment are autistic, schizoid, paranoid and depressive. These positions represent ways of organizing particular character styles that include the patient's defences, utilization of space, and view of both self and the object world.

The autistic position suggests an aloneness and emptiness of such magnitude that nothingness and disconnection are the life experience and are what the patient brings to others. Patients may present in a transference and countertransference relationship a state of blissful oneness or, by contrast, a dreaded sense of emptiness that is analagous to the sensation of falling through space. In the pathological or extreme polarity, I feel nauseous in the very pit of my stomach and have enormous difficulty in staying in this space for any length of time. It all feels painfully muddy and unclear. Nothing has sharpness or delineation. The experience feels like an uncomfortable nightmare that has no form or shape.

As a therapist, I try to differentiate this shape and space from that of the depressive. In the latter, there is a heavy sense of weightiness, whereas with the autistic, nothingness or emptiness seems to pervade the therapeutic space. In this space, we encounter the early problems of attachment and non-attachment to the primary maternal figure. There is a lack of cohesiveness in sensations, perceptions and affects. I feel wobbly and lost; it is very difficult to hold onto the therapeutic experience and concentrate on what is going on in the session. It is like being lost in a forest, where all the trees loom as vague and shapeless. I find myself attempting to avoid or dissociate from this encounter. I may provoke the patient or even become sadistic, if just to feel that I exist. It is so difficult to remain grounded, for the nature of the space is a loss of boundaries and a sense of being alone. Sometimes I forget what is going on in the session, because one sentence seems to be lost right after the other, even though I try very hard to hold onto the material. It is worse than boredom, for at times I feel as if I am going out of my mind. I inwardly wonder how long this interminable session will go on. At times I ask myself if I am part of a sadomasochistic attack. The patient, however, does not seem to want to punish me; it rather seems that I do not have any meaning or relatedness. If there are any fantasies, they are on the shallow side.

Sometimes I find myself tuning out into a comfortable state of nothingness, where I do not feel the pain of being dissociated or in fragmented pieces. Ogden (1989) as well as Tustin (1984) have referred to this state as the autistic position. All of us have had the experience of being in a fog and requiring a period of solitude or isolation. Indeed, a creative beginning may be formulated out of these fragmented bits and pieces. For many, a period of aloneness is required for regeneration. Learning how to use the bits and pieces of one's autistic space becomes the transforming learning experience in treatment.

I note that these patients exhibit a preoccupation with their own bodily parts, as if to give themselves a sense of connection. I am fascinated as I

watch patients touch various parts of their body, soothing themselves, almost as a reassurance that they exist. The space between us is potentially rich with as yet undiscovered sensory motor cues. These non-verbal cues – such as the posture and voice of the patient, and the movement and shifts of the body – furnish important messages. My task is to organize these impressions into a meaningful statement that I mirror back to the patient. Time in this space does not appear linear, for past, present and future all seem to merge. As could be expected, therapy has a vapid, dreary, empty quality devoid of much symbolism and meaning. My job is to offer a container that holds and organizes the disparate sensory motor pieces, while at the same time providing a very grounded, real connection of shape and form.

Ultimately, the major work consists of internalizing my presence so the patient can learn about adaptations through a deep sense of identification in the treatment process. Perfectionism and omnipotence can appear at times as important last-ditch defences to give the patient some kind of organization or hold on reality. Behind this obsessive need for complete control are enormous layers of volcanic rage that seem to erupt out of deadness. Often I am experienced by such patients as the food of the day as they soak up my way of thinking and being. At the same time, my meaning for them is denied out of existence. Thus, on an unconscious level a very subtle process goes on. I am a role model as an object for identification, and I become a fulcrum for learning. I offer stories, tales, movies, explanations, and any and all analogies for them to absorb and learn something about life. It is hoped this process will also act as an anchor to ground them and prevent them from flying away. I serve as ground, mirror and container, communicating basically through sensory motor impressions. Statements are made through a touching, poetic and metaphorical form. I try to find the movement or music in my vocal connections – and certainly a dance or musical therapist might have an easier time in making this very primitive form of contact.

For those of us who have had personal encounters with our own particular form of empty hole, we fully understand this life and death struggle. We need to be offering a sense of hope, and a containment for pieces incorporating meaninglessness and death. Out of such a process, the autistic state can become a forerunner to a creative and reconstructive use of oneself, as a frightening flight into nowhere becomes transformed into a place for solitude and regeneration. The therapist and patient soon learn to respect the feeling of aloneness and the need for solitude, as well as the hunger for structure and containment that can potentially change meaninglessness into form. Of course, many defences against aloneness and nothingness may be observed here, for patients tend to flee into addictive states or hyperactive

disorders. Along with offering groundedness, hope and containment, I try to suggest and encourage connections both from the past and present, through very concrete cultural channels. In this encounter, I am faced constantly with withdrawal, denial and dissociation, and my underlying concern is to offer hope and life against death.

The Schizoid Position

There is a broad continuum, which ranges from the autistic, to the schizoid, to the paranoid position. If the autistic position is one of floating in space, I encounter the schizoid position as being more grounded and anchored in reality. I feel much less drifting and lost in a timeless place. In contrast to the emptiness of the autistic patient, I hear a loud and clear message: 'Hold me, see me, but don't come too close; I want both closeness and distance and it's up to you to decide how to make contact'. There is a wariness and suspicion of contact and a hyperalertness to being invaded or controlled. I often encounter a superficial friendliness beneath this dread of contact. These patients crave their own space, for they are surrounded by fears of potential annihilation and destruction, and of being controlled or manipulated. Projected fears of their own hunger seem to plague them, for their fears of being manipulated or exploited are the dissociated parts of their own inner hunger and need. This hunger, in spite of their denial and dissociation, continues making an impact on me. I hear, 'Break through my barriers if you dare,' yet I encounter a blankness or weariness in their eyes.

Life here also has an empty quality, but indeed the intense pull toward contact seems to be breaking through, for I feel more related to these patients than to those who are lost in an emptiness. Although their fear of attack lurks in the background, these patients become very intriguing as they make intense and close contact with me. I feel that they are virtually inside me, even though they are surrounded by vagueness and amorphousness. The polarities of contact, contrasted with the dread of being invaded or intruded upon, are played out in our therapeutic relationship. The world is often perceived as a cold wasteland, but at the same time there is a search for an oasis of warmth. One may encounter in this wasteland a cold, brutal, and punishing attitude towards women.

Sometimes this quality emerges directly in explosiveness, but often we experience it through a passive/aggressive defensive stance. At times I am split off as the good object, and the bad ones seem to live around us. There is a hunger for perfection and a search for the good object, never quite within our grasp. Often this patient resorts to a grandiose posture where absolute control of everything becomes of paramount importance. Here the schizoid

shares common ground with both the autistic and paranoid positions. What separates schizoid patients from the other two states is their palpable need for intimacy despite the dread of contact. Indeed these patients can be extraordinarily intrusive, for there is a deep introject that at times seems to take hold of their existence, generating a very penetrating form of contact. I create structures where intense contact can be safe and protected. Creative arts, teaching and acting courses can all provide very safe structures where one can be both exposed and hidden, and where one can retreat after the work has been completed.

The Paranoid Position

Shifting to a more extreme position from the autistic or schizoid, we now encounter the sharp, harsh protective mechanisms of the paranoid position, characterized by a greater wariness and suspicion of contact. Although there is a hunger for contact, it is far more difficult to experience here, because the suspicion of invasion if not annihilation is a far more pressing concern that the paranoid patient projects. Hyperalertness to the world and a cold feeling of isolation characterize the life experience. In this encounter, there is a constant calculation and assessment of the world, for attack can occur at any moment. Behind this paranoid approach, I sometimes sense the psycho-path who is ruthless and manipulative in the drive for power and control. However, the terror of reprisal serves to keep this potentially psychopathic individual in the background, and in its place is often a charming, manipu-lative patient who has not yet been able to take the risks of the psychopath. Thus, in a paranoid position, eyes dart back and forth, ever alert and quite a contrast from the empty pools of nothingness or vagueness of both the schizoid and autistic positions.

In common with autistic and schizoid patients, in the paranoid we see a denial of the past and a minimal use of symbolic connections. Such connections in fact seem to threaten their very existence, for omnipotence and grandiose control are far more important than any real connections from past to present. Yet alongside of this omnipotent control, there exists a hidden wish for a bridge to make contact between inside and outside. As psycho-pathic as these patients may appear at times in their calculation and need to control and manipulate, we may also observe a parallel sense of loyalty and deep affiliation. It is important, however, not to cross them, for in their eyes you can easily be transformed from good to bad. In this process, the entire body appears very alert, from the vigilance of the eyes, to the jutting chin, the slippery sense of touch, and the muscular tension, which all say 'Watch out, there is danger'.

Summary of Work with Maternal Privation

My countertransference experience tells me a lot about where we are on the autistic–schizoid–paranoid continuum in our treatment relationship. When I find myself working in the paranoid position, I become equally wary and distrustful of the patient. By contrast, in the schizoid position I experience an enormous need for contact and connection, and at times act out being intrusive. By contrast again, working within the autistic state I seem to float away into a pool of nothingness. Yet patients do not exist unchangeably on one level, but rather are reflections and mirrors of different states that seem to move from one session to another. In all three positions, object constancy and development of an identification become paramount issues in sowing a fertile field for change and transformation.

At the beginning stages of treatment, I rarely confront defences; instead, I try to look for empathic resonances forming a very basic and primitive form of connection. I search for a supportive statement to make for the patient. Rarely are my statements sharp and penetrating, even if they do hold some degree of insight into who the patients are and what they are about. My statements tend, in fact, to be round and soft and holding. Patients who are in a paranoid position rarely respond well to a confrontal, head-on approach. At times, when a patient is in a more lonely, isolated position, I can be more direct and holding.

In reviewing the basic styles of connection, it appears that each patient is very frightened of the relationship, yet all of these primitive mental states need intimacy and contact. In each, the therapeutic space is very difficult to fill. In all instances, I try to be grounded, clear, round, soft and supportive. The interplay between hard and soft contact requires all the subtle artistry that the therapist can bring to it. If I encounter sharp, attacking criticality from a paranoid patient, I try to respond with softer, rounder lines. If I experience vagueness from someone, I attempt to be grounded, concrete and to the point. With someone who is nebulous and floating off into pieces, I try to give especially down-to-earth kinds of interventions. Thus with each of these positions, my unconscious seems to mirror the hidden opposites needed to create the new balances that these patients in reality crave. Here, diagnostic thinking and therapeutic responsiveness go hand in hand; in fact, they are almost one and the same.

The Depressive Position

The depressive position has also evolved from the early maternal holding environment, but rather than presenting problems of bonding or maternal

privation, it concerns issues of separation. As I pass through the port of entry in the work with a depressed patient, I feel heavy and weighted down. Rather than sensing loneliness or nothingness, here weight and heavy blackness seem to pervade every psychic pore. I feel the patient's burden projected for both of us to share, a repetitious, endless burden that the patient never seems to release. I hear the verbal and implicit message, 'I am wrong, I should do it better again, I can't talk about this, it makes me uncomfortable. You'll laugh at me'. These are the hallmarks of the complaints that surround our interaction.

I see the patient's self being walled into an obsessional, masochistic and sadistic prison of deadness and hopelessness. Without conscious thought, I search for my own sense of hope and light that functions as a beacon despite the gloom all around us. Light becomes an important aspect of working with patients in the depressive position. I search for transitions to give the past a bridge to the present, hoping for a joyful encounter. Connections, however, always seem to be filled with either guilt, rage, pain or disappointment. Yet in spite of all this heaviness, I detect glimmers of omnipotence and power that are buried with the despair and hopelessness. Therein lies a hidden potential, that black can ultimately be experienced as sexiness and style, and that the velvety nuances of darkness can offer a clarity and definition of boundaries. Patients rarely understand or appreciate this power, but I do — and so I invite them to explore ways to convert the obstinate negativism that imprisons their existence into an affirmative statement to the world.

Often, their hurt and despair can suck me in and create in me a form of sympathy which I know is really a trap. It is hard for me to fully realize that before me stands a hurtful, cruel sadist, for the experience does resonate with my own early background. Many of my colleagues in the helping professions are prime targets to become rescuers as they live out some of their early background material. The fantasy of rescue is all too simplistic an approach to use with these patients. Instead, I play with their meanness and sadism, helping them become more aware and open about their need to hurt, spite and retaliate. Sometimes I find that humor helps. Occasionally I am para-doxical and provocative, intentionally playing up the fine edge of their passive/aggressive stance to the world.

My purpose is not to hurt, but to demonstrate that hurtfulness, when exposed, can serve as a pathway to expressing anger and fury. In the process, I surprise the patient by the suggestion that black is not always just black, and that a hidden power may be present in the blackness. The conversion of masochism and sadism then becomes my burden, for I too am overwhelmed with the burden of guilt and responsibility that surrounds both the patient

and myself. Sometimes just permitting ourselves to feel that we are in a messy, dirty hole, where we destroy all the order around us, can actually offer some release. My job, therefore, is to become friends with this patient's superego, enjoy the messiness and hidden power of the blackness, and then help both of us discover each other's power. Otherwise, we can easily get lost in a mutually burdensome hold that offers no pleasure or freedom.

How Diagnostic Thinking Evolves in Working with Primitive Mental States

In all the primitive mental states, there is a lack of integration or cohesion of the very essence of oneself, which makes reality a very frightening and tenuous place. As a basic premise, our work with primitive mental states consists of holding mirrors for the patients, to reflect their impact on the therapeutic relationship. Simultaneously, in the give-and-take of the developing relationship, we become aware of our own experience of the relationship, which constantly reorders both the holding and mirroring process. The mirror is there for the patient to utilize in whatever way seems helpful. Thus, if I experience an autistic patient floating off into outer space, a diagnostic container is automatically created inside of me that reflects back, like a mirror's opposite, an image that is bounded and clear. As with many patients who work on a very primitive edge, where the object relation is poorly delineated, a good deal of learning takes place through an identification with me. Both of us experience a big empty hole that appears hungry and in need of filling. I am constantly aware of trying, not to fill that hole, but to resonate with it, and to make it useful. Simply suggesting interpretations is not going to work. However, when I create structures to enable these patients to see themselves, a new relatedness begins that has less to do with filling and more to do with new integrations.

By contrast, in encountering schizoid patients, I find a hunger for connection as well as a denial of it. This diagnostic information, once again, makes an impact on my therapeutic stance, and the workspace likewise becomes nebulous, dissociated and full of ambiguities. Rarely do I sense associations with and connections to the past, and yet there is a search to belong somewhere. I offer movies, books, plays and a variety of other carriers of cultural meaning, for they can serve as important transitional objects for the patient to use in finding pieces of himself in the past and present. In most instances of working with someone who is schizoid, I am rather specific and down to earth, but without developing a clear structure. When I find myself lost in ambiguities and vagueness, with no clearly organized structure, I know we are moving somewhere onto the schizoid continuum. Once I feel the push and pull of contact and avoidance, then I am sure we are really there.

By contrast again, when I discover myself in the paranoid space, I feel attacked, judged and on guard. I simply do not trust this patient. I find myself as paranoid as the paranoid patient. This tells me that we are now living in the paranoid transference/countertransference. My first reaction with the paranoid is to become defensive, but gradually I struggle to regain my centre. When I am there, supportive, non-attacking statements soon come, in which I offer glimmers of insight. Yet, in spite of my efforts, I am often knocked off my centre and easily moved into a confrontation. When I act this out, we both are lost. There is a particular dance that occurs with a patient who is paranoid. I move in rather slowly and take my distance. This therapeutic approach has arisen out of a gradual collection of data on interacting with this kind of patient. I keep responding and resonating to the deep, hidden interiors that need a playful and open exploration. I try to suggest connections of inside and outside, self and object, but most important I respect the patient's need to appear invulnerable and beyond attack.

Thus the dance changes steps when working with patients who are autistic, schizoid or depressed. Each dance is constantly feeding me diagnostic data as to how to change and move along with it. I am offering lightness, movement and hope to the depressed patient as we are weighed down by the patient's shackles of imprisonment. The shift from good to bad, from being idealized to devalued, all happens with lightning speed. The constant through all these states is that relatedness becomes the key to forging a growth of self and other. The overarching challenge of countertransference then becomes determining how to serve as a fulcrum for identification, resonating with the needs of each unique patient, while yet maintaining separateness. The problem of becoming either too distant or too fused with a particular patient repeatedly needs to be faced as a significant countertransference issue. One or the other invariably occurs. At times I can barely understand what happened. Perhaps I am lost in the session and wind up caught in some erotic trap, or else I am so detached and cut off that I hardly offer any kind of resonance. Once lost, it is a difficult trick to continually regain my centre.

It is clear, then, that as the therapeutic process unfolds, I am constantly learning more about the patient and picking up new diagnostic cues. Diagnostic thinking, therefore, is part of the overall therapeutic flow. It changes as my encounter with the patient changes, along with my understanding of how the patient uses structure and form, communicates sensation and fills space. It changes as I learn more about the patient's self-definition and move to the rhythm of our contact. As I sense the nuances and can play

with what is soft and hard in the patient, I create a holding environment where reintegration is possible.

Narcissistic Personality Structure

I have so far addressed the utilization of space and the transference and countertransference issues that are characteristic of the four object relations positions known as autistic, schizoid, paranoid and depressive. Within this psychic organizing system, there are many shades and nuances of character formation that evolve into different positions. This section will explore the narcissistic personality, those persons who, lacking a cohesive self, mask their interior sense of inadequacy by constantly searching for something outside themselves to affirm their own value. This patient implicitly or explicitly holds out the message, 'See me, look at me, let me be the focus of your attention'. I feel a magnet pulling me into this patient's field and drawing all my attention to the nuances of his or her behaviour. Yet, in spite of this pull, I can barely feel the interior of the patient's centre. There is a paradox here, for what the patient thinks of as the interior is basically organized around the exterior. It can be very effortful to work with this patient, for I constantly encounter a burden and feel myself growing angry.

Such patients require, even demand, that I become their appendage as a requisite for relatedness. I am resistant to this demand, but reluctantly join them in their space. I know deep down that I can be easily discarded if I do not serve this role. Sometimes I am idealized or romanticized, but I certainly do not trust this form of interaction. I know underneath there is a ruthlessness that can suddenly appear if I cross them. I can be dropped in the nearest psychic garbage can if disappointment occurs. After a period of time, however, I remind the patient that I do have a separate existence apart from his or hers. This invariably creates a woundedness of self and a passive/aggressive withdrawal. Yet in spite of the risk of abandonment, I know I need to be free of the restrictions these patients place on me. Slowly, a dance evolves. I mirror them, I reflect and empathize, but I introduce a little bit of myself at a time as a separate and distinct entity.

These are often classy, well-dressed patients who present a beautiful picture from the outside. They may mock my office or laugh at my dress, and I can join them in a good-natured laugh at my appearance, which they deem absurd. Indeed, in joining in their need to have the outside perfect, I understand why it is so necessary for them to say, 'At least there's something good and perfect about me that the world can see'. I am often bored with this patient, but the boredom is very different from that experienced with some of the earlier primitive mental states. This boredom stems from the

sheer repetition and lack of give-and-take in the relationship. There is only a superficial level of symbolic dimension. Everything has a flat exterior; nothing develops with any complexity. Slowly, I introduce new reflections containing paradoxes or polarities that do bring depth to the interaction. I set up certain opposites, to demonstrate that matters are not so simple, that not everything can be categorized as either black or white.

These patients have a tremendous need for control and perfection, but this perfectionism is not the same relentless and sadistic trait that I have found with the introject of the depressed patient. The two states can be clearly differentiated in this respect, for in the depressive position there is the eternal prison which locks out joy, pleasure or real freedom. In contrast, the narcissistic state evinces a vulnerability towards depression but at times there are breaks where the patient can really join in with freedom, pleasure and erotic connection. As an extension of the perfectionistic ideal, work can sometimes serve as a substitute for a healthy object relations. Ultimately, though, there can be no real change between us until the hidden grandiosity is faced, a self–object relationship is fully worked through, and the patient can see me as more than just a mirror.

The Borderline

The borderline individual operates, in effect, in the area on the border between narcissistic and psychotic behaviour. When I find myself engulfed in a whirlpool of impulses, and a seething hatred towards my patient slowly filters through me, I know that we are in borderline territory. There are times when I am extremely intrigued and seduced by the seeming goodness of this patient. Then, however, I am fooled, for when I feel everything is going along fine, without warning it changes. The shape of our space is constantly being so thoroughly reorganized through such primitive defences as intro-jection, projection, denial and splitting, that sometimes I don't know whether I am coming or going. I am extremely knocked off my centre – and that is probably exactly what happened in the borderline's past. Feeling this kind of ambivalence of love and hate, ranging from an unfathomable depth of rage at the patient to being completely swept off your feet by the patient's niceness, are all symptoms of being captured by an introject.

Through my countertransference, I probably do know what the experi-ence of childhood was like for this patient. For I am idealized in one session, devalued in the next, and it is all extremely unpredictable. I am fused, then I am separated, and I am always confused. It is clear that this is not a narcissistic patient, for whom structure is much more stable. I am a mirroring agent or someone who is idealized, as in narcissistic territory, but the

explosive changes and unpredictability are all uniquely borderline. Holding firm to my boundaries while fending off intrusion and invasion are only part of my task; yet, sometimes that is all I can do. At times, I wonder if I can refer this patient to my worst enemy! I swear to myself that I will never take a patient like this again.

The treatment seems endless, and yet in spite of all the pitfalls, there is some slow growth. I realize that I cannot avoid or deny my hate of rejection, but I hope to contain it. The next step will be to slowly detoxify this hate and become more playful in relating to this patient, in a way that is neither phony nor simply role-playing. This workspace is remarkable for its sheer dimensionality. It can be warm, sensuous and erotic, or infuriating, provocative and confusing. It can be distant and fragmented, and yet at times extraordinarily related. I sometimes muse to myself that this is a patient only a therapist could love. When I do mirror back hate, I try to reflect it from a very nontoxic position, where I am both centred and grounded. I am perpetually confused as to whether I am being manipulated or whether this patient truly needs mirroring, and both are invariably true. As much as I try to prepare for the unexpected, I am constantly surprised.

Over time, I strive to surrender my hate and re-establish myself as a disciplined therapist who can relinquish these feelings rather than having to deny, dissociate or act them out. This struggle is both the burden and the challenge of working with borderline states. It is to be hoped that most of us will not have many of these patients in our practice, for having an overload in this area can be quite exhausting. I have to admit that sometimes I 'lose it', acting out and spilling over with my rage, or worse still, expressing subtle forms of sadism. Part of the therapeutic work here is to acknowledge frankly to the patient when we have acted out, and re-learn how to assert our centre and relatedness. One final note: in spite of all the complaints of being abandoned, provoked, invaded, and even played with sadistically, many of these patients have stayed with me for a very long time – and in spite of everything, they do seem to get better.

The Obsessive Character Structure

Words, words, words. I am surrounded by them. Some are intriguing, some are boring, but all ask me to join in an intellectual exercise. Sometimes I become as fascinated as the patient in all this rumination, and indeed it seems that everything does have an explanation. Often affects do creep through, and I become engaged. At other times, however, after this drones on repetitiously for quite a while, it creates in me an intellectual sense of exhaustion. This is the experience of working with the obsessive personality,

who relies on intellectualization, often inflexibly, in a quest for power and control. There is an inner tightness to this patient, as frequently I am invited to play a game of power. I become aware of how important it is for the patient to be right and to be on top. Yet underneath all this intensive manoeuvring lie feelings of shame, embarrassment, and mortification. Sometimes, as I am engulfed in words, I understand that the words are really anchoring the patient into reality.

With some patients, under all the obsessional play with words is a deep hole and a lack of anchor. So I pay close attention to the musculature and tightness of the patient. Is the patient highly organized and controlled, or is there a vapid sense of loneliness beneath the words? The distinction is significant, for each clue points to a different way of holding and working. Where there is a bottomless hole, I feel the defences are best left alone, and I offer myself as a safe anchor who can help organize the patient's picture of the world. On the other hand, if I hear a veiled sexual and aggressive push behind the words, I feel more on solid ground to expose what really is there. Thus, if the patient is basically well organized, I involve myself in the game of power and submission. I confront the fears of loss of control and invite both of us to get down to the game of dirtiness, messiness, sadism and aggressive sexual affirmation of self. Although I must chase the patient in his passive/aggressive game, I want both of us to enjoy this game of power; for indeed there is no winning or losing, but just contact and intimate connection.

The Hysterical Character

As opposed to the excessive intellectualizing of the obsessive, in the hysterical character emotionalism and drama are paramount. Indeed, I sometimes find myself wondering if there really is such a thing as a hysterical character – or if I am actually confronting a borderline organization in this patient. I am aware of the colour, the energy, and the theatricality of the affects that enter our space. There is a sense of excitement and engagement. Yet the hysterical personality tends to have more internal organization or depth than the borderline, and I am soon able to form an alliance. If I allow enough space, there is movement, for material begins to be processed as we come together with respect for each other's need for space.

At first I may be experienced as the wise father figure who has the source of power. However, this powerful image of father is soon whittled down to being seen as a trusted colleague, an equal in the relationship. Love, work, and our relationship are just a few of the stages where the drama unfolds. Sometimes I have trouble differentiating between the truly dramatic and the

melodramatic. That is, it is hard to be sure when I am touching what is authentic in the patient, or what is leading me down the garden path with histrionics and emotional explosiveness. These patients can be very charming, at times seductive, and seemingly open – but this openness may be quite deceptive, because they are actually extremely wary of penetration.

I am aware of the patient's need for power and control, and of the desire to be in charge, and I gladly say in effect, 'Go run with the ball and I'll follow you'. Here the experience is quite different from that of working with a patient who is basically borderline, where to allow space and to let go of boundaries would be rather like boarding a sinking ship in a very stormy sea. For some hysterical character patients, emotionality provides a sense of power that disguises an insecurity about their own identity and a lack of self-esteem. At times this can take the form of of sexual flaunting, as a symbolic show of power. I always take care to allow these patients ample space, and eventually the need to prove who is in charge recedes into the background.

Trauma

As I encounter a wide range of acting-out behaviour, suicidal gestures, provocation, rage, and the breaking of therapeutic boundaries, I suspect that I am once again in borderline territory. However, these external appearances can be deceiving. I see the true picture when I find myself becoming genuinely protective and deeply engaged, for that is what happens in working with the patient who has a traumatic background. This person has lived through overwhelming personal experiences such as those involving sexuality, aggression, hate, war, and life-threatening situations, and now lives in terror of being overwhelmed again.

Although the outer personality organization may resemble the borderline in terms of the defences, the experience of the therapeutic space is totally different. I feel profoundly sympathetic to this patient's plight and admire his or her resources for survival. These patients do not create a sense of deep rejection as I might feel with the borderline. It is important to make a distinction between a dissociated person with a traumatic background, and a borderline, for I work very differently with both. For a detailed clinical description dealing with patient artwork, the reader is referred to Robbins (1994, pp.124–140).

With the traumatized, dissociated personality, my function is to serve as a witness and honour what has happened in their background. Traumatized patients will attempt to re-enact their problems in our therapeutic relationship, and this may create very stormy waters. Depending on the level of

development in terms of the traumatic history, we may find highly significant kernels of constancy that have been established. I try to de-emphasize the work in the transference, for they have had enough trauma in being overstimulated and overwhelmed. I do attempt to deal with what is projected in the relationship, but place major emphasis on the reliving of their history, while keeping some distance from the transference relationship. I search for pieces and threads of memories, and yet give this patient plenty of space to roam. Dissociated patients also need sufficient time to move at their own rate as they process treatment material. I am often surprised by the extent of the re-enactment of past pain in the therapeutic relationship, but this does help us to rediscover the memory. In the process, I feel overwhelmed myself, as well as perplexed and confused.

Many traumatized patients find solace in a healing space, for they feel far safer with God or some other form of spiritual presence in the transference relationship. I respect their need for this space, as there may be different holding environments that can create a safe structure for patients to process material. Others find art, or a group experience, that can give them the safety they require. Though I remain aware of the transference as well as the countertransference, the core of treatment is not in this area. If anything, I support the self, offering clarity and providing a safe distance for us to examine the patient's pain and trauma.

The Antisocial

With the antisocial personality, the game of power is pushed to the limit, for I rarely encounter anxiety, guilt or shame. The texture is slick and oily and I feel handled and manipulated. I never am sure what is real, except that I suspect everything revolves around power. Yet beyond the quest for power, nothing has any meaning. There is very little here that represents life, no connection, and only minimal identification with anything of personal value. A patient of this type presents ruthlessness and will stop at nothing in order to have power. In this patient's playing field, the game is hard ball, and it becomes a very threatening transitional space.

The most difficult part of this for me is to find the psychopath inside of myself to match the patient in playing this game of exploitation and power. My job is to outwit or outmanoeuvre the patient and yet hold on to my own values. In this cold and calculating space, I feel very alone and am not fooled by the surface friendliness or placation. There is certainly no trust between us, despite the patient's attempt to be friendly or 'nice'. Sometimes this patient is very winning, and can be extremely successful in work, since everything seems to focus on outmanoeuvring the world. The personal

history of neglect stares at both of us, for there is no hold or connection with love or care. In the end I can only succeed with this patient by demonstrating that by necessity I, too, have learned the game of manipulation and control, and that I understand the world of power. I know the rules, and have used them to achieve my own ends, but along the way I have made my own very clear choices as to how to survive in society. I have taken a hard look at this and learned how to utilize this past history of mine in treatment. I communicate to such patients that I am onto them, and yet at the same time am not offended by their outrageousness. An identification that is offered cannot come out of intimidation or fear, but rather out of respect based on the knowledge that I know how to survive and play the game of power. Ultimately, the patient can observe that there are choices that can be made, rather than having to move compulsively in a set direction where the only goal is death.

Summary

The varieties of diagnostic thinking that have been presented in this chapter are all part of a psychic map. Ultimately, we must enter into therapeutic territory before we can really understand the complexity and nuances of the patient's therapeutic workspace. There are just too many combinations of character formation, carrying a nearly inexhaustible range of self and object representations with their attendant moods, defences and ego organization.

Diagnostic thinking, as outlined above, develops in complexity as it reaches through different levels of the therapist's consciousness. The awareness of images, sensations, affects, perceptions and the use of space all work to create reactions on my part, which then provide diagnostic information. This whole network of factors interacts with my own defences and self and object representations. While I struggle to construct an identification incorporating all these communications, I am also in the process of finding my own centre as well as offering a mirror.

If I am to play with sadism, masochism or psychopathy, I must be able to receive this kind of material without being affronted or reacting with blame, guilt or shame. When I am working from a centred position, I can then play with this material and find a space to make contact with this patient. The variety of ego states that I encounter and experience should not be interpreted out of existence. A feeling of being understood is an important goal of treatment. As a therapist, I learn not only to play with all these forces, but to utilize the patient's language to describe what is going on. It is axiomatic to note that, as a corollary of the above, by nature each of us does work better with some patients than with others.

Images arising from a therapeutic interaction present diagnostic guidelines, from which I derive information on how to proceed in treatment. No patient fits snugly into one single, specific diagnostic category (though some seem much more prototypical than others). Most patients present shades of different character forms that merge with one another. These defences and identifications are projected into the transitional space, where they encounter my own particular defences and identifications. My receptivity to the patient's projections becomes a crucial factor in my use of diagnostic information.

Thus the type and nature of our own characterological issues exerts a formidable effect on our ability to utilize diagnostic thinking. The intersubjectivity of the workspace may tend to bias our perceptions in one framework or another. As a consequence, I find that many therapists have a subjective bias toward a self, drive or object relations framework that mirrors their own particular characterological predilection. I believe that we need to remain watchful for this effect, to avoid allowing any given framework to interfere with collecting and using data in a free and open way.

The framework for diagnostic thinking that I have offered in this chapter is not intended to supplant more traditional approaches to the therapeutic process. Rather, it is meant to supplement and enhance other ways of thinking, to help in arriving at an appropriate course of treatment. As I stated at the outset, diagnostic thinking moves and changes as we proceed through therapy. It can be difficult to separate from old modes of thinking and to be exposed to and accept new ways of experiencing our patients. Yet the potential of being open to new experiences, perhaps finding a new psychic reality, represents the aspect of diagnostic thinking that can be most exciting and useful in therapy. It becomes each therapist's creative challenge to make diagnosis more than just a sterile application of categories, but a living, breathing and enriching part of the treatment process.

References

Ogden (1995) *The Primitive Edge of Experience.* Hillsdale, New Jersey: Jason Aronson.

Robbins, A. (1994) *Multi-Model Approach to Creative Art Therapy.* London: Jessica Kingsley Publishers.

Tustin (1984) 'Autistic Shapes' *International Review of Psychoanalysis* , 279–290.

Therapeutic Presence Within a Therapeutic Theoretical Frame

The Therapist as Nanny

Arthur Robbins, with Laura Robbins-Milne

An interesting analogy exists between the jobs of a therapist and a nanny, particularly as they stand *vis-á-vis* the mother, and it is an analogy which I find useful in analysing the therapist's role. Like a mother, both the therapist and the nanny make a significant emotional investment in the person under their care, and may come to be viewed to one extent or another as a mother figure. Unlike a mother, however, both are under contract and are paid a fee to do a job with an implied time limit, for there is an understanding by all parties that the job will be completed someday and they will part company. The emotional commitment inherent in the mother's position is very different in nature (which is not to say that she always fulfills the role). She carries the ultimate responsibility for the physical and emotional well-being of her child, though it is part of her parenting to see that the child eventually assumes this responsibility. Whatever the maternal tasks of the nanny, the child on some very profound level knows the difference between that person and mother. Similarly, although our patients in therapy may project on us the duties of a mother, the fact must soon be faced that the relationship is that of patient and caring therapist. Even so, keeping these qualifications in mind, there can be little doubt that both nanny and therapist provide an extraordinary, significant, emotional impact that can make a remarkable change in the future well-being of the child and the patient.

In the best of circumstances, the nanny becomes an emotional extension of the mother. In her relationship with the child, she conveys the basic values, principles of discipline and goal expectations of her employer. These areas of responsibility may not always be well articulated, but they are implicit in her job. Yet she will also bring to her work a personal quality of emotional resonance with the infant that, hopefully, will not be at variance with that

of the mother. Ideally, nanny and mother make a joint partnership and work as a team. Of course, not having a time limit or contractual conditions of employment, a mother's range and quality of emotional investment rests on an entirely different basis from that of the nanny. This distinction is not always very clear, however, as some patients report far better treatment from a nanny than from their own mother. In fact, observation and research support the conclusion that a good nanny or day-care centre can to some extent make up for a mother's deficits in caring.

In those many instances where a grandmother takes over the role of mother, we have an exception to the above discussion. The grandmother, though similar to the mother, has a very different emotional relationship to the infant. Yet she does not have a contract, is not a paid employee of the family, and does not become tantamount to a nanny. Indeed, when a grandmother becomes a mother substitute, she takes over the primary caretaking duties and creates the potential for a very deep, bonded identification with her grandchild.

I would like to look now at some of the fundamental problems that can occur with either mother deprivation or privation. When the basic attachment has been a poor one, and there exists no viable mother substitute, we see numerous examples where the resulting deprivation is manifested as medical illness. According to pediatric observations (Miller, Kaplan and Grum, 1980; Money, 1977), children from such backgrounds present a number of physical problems and can be seen making frequent visits to the pediatric clinic. The developmental growth pattern often places them at the low end of the norm. Where there is an absence of mothering, the emotional deficiency has an enormous impact on such factors as weight and height, with the infant usually placing in the lowest five per cent of the growth curve. Pediatricians observe such children as being socially removed, not able to make their needs known. The literature also reports that the child's basic immune system may even be damaged, and there are recorded hormonal deficiencies in children of deprived backgrounds. Yet in cases of poor mothering, a mother substitute can make a remarkable difference. Children in this latter situation will still be frequent visitors to the pediatric clinic and will remain susceptible to physical illness. At the same time, they will not have dropped off the developmental charts, and they do seem to function normally despite frequent physical problems.

Let us reflect further upon the very complex interrelationship of nanny and mother. We have said that, ideally, the nanny becomes an extension of the mother, but many cases are far from ideal. Jealousy and competitiveness can develop on one or both sides, and these factors can undermine the ability

of the nanny to function effectively. At times the nanny may overcompensate and attempt to undo the problems of the mother. Where the real failings of the mother are combined with her jealousy and competitiveness, however, the nanny's hands are tied for she must indeed carry out the duties and expectations of her employer. In such instances, she is not really able to make up for the known deficits of the child's mother.

Similar to the comparison between mother and nanny, to some extent we can make an analogous comparison between the patient's mother and the mother who resides inside the therapist. We can observe an active encounter between both these mothers being lived out in the transference and countertransference relationship. We can also observe that both mothers are potentially competitive and destructive towards one another. As a therapeutic guidepost, in spite of past destructiveness and the patient's problems regarding the primary caregiver, the therapist's acceptance of and even respect for this powerful force in the patient's life is an essential rule of good treatment methodology. Most important, we attempt to set the stage for patients to integrate both the positive and negative parts of their mothers. All too often, we as therapists attempt to demonstrate to our patients that we are better mothers than their own parents. In some respects, this may well be true. We are sometimes better resonators and connectors and provide a structure that is clear and holding. Nonetheless, it is important to recognize that we cannot replace the patient's mother as a fundamental underpinning of the patient's personality. If we try to compete with or substitute for this mother, I believe that, consciously or not, we stimulate a good deal of antagonism and resistance in treatment. However, this caution should not interfere with the patient's becoming acutely aware of the original mother's limitations. This holds especially true for those patients who over-idealize as a defence against extreme loss. Even so, the original mother is all too important an anchor to be thrown out of the treatment process or out of the patient's personality. However buried it may be, the yearning for ultimate love, albeit a very primitive love, cannot be underestimated in patients with extreme object loss. If anything, we need to have a keen awareness of a mother's positives as well as negatives, so there can be a better integration with this basic, core identification.

We move on to some of the issues inherent in the therapeutic process towards a self–object identification. In the best of circumstances, we as therapists serve as a mirror or reflection of a self that needs recognition, honour and an emotional presence. It is the thesis of this chapter that the therapist can be seen as an empathic mother stand-in, or nanny, who can help to compensate for parental deficits that have hindered self–object

internalization. As part of this process, however, the patient must face the bitter realization that the therapist can never make up for the deficits of the mother, and that it is indeed necessary to work through disappointment, rage, and mourning. When this is done, there is a space created for an internalization of the therapist, who can help the patient reflect and mirror this process of being and becoming.

If all goes well, the internalization of this mirroring process proceeds. It takes place within the confines of the so-called 'real relationship' that the therapist offers in terms of his or her own temperament, emotional resonance and identification with the patient's background. Simultaneously, a whole range of countertransference reactions evolves, which can interfere with the empathic contact that is potentially present in our real relationship. We can find ourselves impotent, angry or identifying with the patient's pain and loss. At times we lose our empathic perspective by being too distant or too close. We can become overindulgent, strict, inconsistent, or competitive with the patient's mother, or we can be deeply drawn into our own pain while exploring the patient's particular history and problems. All these complex transference and countertransference reactions are an indelible part of an intricate, intersubjective relationship that needs recognition and sorting out.

The overwhelming majority of our patients present issues regarding early privation or deprivation. As a consequence, the therapist as a real personage offers a very important source of emotional identification that becomes pivotal in the therapeutic process. First, let us differentiate between deprivation and privation. According to Winnicott (1971), privation refers to the damage that occurs when there is an absence of mothering, whereas deprivation encompasses the pain of loss, which is unprocessed, derived from the mothering source. Within this range, we encounter mothers who are overwhelming, destructive, ambivalent or inconsistent, all of which can interfere with the working through of self-differentiation. I use the term 'mother' to apply to the early primary caretaker of the child, the person with whom there is an emotional holding relationship, both resonant and related, that has an enormous impact on the early intersubjective life of the infant. When a self-object internalization is seen in treatment, it occurs within a bipolar range of object resonance and object usage, that is, where the patient first became emotionally attuned to the mother figure and then first began to experience being a separate individual. Thus, as therapists, we attempt to make a powerful emotionally-connected bond with our patients. This is a very delicate and sensitive task, experienced verbally and non-verbally. Emotional presence goes beyond words, for the patient must *feel* understood. When we encounter enormous pools of emptiness within our patients, we

are sometimes experienced as magical, omnipotent or highly idealized. In the end, both patient and therapist must face the painful realization that the emotional hole cannot be filled. This realization can occur if we do not try to live out the role of protector or satisfier of needs. If we hold firm to our frame, a structure evolves that encompasses union and separateness, the experience that we have a limit in terms of our time and space and are not always as available as our patients would desire. Indeed, at times we even fail in our attempts at empathy. At the same time as we strive for a very primary connection with our patients, we must maintain our therapeutic identity. In this therapeutic dance of oneness and separateness, there is an opportunity to mend the splits of good and bad and place loss in a humanistic perspective. Yet it is very sad to realize, during this process, that the deep holes of emptiness cannot be filled despite our hidden wish to be a magical protector. This long, difficult dance is at times explosive, at times despairing, yet ultimately organizing. In light of this perspective, a very good case is made for treatment as a reparative process. While the therapist, like the nanny, cannot substitute for an absent or depriving mother, we can accomplish some repair work in facilitating the patient's self object internalization.

Besides the obvious transference and countertransference relationship, much of the real relationship – encompassing our unique temperamental rhythms and defences – is of paramount importance in making this reparative process work. There are some matches of patient and therapist that should never have passed the starting gate, and they are temperamentally unsuited for one another. Patients who present problems of mothering and object loss have an uncanny way of virtually living inside us as we invest a good deal of our emotions inside them. Yet, as we invest, so must we rediscover our centre and maintain our frame. Many of these patients will be with us for years – and I refer to 10 or 15 years or more. The process of change may be so slow and imperceptible that at times we feel nothing has improved. Sometimes we wonder if this long-term investment is really worthwhile. Yet after years of reflection, despite my limitations, I have observed very significant, major changes in patients of deprived and privation backgrounds. Ego functions and feelings of self-esteem do improve. There is an irony to this observation in a society where short-term treatment is strongly empha-sized. For if anything does seem clear in today's world, both inside and outside of therapy, it is that object loss appears to be an overwhelming characteristic of many relationships. The pain created by object loss is a deep and serious one, and the process of repairing it is likewise arduous and time-intensive. For both therapist and patient who make the choice to proceed, however, there is much testimony that change does occur over the long haul.

I offer the following case history to illustrate the issues involved in the therapeutic internalization process, as well as the notion of therapist as nanny. I recall meeting Tom a number of years ago at our initial consultation. He dressed and moved rather stiffly. He wore a tie with a button-up collar and a starched white shirt that seemed like armour around his body. His manner was very rigid and cut-off. He sat on the couch, and I could observe that every muscle seemed taut. He stared ahead and rarely made direct eye contact with me. He lamented that he wasn't quite sure he was a candidate for any kind of treatment. Speaking in halting tones, he related briefly what had happened in a prior initial consultation with another therapist, which had been a disaster. The therapist was rather inactive and emotionally laid back. From Tom's description, this therapist was a stereotypical 'classical analyst'. Tom complained that he just stared and looked at Tom and allowed any wandering off without offering direction or guidance. It was just too much of a strain, he reported, to be so fully responsible for the session.

As Tom began to speak, I inquired about his background. My initial reaction was that he was floating off into space and would require a good deal of active contact. I empathized how difficult it was to take a stab at another therapeutic encounter in light of what had happened before. I was rather forthcoming about myself, including my professional qualifications and training, and sketched out what could be expected from treatment. I informed him that a therapist is not necessarily required to be a blank screen. He was somewhat reassured by my comments, but I saw the underlying dread in his eyes. We quickly arrived at the financial and time conditions of our contract and, albeit tenuously, initiated a long period of treatment.

I actively asked a good number of questions about his background. There were many long pauses, and he seemed unable to find the words to describe his experiences. Still, I made a mental note that I did not feel burdened or overwhelmed, as I would with a depressed patient. If anything, I felt very sympathetic and emotionally engaged. His fears seemed to connect with me. I knew what it felt like to be lonely and isolated, and I identified with some of the major undercurrents of his background. I also was aware of some of our differences. As his story unfolded, I learned he was the younger of two children. His mother was described as a very cold, depressed woman, who had been abandoned by both parents and reared by her grandmother. She was full of rage and distrust and often, the patient reported, she would blow up and appear crazy and wild. He didn't recall much physical holding or touching on her part. Yet although she was cold, she was also very intrusive and possessive. She ruled the family with an iron fist and her husband, who was on the passive, meek side, served virtually as her loyal servant. During

the patient's adolescence, many fights ensued regarding dress, discipline and manners. Reading between the lines, I gathered that the patient was not only controlled, but also infantilized. He was either left to his own devices or given a very rigid structure to follow. Both as a young child and adolescent, he had very few friends to offer support or comfort. Tom felt betrayed by his father's passivity, since he rarely came to his son's defence. His most important memory was of being left alone to play by himself in his back yard. There he would dig into the ground, building underground caves or hide-outs. Occasionally he wandered out to the block where he would meet the neighbourhood gang. Sometimes he made overtures in an attempt to make friends with a non-threatening child. His mother, however, trusted none of the children on the block, for they were just not good enough for her child.

Kindergarten was a scary nightmare. He vividly and painfully recalled defecating in his pants and being brought home by his sister. He felt a sense of humiliation and shame that was repeated many times during his early years in elementary school. His sister felt that he was a burden and a sense of mortification that he was her brother. She was the star in the family who could do no wrong and was intellectually and academically gifted in school. She had many friends, while by contrast, Tom was a loner. In spite of these problems, somehow he made it through school, although his grades were marginal and reading skills came very slowly. As far as he remembered, life was a very scary, as well as unrelated, affair. There was little joy or feeling of belonging, for both his mother and father brought to their marriage a background as orphans, and rarely had any contact with an extended family. He now viewed his father and mother as hungry children, both feeling alone and inadequate in facing the world. When children on the block would pick on him, he felt ashamed and defenceless. The only solution offered by his parents was to hide out in the back yard. He recalled trying to join in a stick ball game, but was rather inept at holding his own and playing ball. He longed for an older buddy but none was forthcoming. His sister was six years older and was certainly not an ally. He recalled quite vividly how his mother worried about what would become of him. He worried, too, for the whole notion of growing up was a scary one. He remembered going to Sunday school, sitting all bundled up, in reality hiding out, buried in his thick coat and muffler. Sunday school, his Jewish identity, the feeling of pride in the family, the connection to a neighbourhood: these were all alien experiences. He just didn't feel he fitted in anywhere.

During adolescence, he was attracted to girls, but felt painfully shy and inadequate. Although he was encouraged to join a young people's group in his local synagogue, he didn't know how to cope with the situation. He was

often at a loss for words, and felt he was stumbling around like a sore thumb that just stood out and never really belonged. In spite of all his pain and inadequacy, he made passable grades in high school and was accepted at a local college. He majored in psychology as a way to understand himself, hoping to find some clue as to why he felt so bad about himself. At the end of his undergraduate work, he decided to major in school psychology, for he believed it gave him a fighting chance of earning a living, since most school positions did not require a doctorate. He certainly did not see himself as bright or as being able to compete on a doctoral level. Somehow, on the most marginal of terms, he entered a masters programme in school psychology and later secured a job as a school psychologist. His work was largely with children from a blue-collar background. Besides offering psychological testing services, he was required to do short-term counselling. To a large degree, his job became the precipitating cause for his entering treatment. He hated the job and was frightened of the toughness and aggressiveness of the children.

He confessed to me that he really didn't care about children and wonders why he entered the field of psychology. He believed he really does not have the emotional qualifications to do a good job. The one bright spot in his life was the recent acquaintance of a young woman. She was a very caring, mothering kind of woman, and at some point early in treatment, he reported that he would marry in the near future. This woman became his only good friend. He wondered what love was all about, but at the same time this relationship was better than any he had ever had in the past. He felt protected and cared for, although he was not sure whether he was in love with her. Besides, there was very little of a positive nature that he could see in his work. These first few months of therapy have a desperate ring to them. In spite of my caution not to make any precipitous moves, he did get married during the first months of treatment. I also took a stand in support of his not leaving his job, for he truly did not know enough about himself to make any big decisions. He did hold onto his job, notwithstanding the fact that he remained frightened of the children with whom he worked.

Slowly we developed a working relationship in treatment. I listened and encouraged him to tell me more about his life. There were many blank spaces and pauses, and he constantly worried that he was boring me. He could neither lie down on the couch nor feel very comfortable sitting in a chair. I understood the terror he faced, and his sense of aloneness. A deeply felt emotional contact evolved between us.

I recall one very significant session, marking an initial turning point at the beginning phases of treatment. He was staring intently at one of my

sculpture pieces of a young woman's torso, and I encouraged him to touch it. First he was repelled by the suggestion, but then he took a chance and felt its texture. He reported that he was both repelled and intrigued, and also extremely embarrassed. Yet this admission seemed to bring a sense of relief as well as exposure. He now appeared more relaxed, and without making any connection to this experience, he took off his jacket and opened up his collar. However, he was still frightened of lying down on the couch. After another month or so, he decided to take the plunge and lie on the couch. As he did so, he felt stiff and frozen. However, he did offer a dream, which provided both of us with a direct message. He reported that a doctor with a syringe was chasing him. At first he didn't know what the dream signified, but he slowly came to the realization that it had something to do with the fear of aggressive men. I made no suggestion that there were any underlying homosexual fears. Slowly a number of associations came to light. He told me about a piece of his life that became a very important growth experience. He remembered being a psychological technician in the army during the Korean War. He recalls feeling very close to the other men in his company. He was frightened and overwhelmed, and yet proud of that closeness in basic training. The feeling of comradeship was essential to his feeling part of something for the first time in his life.

Another dream soon followed that both surprised and shocked him. He reported that his father was kissing him. The memories soon flooded in of his father's touch, the roughness of his face, and the smell of his hair tonic. These were all part of a secret textural relationship that felt like a kind of forbidden love. For the first time, he allowed himself to feel warm and kindly towards his father. With my help, he recognized that this man had little choice but to choose an allegiance with his mother, for really she held the power in the family. Although he felt betrayed by his father, he also came to realize that, indeed, he had betrayed his father as well. He recognized that he acted out some of his mother's torment. The patient seemed very pleased to investigate the warm connection with his father, and something inside of him seemed to become unlocked and unfrozen. Meanwhile, I offered a very clear frame for him to investigate his life story. I recommended books, movies and plays that might shed some light on his life. He avidly responded to these reading assignments as if they were food, and we discussed his emotional responses to some of the main protagonists. I also began to realize that in addition to his aloneness, there was also a cold, manipulative, exploitive side of him that emerged in discussing his relationship with his professional colleagues and his wife.

One of Ibsen's plays, *Peer Gynt*, furnished enormous insight into his life. He was very caught up with the story, and comprehended the empty void that is the existence of the title character, and the underlying aloneness and emptiness that is brought home as the major theme. Slowly, a ruthless, angry piece of himself, that could be mean and vindictive, also came into focus. He didn't like these parts of himself, but we faced them one by one as they were often re-enacted in our relationship. He was somewhat cagey about money and evasive about what he actually earnt. He tried to manipulate our time frame, and deeply resented having to pay for absent sessions. In spite of his protestations of ineptness and inability to cope with life, he did make a major decision and returned to school in order to complete a doctorate in school psychology. It was remarkable, he reported, how his written work now seemed to flow, and he was both awed and confused as to where all this brightness was coming from. Academic work now did not seem as much of a burden. He received substantial help from his wife, who became his emotional support and helper. Even the children whom he hated now seem less threatening. He recalled with some embarrassment blowing up at a child who taunted him; he lost his control and shouted back at the child. This episode seemed to clear the air, and he felt less threatened by the fear of being out of control due to his rage. He also reports that he felt less nauseous and anxious when starting to work with some of these tough adolescents.

In the meantime, another drama unfolds regarding his wife. He constantly found fault with her and viewed her as controlling and intrusive. He complained about her sloppy appearance and was invariably critical of her. Slowly, we took a hard look at some of the projections he directed on her personage. We started investigating his relationship with his mother. There was little question that he saw nothing good about the woman. We had one of our biggest fights regarding this issue. He yearned in his fantasy life for the perfect woman, who would erotically arouse him and meet all his needs. The women of his daydreams were, at best, escape valves in facing an extraordinarily ambivalent relationship with his mother. I suggested that all she was, in truth, was intrusive and depriving. Slowly, memories moved into consciousness despite his resistance. He recalled her dedication, protectiveness, and care of him when he was younger. She was a powerful matriarch, but there was a passionate love that both frightened and aroused him. He admitted that it was all too tempting to make the mother the heavy and act out his sadism through his complaints about his wife. Gradually, we started to rebuild a very clear picture of both his wife and his mother. This splitting of good and bad was a tortuous path that took years of treatment to repair. I constantly challenged his splitting process and his retreat into fantasy in

search of a good woman who would mother him. Although resenting my challenge, he admitted there was some truth to my statements.

Over the next seven years of treatment, we faced his rage and fury at women. Often he would idealize me and see me in exceptionally positive terms. At times I was seen as the strong, tough male ideal that he craved; yet he was able to face that he was very frightened by his love and need of a protective male. At one crucial session, out of his mouth came a most embarrassing and shameful comment: 'I'd give you anything – including my penis.' I recall my response, which was met with a good deal of laughter and relief. 'I don't need it; I have one of my own'.

Tom went back and forth, scrutinizing both father and mother, and studying both the needy, intimidated, intruded upon, and at times infantilized child who was frightened of the world, as well as the man in him who required support of his sexual identity. Slowly, he was able to see me in far more human terms. He saw some of my lacks and failings as a therapist and at times even challenged the adeptness of my therapeutic technique. He claimed I was over intellectualized and too removed and that he would work with patients differently. The encounter had the feel of an adolescent boy who is testing his masculinity, and we both enjoyed the experience and recognized our differences as therapists.

Notwithstanding this new burst of self-confidence, there was still a deep sense of aloneness about him. He utilized the powerful mother inside of him as a meaningful bridge in his work with various school committees and colleagues in his profession. Much to his surprise, he enjoyed leadership and displaying his aggression by taking charge of important community activities.

In the meantime, the essential character work continued. I challenged his aloofness as being a way to feel superior. I was confrontive with his sadism and his tendency to be spiteful and vengeful towards anybody who crossed him. We took a tough look at his fantasy life and all the compensations that it seemingly offered him. At times he could not understand my tough confrontational edge, but he respected my values regarding therapeutic integrity. Slowly, during the last phases of treatment that lasted at least a year, I started moving back as he began the task of becoming his own therapist. He was now less angry and more reflective.

Over the course of the seven years of treatment, two sons became part of the family picture. He recognized the pleasure that took hold of him in being a father to them, and he made a great effort to be different from his own father. He realized how easy it was to betray the male inside of him and let his wife take over the responsibilities in the family, and he worked to deal

with this realization. We both perceived that his aloneness and need to withdraw would present a lifelong struggle. He recognized his need for space and became involved in photography as a hobby. The dark-room afforded a quiet aloneness that feels reparative from the stresses of the day, but he strived not to use it as a retreat from the family. He resented being overstressed and overstimulated, as people still could overwhelm him. He was less ashamed of being a loner and felt more in charge of himself. Socially, he no longer felt that he stood out like a sore thumb, for he had found structures, such as work and volunteer organizations, that made it possible for him to make contact with others. Yet we were both aware that the alone part of him remained a very fundamental part of his character.

Near the end phases of treatment, he took a good look at his entire life scenario. He understood that the very powerful, overwhelming mother and inept, passive father could easily be acted out in his relationships with others. The characterological work provided a significant place for the two of us to fight it out, toe to toe, regarding his defences, and it became a fulcrum capable of facilitating a self-object therapeutic internalization. Occasionally, he still betrayed himself, but less frequently than in the past. He was still prone to passive withdrawal, but now knew, somewhere deep inside, that this was a betrayal of a new-found value system, a new understanding of what a man is all about.

I was aware that his manner of talking and dressing had changed remarkably. He was far more relaxed and seemed to avoid clothing that is stiff and unyielding. A genuine feeling of fondness had developed over time between us in the real relationship. Yet this reality has not been a rationale for avoiding the tough work of transference and character analysis. Like an empathic nanny in the employ of a deficient mother, I was able to help him repair some of the early ego defects emanating from his parental background. He was more related, and certainly more effective as a functioning human being. He also had both a positive and negative understanding of his mother and father. He now utilized their positive memories as bridges rather than barriers in his interpersonal relationships. The basic defects of an autistic and schizoid personality were modified. There were still times when he was frightened of intrusion and retreated into aloneness. Although there had been a shift in his underlying character formation, both of us had to make our peace with the limitations from his past reality that will forever rear up in times of crisis and stress.

At the end of the seven year relationship, we took our leave of one another, as the nanny leaves the child. The real relationship was a fond and emotionally important one for both of us. Yet, as with the nanny relationship, our

limited time was over, and I was not a replacement for the bonded relationship of mother and father. Nonetheless, therapy became a place for the crucial mirroring of a self, previously often left to struggle on its own in the patient's past conflicts and crises. Now, Tom had an internalized friend inside along with his wife and colleagues.

In a psychoanalytic context, treatment proceeds within the frame of a number of theoretical models. The first part of Tom's treatment was characterized by an ego-self psychological orientation. Within this framework a good deal of holding and resonating took place. During this process, a support structure existed, with a clear communication that the therapist was not a parent substitute. Yet through a very active and stimulating form of engagement, the deadness and emptiness of the patient's earlier background seemed to be repaired. Stories, plays, and movies were part of a new and invigorating connection to the outside world. Still, it should be noted that the therapist did not take over responsibility for the direction of treatment. As treatment proceeded, a significant degree of separation anxiety evolved while the patient's self emerged. In the process, the patient experienced the very defined boundaries of the therapist, which ultimately provoked rage as well as self-definition.

In time, the patient's unconscious identification with his father slowly came to light. With this new development, the treatment now moved to a different level of engagement. An active confrontation with the patient's defences was required, and the negative transference came into full bloom. In conjunction with this development, the patient was able to tolerate and become far more comfortable with his own aggressive and sexual libidinal life. The splitting of the good and bad mother and the exploration of his fantasy life marked an important shift in treatment. We see here a shift into a new model of treatment, that of a drive psychology, which created a more appropriate form and shape, eventually engaging both participants in becoming present with each other. Thus, each new model of processing created a developmental frame for the therapeutic work to continue. The overall model was psychoanalytic, yet there was evidence of the important real relationship as well as work on transference and resistance. The unfolding of the genetic story and the working through of transference material were significant forms of expression that ultimately gave shape and direction to meaning.

References

Miller, W.L., Kaplan, S.L. and Grumbach, M.M. (1980) 'Child abuse as the cause of post traumatic hypopertuism.' *New England Journal of Medicine 302,* 724.

Money, J. (1977) 'The system of abuse divaflatin (psychosocial or reversed hyposomatotropism).' *American Journal of Disease Child 131,* 508.

Winnicott, D.W. (1971) *Therapeutic Consultations in Child Psychiatry.* New York: Basic Books.

The Healer as Therapist

Sandra Robbins

The Healing Environment

My healing room is an oasis for me and for my patients. Plants hang in the window, catching the sunbeams. Wind chimes sing in the breeze. Crystals, seashells, sacred objects and paintings help to ground and centre the energy. Often I call upon their energy to assist me in the healing process. The rug is hand-loomed of natural wool. The batik cotton cloths on which my patients lie have been blessed in a Native American ceremony. All who enter the space are asked to remove their shoes, as a symbolic reminder that the outside world will remain in the waiting room, and because our shoes carry the energy of the diverse rhythms of the bustling and often toxic city. A vase holds fresh flowers chosen by my pendulum so that they are correct for the healing. I always bring in a bowl of fresh water at the beginning of every session, because water is an energy conductor and an absorber of toxicity. The colours of my clothing are chosen carefully for the healing, and the fabrics are always of natural fibre. I am aware in selecting my jewellery that gemstones and stones are conductors of energy, and I do not wear impure metals. Before the session begins, I spend some time in meditation to prepare my own energy fields. I remove my watch as soon as I start to work, as a ritual detachment from a linear time/space frame and entry into a timeless, spaceless environment. The room, the clothing I wear, and my own therapeutic stance all clearly reflect my belief that everything has its own energetic field and that all fields impact each other. The healing environment is an integrated whole.

The Premise

'To heal is to be whole', while often stated, is less often truly understood. The premise of spiritual, or hands-on, healing is that all things have their own energy fields, yet at the same time all things are one. Put another way, all things share the same source. A constant energetic interaction exists in which everything affects everything else. The ripples of a stone dropped in a pool ultimately affect the ocean. As a spiritual healer, I am constantly focused on the state of the energy. My aim is to become a conduit to aid in dislodging toxicity or 'dis ease', better known as disease, from the disturbed energy field. The process remains the same whether the field presents itself as animal, vegetable, mineral, air or water. It is accomplished by opening the boundaries of the field, so that it can be entered. The opening of the boundary is achieved by the energetic interaction of the healer, the patient and the creative power of 'all that is'. Once the field is entered, we facilitate movement or vibration – which are other terms for energy – so that transformation and change can occur. When the toxicity is transformed, the field changes. The ultimate goal is for the field to return to a state of harmony and balance so that it is healed or, in essence, whole.

The Therapeutic Stance

With the knowledge that everything we do affects everything else, the world is viewed from a particular perspective. This perspective shapes my therapeutic stance and similarly, I believe, the stance of other practitioners in the spiritual, shamanic or hands-on healing community. As I write these words, I realize it is difficult to settle on a single descriptive title for those of us who practice in this field. I am aware that many people have a hard time understanding our work, and it is a common occurrence for eyebrows to be raised when I try to explain what it is I do. It is reassuring, however, to see the expanding awareness in the community at large of this mode of practice, and to know that it has begun to be explored and respected as a viable avenue for therapy. When I began my practice, people seeking my work were usually physically ill with major diseases such as cancer and AIDS. The advent of life-threatening illness frequently results in the softening of boundaries, so that the willingness to view time and space and the relationship between mind and body has the potential of taking on a new perspective. This is true not only for the individual, but also for society. Over the last decade we have seen a real shift in acceptance of the position that physical, emotional and even societal illnesses are not so separate and, in fact, are frequently interrelated. Such acceptance helps to create changes in belief systems and

a growing willingness to augment the medical model, and even to seek alternatives to it. I now see a variety of patients, with a wide span of presenting problems, for people are more open to exploring therapeutically the energetic interrelationship of physical, emotional, mental, karmic and spiritual disease.

My stance and my discipline as a spiritual healer require that I be as clear as possible as to my own state of being: whether I am in the here and now, or dreaming, or in meditation or light or deep trance, or shamanically journeying. In my work I clearly distinguish between imagination, visualization, and a state that I call 'seeing', all of which I will describe in detail below. I approach my work with a focus on being fully present for the patient, setting aside both consciously and ritually my egocentric and personal space. If my life circumstances are such that I am unable to be 'present', then I will cancel the session, for the work depends on my being able to maintain complete focus on the client. From the moment someone walks into my 'healing room', I energetically and consciously open my boundaries so that I am fully present and focused.

Therapeutic Presence

To maintain the stance of full presence demands working from a grounded and centred position. From this position the healer can then focus cleanly on the patient. This discipline allows the healer's ego to feel safe enough to get out of the way without the self being threatened. This therapeutic stance also eases the way for the healer to open the boundary of self to fully include the patient and, as the session progresses, to become 'one' with the energetic space of the patient.

This stance of presence without distraction comes more easily for some than for others. The state of being fully present serves us, not only as therapists, but also in many of our life tasks. When I have taught therapeutic presence to students, they often report a profound sense of being at home with themselves and a feeling of safety.

Centring and Grounding

To be present, the therapist must first become centred and grounded. Many people talk about these states but few explain how to achieve them or how they feel. It is also wrongly assumed that they are one and the same. To be centred is to be in the centre of the self, or the centre of the sphere of your energy fields. To be grounded is to send your energy vertically down to the centre of the earth. The state of being centred and grounded can be illustrated

very pragmatically: if you have achieved it, you literally cannot be pushed over.

By definition, being grounded means being connected to the Earth (the ground). Like a tree, when you are grounded, your roots are firmly planted in the Earth so that, in effect, you are tapped into the Earth's energy. The Earth is an enormous generator of infinite energy. Just think about it: everything you eat, everything you drink, the air you breathe, comes from the energy of the Earth. The Earth is a natural source of energy, which, like electricity, you can plug into and access. If you limit yourself to your own energy, you will soon be exhausted and depleted. If you use other people to be your source of energy, those people will soon resent your draining their batteries, so to speak. This drainage on other people is often done without conscious awareness. However, we all know people who seem to constantly exhaust us, or, on the other hand, we may have had people tell us that we are exhausting them. This happens when we use each other's energy fields as a generator. Therefore, it will serve you well to access a generator for yourself that will not resent or resist you, and that is an infinite source of circular energy, both giving and receiving. What more natural place to go to than to Mother Earth! The metaphor has archetypal resonance. As embryos, through the umbilicus we are literally tapped into the energy of, and are dependent on, our birth mothers. I believe that Mother Earth is called such, because on some very primal level we know that our symbolic umbilicus is also tapped into the energy of, and dependent on, Mother Earth.

An Exercise in Centring and Grounding

Centring and grounding can be achieved through a simple exercise. Start by standing in alignment, meaning that you are standing straight, with your feet at a comfortable width apart and the crown of your head reaching for the sky. (You can also do this exercise sitting or lying down, but it is more difficult to test it in these positions.) With focus, breathe and stretch and place yourself in your space.

CENTRING

To centre, close your eyes and peacefully take a few breaths into the centre of your solar plexus. The breath helps you move into a mild meditative state. Using the image of lighting a candle in the centre of the self is a nice way to peacefully find your centre.

YOUR GROUNDING CORD

To start the process of grounding, from the base of your spine (for men) or between the ovaries (for women), sense your tap root or your grounding cord dropping straight down into the centre of the Earth. If it does not want to go straight down, visualize it and send it down with mindfulness. Ask for it not to curl up or go horizontal, or circle around, or the like. If your grounding cord or tap root does not go straight down, being grounded is probably not easy for you so you may have to focus and practise this with clear intention. You may see your grounding cord, feel it, or even hear it. Simply ask for it and sense what happens. It is sensed differently by different people. The essential point is that whatever it seems like, it is your image, not somebody else's. It is not predetermined; there is no right grounding cord. People have reported their grounding cord looking or feeling like an umbilical cord, a beam of light, an iron bar, a tree tap root, an energy beam, etc. You may find at different times that it may show itself in different ways.

YOUR ROOTS

When you have a clear sense of your grounding cord going toward the centre of the Earth, like the tap root of a tree, move on to the next step of sensing your roots. Like trees, we have both a tap root (our grounding cord) and roots that extend into the Earth from our feet. For those who are familiar with the chakra system, these latter roots are the energy fields from the root chakras in our right and left feet. First ask for and sense your roots from one foot and, once established, from the other foot. Again, the roots will seem different to different people. Do not make judgments about them, as to whether they seem adequate or inadequate, deep enough, large enough, sturdy enough, or wide enough. This is not a test, but rather an acknow-ledgment. In addition, it is not uncommon for the roots from the right and the left foot to seem very different. Many of us are right and left sided. The important thing at the end is to ask for balance between your roots from your feet and your tap root so you feel secure and grounded standing on the Earth.

TESTING

To test whether or not you are centred and grounded, ask someone to push you! You may be surprised at how solidly you are planted in the Earth. On the other hand, if you are able to be pushed over or off your spot, then you have not yet achieved groundedness. Do the exercise again until you cannot be pushed over. To complete the testing with this pragmatic approach, after you are solidly planted visualize yourself pulling up your roots out of the

ground, including your tap root, and then ask someone to push you and feel what happens. Once again, you may be surprised at how far you can be pushed off the place that you seemed so solidly planted in just moments before. I recently had an interesting experience in demonstrating this phenomenon with a 190-pound man. He centred and grounded himself, and I pushed him and found him immovable. I then told him to image pulling his roots up and proceeded to lightly push him. To the immense surprise of both of us, he went flying across the room, landing with such impact in a chair that he broke it into pieces. It was a very graphic, funny and expensive experience of understanding what it feels like not to be grounded.

For the next phase of this exercise, after doing the imaging standing still, practise walking with your roots (right, left and tap roots) securely in the ground. Again, to test yourself, have someone push you. See if you can be pushed off your pathway. If so, you are not grounded. Practise being grounded when you walk on the city streets, or anywhere you might feel insecure. It is an interesting exercise to do in a subway, and chances are, you will feel very different from what you are used to.

Imaging

The centred, grounded position is the starting point of being fully present. It is a position of safety and security, affording the freedom to move in any direction without anxiety. This security permits you to set aside your ego or personal self and open your boundaries, so that you can truly be present for your patient, whatever modality of therapy you practise. The discipline to achieve this state of presence can also, like grounding, be accomplished through imaging. There are three different methods for receiving or creating images, and I will describe them in depth in the next paragraphs. These methods are: imagination, visualization, and what I call 'seeing' (for want of a better term). None of these are limited to visual images. You can use any or all of your five senses – hearing, seeing, touching, smelling, and tasting the experience. The sensation can be kinesthetic or physical, emotionally charged, or even intellectual. Sometimes it can be all of the above. In common terminology, we generally do not differentiate among these three methods and frequently describe the whole process as 'I'm just imagining it'. Imagination is one form of imaging, but since the words are so similar, they are often used interchangeably. However, although frequently there is an overlap in these three modes of imaging, they each have a different focus.

Imagination

To use one's imagination is to use the power of fantasy, 'make believe', or 'once upon a time', and is usually accessed from the here and now space. It is what we use when we create a story, a poem, a song, a painting, or see images in the clouds, or play a game like charades. Our imagination helps us reach our creativity and put it into form. It is a powerful tool, without which life would not be much fun. Yet adults tend to think of this tool as the province of childhood, for we are aware that the imaginative process is the basic element of play, seen as the work of the child. As adults, we tend to separate work from play, although we may envy the artists and others for whom use of the imagination is an underpinning of their work. Without actively engaging in the creative process, we take the juice out of life, and our day-to-day existence can become quite boring, dry, and even joyless.

Visualization

To visualize is to decide on a specific image and then bring it into focus, giving it shape and and form in your mind's eye, using any or all of your five senses. It is a very powerful and effective technique used in almost all forms of therapy. For those familiar with the chakra system, it would mean using your third eye to give shape, colour, textural form, possibly sound and feeling. An example would be when someone who is ill visualizes the good cells eating up the bad cells, or when someone who is trying to lose weight visualizes how being thin would feel and look. It demands clear focusing and mindfulness on a specific image. The manifestation of a thought form, meaning thinking something and finding that it actualizes in the here and now, is frequently the result of the process of visualization. The Simontons brought this technique into sharp focus in their work with cancer patients.

Visualization is most potent when it is accessed through the meditative state. The change in brain waves makes a significant difference when visualization is being used to create transformation or healing. For example, not long ago I caught my finger in a door, and the finger immediately became swollen and black and blue. Since my finger really hurt, I decided to take a few minutes to do some visualization techniques. I took a few breaths, centred and grounded myself and moved into a meditative state. I visualized the fluid from the swelling in my finger being dispersed throughout my body. I sensed this both on the visual and on the kinesthetic level, seeing and feeling the fluid moving. I also visualized the blood circulating so that the black and blue discolouration would disappear. I also visualized putting the pain I was feeling into a helium balloon, and asked for it to be lifted out of

my finger. In addition, since I know hands-on energy healing techniques, I ran my other hand over the energy field of the finger, cleared the field of the congestion that I felt, and asked for healing. Within 20 minutes of starting the process, my finger was a normal colour, and the swelling had completely disappeared. It still hurt but far less intensely. Although I am quite aware of the power of these techniques, even I was surprised at the speed of the transformation. It felt like a little miracle. Approximately five days later, there was a thin blue line across my finger at the spot where the door had closed on it, reminding me that indeed I had injured my finger and just how powerful visualization and healing can be. Keep in mind that this healing occurred from the meditative state, a non-linear time/space frame, rather than from the here and now, or linear time/space frame, from which we usually access our imagination.

Seeing

The third form, which I call 'seeing', also comes from the non-linear time/space frame and usually occurs in an altered state of consciousness. It comes from non-ordinary reality, which has no material form in the present time and space. It means simply letting an image emerge from the meditative, trance or shamanic journeying space, without any preconceived notions of the image or any visualizations. It is letting your body or its energy fields show you what is going on, using any one or more of your senses. Perhaps it will be easier to understand if I liken the image to a vivid dream state, although the state of 'seeing' does not generally result from dreaming. It is possible, however, that certain dream states, such as predictive dreams, could actually involve a state of 'seeing'.

In contrast to visualization or imagination, you remain passive, an observer. You stay out of the way of the body's images. You try to remain nonjudgmental and accepting, letting the image just come. Sometimes the images may seem frightening, sad, or without any meaning, but it is important to trust the process. The only role you play in bringing the images to you is to focus on opening the field to see what you want to see. For instance, you can ask for the body's images of the landscape that needs healing. If it is a specific part of the body, let us say an ulcer, you ask for the ulcer's landscape. Every individual body has its own landscape, and its own individual process of healing. The landscape you see may be the emotional or the physical landscape. Whichever is showing itself is the one that is ready for healing. For example, you may see people in it or you may see craters. It is possible that the people are coming from the emotional field and the craters

from the physical. Do not presuppose. Wait for the content and the affect to let you know.

I will frequently ask my patient what the body's landscape looks like, so that what is needed for healing can be accessed. In this technique, when the patient reports seeing a black hole, or a desert landscape, or feels there is a large rock, or hears a panther growling or whatever, these images do not come from using the imagination, nor from selecting an image and placing it there as with visualization. The images come from the body's own energetic landscape, and the patient is allowing them to emerge. I call this mode of accessing the image 'seeing', from the word 'seer', one who is able to see beyond the material reality.

The following example may make this clearer. I was doing a healing with an African drummer whose chest was very badly congested, and he thought he was suffering from pneumonia. I placed myself into a non-linear time frame, grounding, centring, moving over into the altered state of consciousness of meditation and light trance, and prepared to do a healing. However, no matter how I tried, I could not really access his energy field. I could not sense what was going on so that I could be a conduit for healing. I told him that his fields were closed to me, and that if he was not ready to do the work, it was okay. This was quite unusual because when people come to work with me, they are mostly in a receptive place or they would not have asked for healing. His response was that he was ready to do the work but I had to ask permission from his ancestors. So, from my non-linear time/space frame of non-ordinary reality, I proceeded to ask for his ancestors. In my mind's eye, I clearly saw three figures which I described to him. From my description, he recognized them clearly, even knowing them by name. I heard them give him and me permission. His energy fields became accessible and open to me, and we were able to do the work. For me, it was one of those moments of pragmatic validation of what I 'see' in this space of non-ordinary reality.

Unlike the hallucinatory chaos of psychosis, the space of 'seeing' is one in which I place myself with intention and focus. I am clear that I have opened my boundaries. I have chosen to be in this space and know how and when to come out of it. I help clients to enter into the non-linear space and to access their powers of seeing non-ordinary reality within a clear framework. I sometimes wonder whether this modality of healing would help psychotics who hallucinate. Since I am so clear in my own structure, perhaps I would be able to join them in their place of 'seeing', to help give it a structure, assist them in dealing with their non-ordinary reality entities, and bring the patients back to a boundaried place where they could have a choice in their state of being.

Using Imagery to Achieve Presence

The next step will be to put this information about the way we image to the task of being fully present for your patients. From the safety of being fully grounded and centred, it is time to move the ego aside, open your boundaries, and focus on the client. To accomplish this, let us return to the techniques of imagination, visualization and seeing. You may use any of these to achieve the therapeutic stance. In fact, it might be useful to try each one and see which works best for you. (This try-and-see approach, by the way, is also useful for imaging the root systems in grounding.) I will now guide you through using the three imaging techniques to detach from the personality self, open your boundaries, and thus achieve presence.

IMAGINATION

To move the ego or personality self aside, you could employ an imaginative process in the here and now. For example, you could imagine taking a big suitcase, packing up all your troubles, your pleasures, or any other circumstance that might stand in the way of doing the work, and then leaving the suitcase outside your office door. This is just one scenario. Try any imaginative scenario that works for you.

VISUALIZATION

Now, to use the same image but make it a visualization, you might close your eyes, take a few breaths into your centre, and move into a meditative state. You would ask for the suitcase to be filled with the baggage that is attached to your ego or personality self, so that you are a clear conduit that will be available to your patient. You would trust that the suitcase was now filled with the necessary baggage. Then, with clear intention and focus, visualizing the process from the altered state, you would place the suitcase outside the door.

SEEING

If you wish to use the mode of seeing, first take a few breaths to affirm your centre and grounding. Now ask for your energy field to show you your ego or personality self, with the intention of moving it outside your field, so that you can focus completely on the patient. It might happen that you feel or see an image of a person, or a full image of yourself, or even a ball of energy coloured blue, pink, purple, or who knows what colour! Whatever comes, comes. To achieve seeing, you must have no pre-conceived notion of what you will see. No suitcase, no expectations. If you do not see anything, that can work, too. The important thing is that your intention is clear. You have

asked for your ego or personality self to stay out of the way for the duration of the therapy session.

Opening the Boundaries

Now from the position of being grounded and centred, with the ego or personality self moved out of the way, the next step is to open your boundaries. We live, in effect, in a bubble of energy, and we can control its size and its permeability with our imagery. We are a mass of magnetic fields of positive and negative energy and auric fields of colour; an energy bubble of vibrations that are always moving in and out, affected by our sense of safety, our intention, and our focus, reflecting what is going on in the world around us. When we enter a space, if it feels safe, we tend to open our fields and our boundaries. Conversely, if it feels dangerous, we tend to pull them in. The tighter we pull them in, the less comfortable we are.

Opening the Patient's Boundaries

Many of your patients will have fields that are tightly pulled in, because the world has not been a safe place for them. Moreover, your patients often feel that rarely has anyone really been present for them. In metaphysical terms, this means that others have not been willing or able to open their energy fields to be available or sensitive to the patients' needs. Therefore, it is hard for your patients to open their boundaries to you, for trust is not familiar territory. On the other hand, they are usually in great need of someone who is willing to open boundaries, who will trust them and who can be trusted to be present for them, at the level that they can tolerate at the time of treatment. Thus to enable patients to open their fields, we as therapists must create an atmosphere of trust, being fully energetically there with the patient, with our own fields open and often permeable. Also, helping patients to centre and ground will often assist them in creating a personal space of safety.

Opening the Therapist's Boundaries

For the therapist, open boundaries are difficult to maintain consistently unless we do it with discipline, so that we do not absorb toxicity from the patient. It is likely that you will indeed receive some 'toxic dumping'. Therefore, discipline is needed not only in opening your fields, but also in clearing and closing them at the end of the session, so that you do not wind up with your patient's 'stuff' strolling around in your field. I will describe how to do this later on in the chapter.

To open your boundaries, you can use the same techniques of imagination, visualization or seeing. It might be helpful to have a friend with whom you can practise the procedures.

IMAGINATION

Imagine that you have a bubble of energy around your body that you can expand and contract. Imagine its border two feet away from you, four feet, eight feet, and keep opening it until it is a big sphere all around you that fills the room. Then practise bringing it back in close to your body. Now do it with a friend as witness, seeing if your friend can sense how close or far away you intend to be, purely by how open or closed you have imagined your boundaries to be.

VISUALIZATION

To begin visualizing, take a breath into your centre and go into a light meditative stance. You may want to close your eyes to visualize your bubble. Clearly, with focus and intention, watch your bubble growing larger and smaller. See how much control you can have. Since your presence has to be maintained in the here and now, as well as in the non-ordinary reality of the altered state, practise doing the same exercise of visualizing with your eyes open. Again, practise this procedure with a friend, and see how close and how far away you can be, without physically moving, of course.

SEEING

Start by taking a breath into your centre, and go into a meditative stance. From your place of 'seeing', ask to see your energy field or bubble. Explore whether it has a specific colour, shape, or size. Ask for it to grow or to shrink. Remember that the seeing may be imaged from any of the senses. Rather than visually seeing the image, you actually may feel it or sense its size, colour, density, or vibration. Again, practise with a friend. See if your friend can feel your presence right in front of him or her. Next, pull your bubble back in close to your body, and then come back close to your friend. Does your friend sense where you are? Do you know where you are? Can you sense your friend's energy field?

With a little practice, you can very quickly bring yourself fully present. You will have to sense from your patient how close you can approach with your energetic field. Some patients need you to be present but energetically somewhat distant; others need you to be energetically very close; still others need you to embrace them. The more you practise, the more you will sense what is the correct distance. Your knowledge of presence will also let you

know when your patient is present. The chances are that the more present you can be, the more present your patient will be. In fact, whether you or your patient are present, and for how long, is often a barometer of how well the session has gone.

This process may seem very complicated and time-consuming. The truth is that the whole procedure can take just a few seconds. As with walking, you do not need to think about how complicated the act is or how many stages you went through to learn how to do it. In fact, being present is much simpler, and with practice will happen as quickly and naturally as walking or riding a bicycle. Once you have learned how, it becomes an automatic procedure. Perhaps you are doing it automatically already! However, with conscious awareness, you will have control of it, and will find a new ability to gauge how the presence of you and your patient affects the therapy. By being present, working from a centred and grounded position – using the Earth as a generator – you will find that the sessions flow much more easily and that you will be using much less energy.

These techniques for achieving presence are applicable to all modalities of therapy. The difference in how I use my presence as a healer is that much of my practice takes place in an altered state of consciousness, in non-ordinary reality. In addition, to achieve results I frequently open my boundaries so that I am inside the energy field of my patients, sometimes feeling their pain, clairvoyantly seeing their images, or hearing the sounds of their bodies.

A Healing Session

Time Frame

My sessions often last from one and a half to two hours or longer, if necessary. Since most of my session takes place in a non-linear time/space frame, it is difficult for me to adhere to a linear hour. However, there are many healers who do sessions by the clock. A major difference between a healing session and the more recognized therapy session is that a large portion takes place in an altered state of consciousness. As stated earlier in the chapter, I fully prepare myself and the room to receive the client. I make it a point to ground and to centre before we start, and to prepare to open the boundaries of my energy field so that I can be fully present.

My practice consists of a variety of patients. I treat people for both emotional and physical problems. I see some people on a weekly basis, others biweekly, others occasionally over many years, and others for a single session. It will depend on the nature of the problem and on the needs of the patient. Some people want the distance of a monthly visit, others the freedom of

asking for a session in relation to specific need, and others need the intimacy and continuity of a weekly session. If I am dealing with a serious illness I usually will see a patient for a number of weekly visits. In some instances, as with one of my leukemia patients, the healing sessions occur weekly over a number of years.

Preparation

At the beginning, my sessions are similar to traditional verbal therapy sessions. We usually spend the first half hour discussing what is going on in the client's life and current situation. I focus on the problem at hand, making sure I know what the client wants and needs from the session. However, most important, I am setting the stage for our work by establishing rapport, trust and safety. This is crucial, because if either the client or I are not comfortable with each other, then the next stage of the process – working in an altered state, getting into the energy field, and making a change – will be much more difficult, if not impossible.

The Healing

I will describe a healing session where, for the most part, the imagery was accessed by the patient from the place of 'seeing'.

The patient (whom I will call 'Pat' in this chapter) is a woman whom I have seen a number of times over a two-year period. The last two sessions had dealt with fear and finding a place of safety, as well as a permeating anxiety and fear around hunger. In these sessions she had found a safe space, a room she calls her 'cave', inside her chest. At first the cave was dark and ominous, but with exploration and healing it became filled with light and safety. This is a space to which she often returns. The session I am going to describe took place during a period in which she was dieting. This created tremendous anxiety, wakefulness at night, constant clenching of teeth, and fear of dying. In addition, in her words, she had become 'a bitch to live with' and was making her family 'crazy'. Nevertheless, she felt compelled to maintain the diet. In our discussion at the beginning of the session, she said her mother had told her that when Pat was an infant, she adhered to a very strict schedule of feeding Pat every four hours. For the most part, according to the mother, she propped the bottle because it was easier that way. Pat's enormous fear of starvation seemed to be coming from an early non-verbal level that was pre-cognitive. At the current time, she wanted to deal with the ever-present anxiety and fear of dying that occurred whenever she dieted. Pat also mentioned that in the last few days she had seen a number of crows,

and felt almost as if they wanted to tell her something. They had truly caught her imagination, and she felt they might be important to the process.

After our talk, I began the healing portion of the session. I usually have the patient lie on the floor, or on a futon, on the cloth I described earlier that had been blessed in a Native American ceremony. The patient's head will face north, and I also face north. I always bring in a bowl of water, because it is both an energy conductor and an energy collector. If it seems correct for the session, I may place crystals on the patient's body, or have the patient hold crystals, or I will hold a crystal. In this case, Pat held two large quartz crystals in her hands, and on her heart chakra I placed a crystal that I had meditated on for rebirth. In addition, I will frequently dowse the patient's energy field with a pendulum, a crystal at the end of a chain. I learned this technique many years ago from Rosalind Bruyere, a renowned healer. In dowsing Pat's field, her energy field indicated to the pendulum that until the age of ten months she had always felt hungry, in fact on the edge of starvation. We discussed the fact that, for Pat, dieting really pushed early buttons of fear of dying, and that perhaps dieting was not something she was ready to do. However, she reiterated that she wanted to deal with the fear. So we began the healing.

To enter the space of non-ordinary reality, I do a short ritual that I was taught by Rev. Eva Graff, another well-known healer. I say the words, 'I am Sandra', which helps me to ground and centre myself. Then I say 'I am', which helps to set my personality self aside and open myself to the space of 'all that is'. Then I say 'I am asking for healing for (the name of the patient)', which helps me to focus. Thus, to create the presence in non-ordinary reality, I ground ('I am Sandra'), I open my boundaries ('I am'), and I focus ('I am asking for healing for…'). During this process I am also moving into a light trance state.

In this session, I started by placing my hands over Pat's solar plexus, for I felt she needed to be centred, and I ran some energy. Then I asked her to ground herself, so that she would feel safe to explore her fear. She said that it was hard for her to get out of her head but that the grounding cord felt very thick. I asked her to take a few more breaths into the centre of her body. Then I asked her to 'see' what her body wanted to tell her.

From her place of 'seeing', the image that Pat saw was of angels kissing a fat, blond baby boy. I asked her whether the baby was herself. She checked and said it was not. When I asked her to see herself, she saw an emaciated, starving baby girl, which made her very sad. I asked how she could bring healing to the baby girl, and she said that it wanted to be close to the baby boy. She imaged this, but it did not seem to help. When she looked again,

she said the baby girl wanted to be covered with a blanket. She visualized herself covering the baby, but she still felt very sad. Then I asked her if she wanted to bring the babies into her room of safety, so that she could heal the baby girl. She said 'yes'.

She visualized the space that she calls a cave, and entered it with the two children. Then she went back to the mode of 'seeing'. When Pat asked for healing for the starving baby girl, the baby turned into a frail old woman who withered and became ashes. Pat felt sad but said it was 'okay'. Also, in the cave along with the two babies, a warrior appeared. She felt it was the warrior in herself, which she described as:

> A warrior, thin like a weathered hard runner, standing there with my armor and sword. I can't ever relax my vigilance. I must always protect myself against death – the enemies that could kill me. I'm very lean and hard.

I then suggested that she ask for healing for the warrior. She said the warrior would like to hold the baby boy, but she is afraid. We asked the warrior how she could be healed so that she could hold the baby. She answered that to have healing, she would want a door closing the cave. That, however, was not acceptable to Pat; she was not willing to close up her cave of safety.

Then suddenly the image of the warrior turned into a panther. 'She (the panther) is very guarded and afraid. She can't think of how to make herself safe. She also wants a door to the cave, but it is still unacceptable.' I asked whether there was some other way that the panther would feel safe. Choosing a cage, the panther went in, turned around a few times and lay down. She evidently felt safe and went to sleep. Then a crow came into the cave, laughing and screaming 'Lighten up! Lighten up!' Pat said she was too wary of the panther to 'lighten up.' Pat's next comment was:

> The crow is revealing that he is here to guard the panther. He's perched on the cage. I am still wary. What will happen when the panther wakes up? How will she get out? What will she do? The crow is showing me that the cage is really part of the panther, that when the panther wakes up the bars will become part of the fur again.

Then it happened. The panther woke up, very agitated and full of rage. It paced in an infinity sign. When I asked what the panther needed to heal, the panther became huge and exploded.

> Its teeth flew out in all directions, and its lips went in opposite directions. Its blood, guts, fur were everywhere – on the baby, on me, all over the cave. The crow is delighted. It's having a big feast.

Figure 5.1 The crow

I asked how the baby was doing in light of the explosion. She said the baby was startled for an instant but was okay. As to how Pat herself felt about what happened, she said, 'I'm shocked, and repulsed – and I feel a sense of relief. I'm okay though. All I have to do is wash it off, take the baby and go to the river and wash it off'. When asked where the river was, she said there was a river running right outside her cave. How did she feel about the mess in her cave? She answered that the crow would take care of it; she did not have to worry about it. So she proceeded to strap the baby to the front of her chest, facing her with his head between her breasts. He went to sleep very contentedly. They left the cave and went to the river, swimming deep down under the water and bathing. She commented that she was not concerned about the baby drowning, for he was okay with her under the water. When I asked her how it felt, she answered, 'It is glorious'.

I asked her whether there was anything left to be done, and she said there was not. We sat a bit and she began to feel very sad. The thought of losing the warrior became overwhelming. (In fact, she later told me that at this particular point in the session she had actually wanted to undo the session.) I asked her if she wanted to see what had happened to the warrior. So she asked to see the warrior and found her lying in a fetal position. 'She looks a little withered but softer. She is still lean, brown and tall, but soft. She's so tired, curled up on the hard floor.' When I asked her what the warrior needed, Pat said she needed a feather bed, a blanket and some rest. Her next image was of the warrior on a feather bed, covered with a blanket, comfortably going to sleep. 'The crow is there too,' she said. 'He also needs to sleep after his big feast.' I asked her how the baby was, and she said that the baby was still contentedly asleep in her arms. I asked her whether she wanted to check the cave. She said:

> No, I know that the crow has taken care of everything, even the ashes of the little emaciated baby girl that turned into the old woman. I feel very light and very content. I really feel okay. We can end now.

So we ended the healing part of the session.

Closing Ritual

To end, I customarily use a ritual that I also learned from Rev. Graff, which keeps me from walking around with the personal energy of the patient in my system. I placed one hand in the middle of Pat's forehead, with the palm of my hand covering her third eye and my other hand over her heart chakra between her breasts, and visualized her personal energy returning to her. I was careful to tell her that the healing would remain, and that I was only returning her personal energy, because it does not serve us to walk around in each other's energy bodies. Then I put my hands on my third eye and my heart chakra and asked to separate my personal energy from hers, and visualized my energy returning to me. Next, I asked her to visualize a magnet in front of her body taking back any additional energy that might be still floating out there. She took a breath, closed her eyes, and visualized it. She told me when she was finished. (The first time clients do this, they are always surprised by the feeling that they actually have taken their energy field back to themselves. There often is a feeling of relief and power that they really feel separate and whole. Sometimes they worry that this may interfere with the healing, and so I reassure them that it will not.) Then I do the same; I visualize taking back all my personal energy to my own field. I will frequently see different images with different people. The separation may be

very easy, or at times it may take longer. Sometimes I see my ball of energy making a complete circle around the patient before it separates, almost as if it is caressing the patient's field. Occasionally the separation is really difficult. At such times, I tell patients that I will hold them in my heart chakra, with love, and I check with them if that is okay. Usually they feel a sense of relief when I say that. Some patients feel 'spacey' either before or after separating. Then I will often put my hands on their feet and ask for them to be grounded and balanced. I hold my hands there until I feel the energy balance out, and I may also ask them to image their roots.

The Healing Session – Aftermath

This was the result of the healing session I described, as reported a few days later by the patient:

> I felt very light, as if a huge burden had been lifted. I went home and made myself a nourishing lunch. I even let myself have a piece of bread. I felt that I could really feed myself. All week it has been like I am a new person. I'm no longer afraid. But mostly, I'm no longer angry at everyone. I'm not acting like or feeling like a bitch. I watch what I eat but I'm not obsessed with my diet. It's like it is okay that I can let it alone. I'm still clenching my teeth at night but I think it is an old habit that hasn't caught up yet with what I feel. I keep checking in with my warrior and she is okay. I'm so glad that she isn't gone. I would have missed her terribly.

The Case – Discussion

The above case illustrates the use of presence, trust, and imagery. Our first period of talking set the stage so that the patient, 'Pat', knew that I was fully paying attention to her needs and the area she wanted to explore. I came with no hidden agenda. Our past history was very useful, for she had already found an internal space of safety, her cave, that was authentic to her. This meant that when she felt frightened she had a place to go, where she could safely explore her life-threatening fear. It should be noted that at the beginning of the healing she was not consciously tuned in to her rage. She is, however, very adept in the art of letting go and allowing her authentic imagery to appear on many sensory levels. Not all clients are as easily open to receiving images. In this symbolic process, Pat was able to access many facets of herself: the vulnerability of the baby, the transformation of the baby girl, the defensiveness of the warrior, the rage of the panther, the wisdom and caretaking of the crow. Towards the end of the healing, there was a

moment when we might have missed the transformational significance of the warrior after the explosion of the panther, and the patient would have been left feeling vulnerable and defenceless. For Pat, the warrior is a vital life force. The fear of losing her, a very familiar figure who was Pat's defender, had given way to a profound sadness. In her imagery, Pat had transformed the warrior – with her sword and shield – to a panther who exploded when asked how she needed healing. Yet the explosion did not mean the warrior was gone! Evidently the panther was just an aspect of the warrior. The explosion, though an enormous release of transformational energy, did not annihilate the warrior. The patient, however, did not realize this. It was my 'seeing' the warrior's presence once again and directing Pat to look for her image that let her realize the warrior was still very much alive. She looked different, somewhat softer, having put down her sword and armour and needing some well-earned rest and recuperation. Even the crow needed to sleep off its huge feast. Pat and I still are not sure of what the blond baby boy represents – but we will trust that when the patient is ready, her imagery will let us know.

When we look back at the healing session, processing what occurred, we can see how strong and symbolic the imagery was as a transformational force. With ease, Pat moved back and forth from her place of 'seeing' and the clarity of visualizing. In addition, it is interesting to note that her earlier sighting of crows in her everyday life, in the week before the session, had stimulated her imagination and became an important aspect of the healing.

Summary

The case illustrates the evolution of a number of stages. Before the patient walked into the room, the process had begun. I had prepared myself and my room, so that the energetic environment supported the work. Together, with the help of 'all that is', we opened the space. With love and compassion, the boundaries opened and the imagery came. The panther could 'explode', the energy change, and the fear of dying could transform. To quote the patient when she swam in the water after the explosion, holding the baby between her breasts: 'It is glorious'. The warrior is resting up for her next bout. The crow will keep reminding her to 'Lighten up! Lighten up!' Symbolically, a light has been opened up in the patient's darkness. We can only wait and see what is revealed next.

The elements that set the stage, and are important to permit healing to take place, are the same for all forms of therapy. Creating an atmosphere of trust is foremost. A major element that creates and permits trust is 'presence.' If you can permit yourself to be fully present – grounded, centred, opening

your boundaries, and setting your ego or personality self aside – then you can clearly focus your energy on the patient. In this holding environment of acceptance, and non-judgment your patients can permit themselves also to be present, to open their boundaries, and to place their trust in the therapeutic process.

Therefore, as we have seen in the case history, presence cuts across many lines of consciousness. It moves back and forth from lightness to darkness, from the non-ordinary reality in a non-linear time/space frame to the here and now, and often encompasses an archetypal symbolism. This expanded use of presence offers a unique opportunity for the exploration of authentic imagery permitting transformational change and, thus, healing.

The Impact of Pregnancy on the Psychotherapeutic Process
An Integrated Approach to Working with the Self-Disordered Client

Melissa Robbins

Introduction: Pregnancy and Therapeutic Presence

In my eighth year of practice as a psychotherapist, I experienced a new and puzzling development. I became pregnant. While personally, this was a transformational experience, it became clear that its impact on my practice was equally enormous. In quite physical terms, my pregnant belly was hard to avoid, even for those clients most adept at defensive strategies.

Over the last 30 years, as more women have become psychotherapists, the effect of pregnancy on therapeutic presence and process has been explored in the professional literature. The majority of this writing, however, examines the intrusion of pregnancy on the therapeutic process from a psychodynamic perspective. As my approach to psychotherapy diverges in many essential ways from a psychodynamic one, I found little to guide me through the many dilemmas raised by my pregnancy.

The following discussion examines the problems facing a pregnant therapist working with the particular population I treat, and addresses the issues raised when utilizing a 'non-regressive' treatment model. The vast majority of clients I work with can be thought of as 'self-disordered'. By self-disordered, I mean clients with significant self-deficits in several areas including affect-regulation, self-care, and relational capacities. These clients often struggle with eating disorders, substance abuse, have experienced trauma, or may be thought of as character disordered. Due to their tendency

to either flee from therapy or regress in therapeutic relationships, and their need for structure and concrete help in managing the stresses and demands of daily life, I have utilized what I will be calling 'an integrative model'. In this approach, while the therapeutic relationship is extremely important, transference work is not the focus of treatment. Since a therapist's pregnancy is enormously evocative for this (or any) population, however, both transference and counter-transference issues will inevitably need to be managed, but done so in a way that hopefully keeps therapy moving progressively.

In the following discussion, I will provide a brief literature review on the subject of the pregnant therapist, describe in more detail what I mean by 'integrative model', and provide clinical examples of how one might manage a pregnancy when working non-regressively with a self-disordered population.

A Brief Literature Review

The majority of literature on the subject of pregnancy and psychotherapy is written from a psychodynamic perspective. Given that this approach places the therapist–client relationship at the heart of the therapeutic work, it is no surprise that clients' reactions to the unavoidable disclosure of pregnancy would be most closely examined in a dynamic psychotherapy. The therapist's pregnancy brings her sexuality and intimate personal relationships into the room.

In keeping with an analytic frame, clients' responses to the therapist's pregnancy have been described as intense transference reactions reflecting the particular intrapsychic conflicts, developmental issues, or object relations intrinsic to the existing therapeutic work (Fenster, Phillips and Rapoport, 1986). For example, depending on the client's particular history, issues of identity, sibling rivalry, or sexuality might become prominent. For most clients, fear of abandonment, rage, and grief become themes, in conjunction with those defences most comfortable for the particular individual. Clients may experience a flight into health, may begin to isolate, become silent and resistant, or may miss appointments and take unplanned 'leaves' from therapy (Breen, 1977; Fenster et al., 1986; Nadelson et al., 1974; Paluszny and Poznanski, 1971).

Consistent with a traditional analytic stance, dynamically oriented therapists are encouraged to utilize the client's reactions to the pregnancy as a lens though which interpretation and exploration can be focused. While there is acknowledgement that the 'real' relationship becomes a more integral aspect of psychotherapy at these times, and that more actively confrontational interventions might be required, the analytic contract of exploration and

interpretation must be honoured. Within this therapeutic frame, acting out and regressive behaviours are expected and anticipated, but responded to with close and careful analytic interpretation.

An Integrative Model

The following discussion approaches the intrusion of the therapist's pregnancy into psychotherapy from a different perspective. This approach to psychotherapy utilizes an integrative model, incorporating concepts from object relations, ego psychology, and self-psychology, with cognitive–behavioural strategies and techniques. In this frame, the client is conceptualized as having significant deficits in several areas including affect management, capacities to use self-objects for self-soothing and self-cohesion, appropriate recognition and use of signal anxiety, self-care, and judgment. The therapist uses strategies and techniques to respond to the client's internal and external need for structure and support, and by so doing provides an accurately attuned relationship that can be internalized. As in a more dynamic psychotherapy, it is the therapist–client relationship that promotes the growth of self-structure and capacities, although the relationship is not the focus of treatment. The literature in this area has focused largely on eating disordered and addicted populations, although it may also be applicable to working with clients who have significant character pathology and/or histories of childhood trauma (Brisman and Siegel, 1984; Goodsitt, 1985; Khantzian, 1981).

While self-disordered clients are difficult to treat, they are also a growing percentage of any practitioner's caseload. This discussion will not in any way attempt to cover all aspects of psychotherapy with this population; instead, it will focus on a particular kind of therapeutic dilemma, and how the therapist's pregnancy poses particular kinds of risks. I will utilize case examples and discussion to describe how pregnancy can be handled within this therapeutic frame.

The Therapist's Use of Self

A central dilemma self-disordered clients pose for any psychotherapist is how to handle the enormous sense of need and dependency they bring to the therapeutic relationship. While the client may present in a range of ways, including the appearance of automony and independence, and a fierce reaction to any attempt on the therapist's part to direct or control the client's flagrantly self-destructive behaviour, there is almost always an implicit or explicit request (or demand) to be taken care of, healed, 're-parented', or

saved. Unfortunately, as many experienced and inexperienced therapists discover, attempts to gratify these wishes by encouraging the illusion that the therapist has the power to rescue these clients from their tremendous sense of isolation and pain often evokes increased regression, panic, demands for unrealistic attention and heroics on the part of the therapist. The therapist often feels presented with two unsavory options: to make working with the client the therapist's central life activity with ever diminishing rewards, or to abandon the client as an 'untreatable borderline'. In the words of one client, 'my therapist encouraged me to depend on her, and than when I did, when I felt most frightened and alone, she couldn't really handle it. She abandoned me, just like every one else.'

An integrative approach attempts to respond to the very real self-deficits of these clients appropriately, but also non-regressively. Drawing upon self and ego psychology as well as object relations theory as a conceptual base, the actual therapeutic approach utilizes active intervention strategies including cognitive–behavioural techniques, as well as, at times, expressive therapy modalities. In this approach the explicit therapeutic contract might be stated as: 'While I cannot save you from the terrible loneliness and pain you live with, I can help you find ways to utilize and enhance your own very significant strengths in responding to these vulnerabilities'. It is a therapeutic contract that explicitly identifies the client, rather than the therapeutic relationship, as the focus of treatment. Structure and active intervention strategies are utilized to help contain clients' intense affects, shore up defences, and manage self-deficits. As stated previously, however, while the therapeutic relationship is not the focus of treatment, it is an essential curative force. In fact, it is by avoiding explicit attention to the importance of the relationship that it becomes a safe enough 'container' for the client's growth.

Enhancing the Client's Resilience

Once a therapeutic contract is established that keeps the client, not the therapy relationship, as central, the initial task is to re-frame problems as solutions. The psychotherapist helps the client understand how her attempts at surviving her internal and external experiences have been her best efforts, her 'solutions', worthy of respect. For example, for someone whose early parenting left them unable to self-soothe, or regulate intense affective swings, bingeing and purging or utilizing a substance like alcohol or marijuana helps her 'numb out' or provides emotional relief. Unfortunately, it is an attempt at self-care that requires ever increased 'doses' to experience the same effect, and cannot be integrated into more flexible and development enhancing capacities. The work becomes helping the client both interrupt these now

self-diminishing behaviours, while identifying new, more durable self-regulating activities that can be integrated into self-capacities. In identifying new strategies, however, the client's original resilience and adaptive strengths continue to be supported and enhanced.

The Therapeutic Relationship

While the client's strengths, vulnerabilities, self-capacities, and deficits are the focus of treatment, clearly a solid and allied therapeutic relationship is the only context in which to do this work. In fact, while examining the client's transference reactions to the therapist is not focal, I would argue that this approach enables the client to internalize the therapist as a less conflicted and soothing relationship in the service of her development of a more cohesive and mature self. While the therapeutic relationship is not at the centre of this approach, it is certainly a central resource for the client's growth.

Part of the dilemma for therapists treating these clients is how to maintain a therapeutic presence that does not rapidly become either regressive or abandoning. For clients who enter therapy with a more developed sense of self, therapeutic regression is often a means towards an end, a way in which clients are enabled to re-integrate more adaptively. For clients with significant self-deficits, however, regression often leads to an ever increasing spiral of panic, desperation and need, overwhelming their significant relationships, including those with their therapists. As a result, these clients often choose to live in isolation, walling off that part of them that is starved for authentic human contact.

Thus, the goal of this therapeutic approach is to utilize structure, strategies and an emphasis on the client's own resilience and strengths to provide a safe enough container for the therapeutic relationship to survive. While the relationship is not the focus, as in most psychotherapy, it is the client's ability to utilize and integrate the therapeutic relationship that is most curative, enabling her to develop a more adaptive and flexible sense of self.

The Therapist's Pregnancy

The therapist's pregnancy presents particular challenges to this style of psychotherapy. Despite the explicit agreement to steer clear of transference work, clients with significant self-deficits tend to have intense reactions to their therapist's pregnancy, and contending with these reactions becomes an unavoidable aspect of the therapeutic process. The particular challenge to this kind of therapy is how to continue to honour the original contract to

make the client the focus of treatment, while sufficiently tending to the transference (and counter-transference) issues that the therapist's pregnancy evokes. If the therapist fails to do this, she will be confronted with a major therapeutic impasse. Clients will press for early terminations, experience increased regression and acting out behaviours, without their therapist's help to explore or contain these strong feelings and impulses and maintain a therapeutic progression.

In a purely cognitive–behavioural therapy, skill building is the primary emphasis and the therapeutic relationship is not viewed as the agent of change. In a cognitive–behavioural frame, a maternity leave presents the client with an opportunity to review and solidify their progress through a planned vacation from therapy (Statlender, Weisburg and Rosenberg, 1988). In accordance with a cognitive–behavioural approach, transference reactions would not be dealt with in any direct way. In contrast, for therapists utilizing the integrative model I have described with a fairly vulnerable population, the therapy relationship continues to be a central curative force, although not the explicit focus of treatment. The client's reactions to the therapist's pregnancy and upcoming leave make only too clear the centrality of the relationship as a safe container for growth and development.

Preparing Clients for a Maternity Leave: Therapeutic Tasks

There are three tasks facing the therapist at this time. First, the therapist and client together must identify and explore the feelings raised by the therapist's pregnancy and upcoming leave. Second, the therapist will need to enlist the client's resourcefulness in identifying strategies to help them handle the intense feelings raised by this event. Third, the therapist must manage her own countertransference reactions evoked by her clients' increased demands and often sadistic impulses. These are the same three tasks that form the groundwork for integrative therapy at any time, and thus also provide and reflect a continuous and consistent therapeutic frame. In the following section, however, I will discuss in more detail, the specific ways therapists and clients may work through these tasks during a time of increased vulnerability for both of them.

VERBALIZATION

Eating-disordered, substance-abusing, and traumatized clients with self-defi-cits tend to rely on actions rather then words to express themselves when they feel most vulnerable. Exploration and interpretation is the central task for most generic psychotherapists, but with this population it is extremely important that the therapist emphasize enhancing the client's own ability to

identify and verbalize feelings, rather than step in too quickly with interpretation. These clients tend to have histories in which primary caregivers utilized them as narcissistic objects, projecting feelings on the client and over controlling their behaviours. In the words of one client, 'From as far back as I can remember, my mother was always telling me what I was feeling and what I needed to do. I never had a chance to sort any of it out for myself.' Thus, a therapist's accurately attuned reflection in the service of helping these clients verbalize their intense internal affective states is extremely important, but with some care not to over interpret and claim authority over the client's internal experience.

While working to verbalize rather than act-out feelings is an essential task, unlike a more integrated population, verbal exploration and interpretation will probably not be enough to sufficiently reassure and contain their intense responses. The second task of collaborating with clients to create affect containing structures and capacity enhancing strategies is most often required in order to weather the intense disruption in the therapeutic process and relationship a maternity leave poses.

ACTIVE INTERVENTIONS: STRATEGIES AND TECHNIQUES

The second task facing the therapist is to enlist the client's resourcefulness. In the face of the intense feelings raised by the therapist's pregnancy, the client may need help to develop or enhance her capacity to contain or manage daunting affective states. The threat of abandonment and the ensuing terror and rage is most often a central theme for these clients. Their therapist's pregnancy poses an enormous narcissistic wound. Not only will there be an untimely break in the therapeutic process, but the therapist's pregnancy is undeniable evidence that there are other relationships in her life that are more important then her relationship with the client. In the face of this event, the client is at great risk of retreating into a difficult non-productive regression. Thus, the pregnant therapist's challenge is to walk the line between attuned interpretation, exploration and reflection, and active interventions to help her clients structure and contain this frightening process.

The kinds of strategies that might be useful at a time like this fall into separate categories. One set of interventions might be thought of as affect containing techniques. As the client struggles to cope with her rage, anxiety and at times panic, the therapist might collaborate with her to identify ways to safely handle these feelings, permitting them to exist without allowing them to overwhelm the client or the relationship. In the words of one client, a strategy that provides a safe and contained 'time-out' from interpersonal interaction when overwhelmed by rage.

A clinical example of this utilized an expressive therapy technique. The client, who I will call Mary, had become frightened at the intensity of her rage at me, and felt unable to either render it less toxic or move to some resolution. Mary and I decided to utilize a portion of periodic sessions as a time for her to work on her own with art supplies to express her feelings. This was framed as a kind of 'time-out' from relating her rage. Mary had taken care of young children and recalled the usefulness of providing enraged toddlers with a 'time-out' experience, giving them a chance to settle down and master their own feelings outside of interacting with playmates or herself. She remembered that when she attempted to relate to her young charges at these times, she often found herself locked in a battle of wills, and felt both herself and the child becoming increasingly out of control. We decided that while I would remain in the room, Mary could choose whether or not to relate to her art work with me, or just utilize the time expressively and than to move on to other matters. To reinforce the experience of safe 'containment', Mary then added to this exercise the use of an actual container to fold up and place these drawings in, closing the box with a solid, impenetrable lid. This activity was not done instead of talking about the feelings, but provided an alternate mode of expression in which she could focus on managing her own feelings outside of relating to me, but still in my presence. By so doing, Mary permitted herself to have these feelings in the context of a relationship, without experiencing them as annihilating. Mary's family history with anger was that it had been permitted to become extremely dangerous and out of control, with no safe presence of an effective limit-setting adult. Managing this particular feeling safely was entirely new territory for her.

Another set of techniques could be described as connection-maintaining strategies. The threat of abandonment is often so intense for these clients that exploration, interpretation, and verbal reassurance may not be enough to help them sustain a sense of connectedness to the therapist during her leave. In anticipation of the break, these clients often begin to withdraw prematurely in an attempt at self-protection. While this can be interpreted as an adaptive strategy on their part, it is also helpful to work with them to expand their repertoire of responses to threatened abandonment. For example, clients may choose to write letters to the therapist during her leave, keep a journal to share all or parts of with the therapist, or use transitional objects that the therapist and client together have identified over time as representing their relationship. One client, who I will call Sarah, had brought in a series of symbolic objects such as a sprig of Thyme (time) from her garden, stones in the form of a bridge, and a small emblem depicting the saint of navigation.

Sarah created a parallel set of these objects in her own home, and carried with her a vial containing this thyme to help her remember that she was not alone in the universe when she felt most desperate. All of these objects could be called upon as resources for Sarah during my leave.

A third set of techniques are designed to support the client's sense of mastery. A therapist's maternity leave is a time when clients feel especially out of control and helpless in the face of an event they experience as happening to them. This is especially evocative for clients with trauma histories who often experience the world as a place in which they have little efficacy. Thus, therapists may explore with their clients how they might utilize the maternity leave to learn a new skill, or take on a project that they need other resources outside of their psychotherapy to pursue. For example, one client decided to work with another clinician during my maternity leave to learn relaxation and stress management techniques. Another client decided to utilize the money she would have spent on therapy to take a set of intensive yoga classes as well as participate in an expressive therapy group. These are just some examples of a range of ways clients can be encouraged to take some measure of control at this time.

The fourth area in which the therapist will need to intervene actively is to provide secure enough safety nets during her leave. This would be true in any psychotherapy, but unlike work with resilient individuals, these clients may need more intensive coverage during their therapist's maternity leave, including participation in day or evening programmes, time limited support groups, or being seen by another therapist, rather than the more common practice of providing them with someone available in case of emergency. Even if the client decides not to utilize these options, knowing that their therapist intends to leave them in competent hands conveys her understanding of the level of vulnerability they are experiencing.

TECHNIQUES, THERAPEUTIC PRESENCE, AND COUNTERTRANSFERENCE

During a therapist's pregnancy, an integrative model utilizes strategies and active intervention techniques to foster and enhance an accurately attuned therapeutic relationship. Unlike a skill building approach, strategies are in place in order to help the therapist and client maintain and enhance their relationship, thus facilitating internalization and development of more mature self-capacities. When done well, these techniques provide the therapeutic process with increased structure and safety, enabling client and therapist to tolerate very difficult affects at a particularly vulnerable time for both of them. This approach, however, is not without risks. As in any treatment model, when the therapist's unexamined countertransference begins to guide

the work, therapy can easily be derailed. During a therapist's pregnancy she will be especially susceptible to utilizing strategies defensively, attempting to protect herself and her baby from her client's rage and sadism.

This was clearly illustrated with the client Mary. While using a time-out and containment technique to manage her rage was initially and ultimately helpful to her, part way through the process she was able to voice her accurate sense that I was intrusively presenting this strategy to defend myself from her strong feelings. This was a re-enactment of Mary's relationship with her mother, who also could not tolerate the intensity of her feelings and would emotionally and physically abandon her in the midst of frightening experiences. While this became a useful piece of work that was ultimately reparative, my receptivity to examining my countertransference was essential. Clearly, strategies and techniques are only useful when they enhance therapeutic presence, and can easily become barriers to authentic connection.

Summary

An integrative model utilizes concepts drawn from self-psychology, ego psychology, and object-relations, and incorporates them with active intervention strategies. The goal of this form of therapy is to provide a therapeutic experience that supports the development and internalization of self-capacities through a therapeutic relationship. This form of therapy is especially relevant for a population with significant self-deficits, such as individuals with eating disorders, substance abuse, trauma, or character pathology.

A therapist's pregnancy poses a particular threat to a non-regressive approach, as it evokes intense transference reactions in clients, as well as countertransference in the therapist. If therapists are able to stay consistent within the therapy frame contract, however, they and their client can navigate through this difficult period. If therapists are receptive to examining their countertransference, they can remain in authentic contact with their clients, while protecting the therapeutic process from derailment.

References

Breen, D. (1977) 'Some of the differences between group and individual therapy in connection with the therapist's pregnancy.' *Journal of Group Psychotherapy 27*, 499–506.

Brisman, J. and Siegel, M. (1984) 'Bulimia and alcoholism: two sides of the same coin?' *Journal of Substance Abuse Treatment 1*, 113–118.

Fenster, S., Phillips, S. and Rapoport, E. (1986) *The Therapist's Pregnancy: Intrusion in the Analytic Space.* New Jersey: The Analytic Press.

Goodsitt, A. (1985) 'Self psychology and the treatment of anorexia nervosa.' In D. Garner and P. Garfinkel (eds) *Handbook of Psychotherapy for Anorexia Nervosa and Bulimia.* New York: The Guilford Press.

Khantzian, E. (1981) 'Some treatment implications of the ego and self disturbances in alcoholism.' In M. Bean and N. Zinberg (eds) *Dynamic Approaches to the Understanding and Treatment of Alcoholism.* New York: The Free Press.

Nadelson, C., Notman, M., Arons, E. and Feldman, J. (1974) 'The pregnant therapist.' *American Journal of Psychiatry 131,* 1107–1111.

Paluszny, M. and Poznanski, E. (1971) 'Reactions of patients during the pregnancy of the psychotherapist.' *Child Psychiatry and Human Development 4,* 266–274.

Statlender, S., Weisburg, L. and Rosenberg, R. (1988) 'The pregnant therapist: Practical and theoretical issues.' Paper presented at a meeting of the American Psychological Association. Atlanta, Georgia.

Therapeutic Presence in Holistic Psychotherapy

Michael Robbins

Preface

As the son of one of the founders of the expressive therapy movement, I learned a tremendous amount about therapy around the dinner table and during long walks in the country. It is a rare privilege to have my father also as one of my most significant professional mentors. He has always had a playful, rabbinical way of engaging his children in intellectual combat. While we wrestled with him, our ideas and identities were forged in a particular kind of family crucible that had elements of mental discipline, intuitive wisdom and creative fierceness. I always knew that I could bring my creative or intellectual endeavors to the fire of his mind for an opinion. My relationship with him has given me the opportunity to learn the art of psychotherapy within a circle of love which has left indelible imprints on my theoretical understanding as well as my personal style and aesthetic approach to therapy. As I grew older, to my surprise and delight, our process would often be reversed when he would ask for my input on his artistic projects, some aspect of transpersonal or body oriented psychotherapy or simply use me as a sounding board for his latest brainstorm. As I approach the age of 40, with a family of my own and a successful career, there is something poignant about writing a chapter for a book which he is editing. The circle completes itself, the dialogue continues, our relationship is different and yet it is the same.

Introduction[1]

As the field of psychotherapy moves into the twenty-first century, there is a greater awareness that all the dimensions of our lives are inextricably inter-related. It is becoming increasingly impossible to treat someone psychologically without also taking into account their physical and spiritual well being. Like the eastern proverb of the blind men each describing different parts of an elephant and believing they were touching different creatures, we are coming to the common sense realization that as practitioners specializing in one area of healing or another, we all have our hands on the same animal. All the systems of a human being exist as a functional unity. Furthermore, developing scientific paradigms indicate that change at any level has reverberations that echo from the molecular to the cosmic levels in a great chain of being. Perhaps if our sensitivities were developed highly enough we would realize that it is life itself that we touch every time we make an intervention as a healer.

Throughout human history, creative people have been the transformational, healing agents of society. One can infer from this that the therapist who has an intimate knowledge of the creative process is uniquely qualified to guide clients in a process of authentic regeneration. When this regeneration is complete, the therapeutic artist has touched his client on many levels and often worked in several different modalities. If an expressive therapist can facilitate a person in reconnecting with his or her creativity and consult to the process of formulating lively and strong containers for vitality and self-expressiveness in body, mind, and spirit simultaneously, the process of healing may progress with a synergistic complexity and integrity.

An Integrative, Eclectic Approach

Every therapeutic encounter is a work of art. All clients and therapists are works in progress. In the artistic process there are no rigid dogmatic rules which one can apply unilaterally. Similarly, in therapy, the seasoned therapeutic artist lets go of preconceptions and attends to the healing muse. In this way he develops a disciplined attunement to the rhythms and timing of the therapeutic process. The voice of this healing muse can be grounded in certain therapeutic principles and felt in the different listening perspectives which are appropriate to the specific developmental issues which the client

1. A note about pronouns: throughout this article, in most cases, I have used the masculine pronoun for simplicity and style. It is to be understood that this usage is inclusive of the feminine.

is working through (Hedges, 1991). Each practitioner hears this voice through the filter of his own emotional development and responds relative to the psychological defences he has been able to modify and master.

In learning the art of therapy, practitioners must constantly be sensitive to a multitude of contexts. An intervention which succeeds marvelously in one session will fall flat in the next. Like a well trained dancer or Tai Chi practitioner, the stance of an expressive therapist strikes a balance between structure and spontaneity, theory and the lively encounter of the moment. He must learn to keep his boundaries open and permeable between the apprehensive and intuitive world of feelings and empathic presence and the comprehensive, analytic world of theoretical perspectives which informs and contains his instinctual sense of things.

Each practitioner has certain limitations which they bring to the therapeutic encounter. These are the 'facts' of the therapist's life, and include such obvious things as gender, age, socio-economic, ethnic and religious background. Less obvious but equally important are the therapist's beliefs, spiritual practice or lack of one, sense of morality and values, and the way they organize and make meaning of experience. All of these 'facts' have a vital impact on how the work proceeds. Every therapist is also a field of possibilities, a mysterious and spontaneous movement into the unknown. In this way, the therapist and client share in the existential tension of the lives into which they have been thrown and the formless emptiness from which all acts of creativity and renewal emerge. This is the ground zero of the therapeutic encounter. When healing occurs, both participants have learned to balance the known and the unknown and engaged in a process which has skilfully provided the client access to the forces which transpire behind that which appears.

As the therapeutic container is able to bear the anxiety which we all face when confronted with the unfamiliar, it is also building an even deeper capacity to hold the awesome power of the life force. This life force by its very nature is an indefinable, fathomless field of limitless vitality and possibilities. The confrontation with the life force must inevitably be titrated over time. In this process the therapeutic dyad or group ventures out into the particular field of possibilities which are available to it at any given moment and begins to notice differences between the repetitive loops of what it already knows how to do and the edge of the unknown, where there is the possibility to learn something new. In short, a productive therapeutic process helps clients to develop a more complex, rich and differentiated experience of self, other and the environment through a series of developmental steps.

In productive therapy there has been a successful negotiation between the subjective worlds of the client and therapist and the creative essence of all things. A well crafted healing environment invites these three forces into a dance. The art of the therapist is to be able to skilfully manoeuver inside of this container and to develop a bone-deep knowledge of when to push, when to step back, the timing of confrontation and support, and the ability to hold faith in the creative source from which healing springs.

The Principles

Like all healing arts, a therapy which takes into account the body, mind and spirit of a client is guided by certain principles. These principles are applied in the context of the particular developmental issue which the client is working through.

Presence

The first is the quality of presence. The particular, functional definition of the quality of presence which I use is the ability to contain and have access to many conflicting polarities and aspects of the self simultaneously. It is this depth of self-knowledge which allows the therapist to resonate energetically with the client's experience and provides a field of compassionate acceptance for the material which the client delivers into the therapeutic arena. The therapist who knows and has explored in his or her own therapy the experiences of sadism, masochism, dependency, lust, love, ecstasy, and terror at the edge of the unknown (to name a few) and can energetically communicate this non-verbal knowledge is well equipped to work with clients who are struggling with these issues. Presence gives us the ability to touch someone in the deepest core of where they live and ultimately may be the most effective agent to help someone overcome their stubborn resistance to change.

For many clients, it is the therapist's capacity to be deeply present with them that makes the most fundamental and lasting impact on their lives. Indeed, one of the most important outcomes of a successful healing process may be that the client develops an ability to be present and centred within him or herself in a wider range of the human experience than before they entered treatment. In other languages, one might call this the ability to contain without repression or acting-out, or making the unconscious conscious. In modeling for our clients the discipline of contactful, compassionate presence to all aspects of the human experience, we are teaching them one of the most subtle and sure paths to wisdom.

Process

The second principle is process. Process means that the therapist places a fundamental value on exploring the moment to moment unfolding of the client's experience, avoiding premature closure, explanations or interpretations. It is through the principle of process that we create a window into the spontaneous possibilities of our authentic selves.

Many writers have observed how good therapeutic process has a meditative quality. In meditation one feels into the currents of one's inner life with a progressively heightened sense of awareness. In therapy, both the inter- and intra-psychic realm become the object of contemplation. In this way the participants re-potentiate themselves and the inter-personal space with the magnetism of the authentic self. If this alchemy is successful, the client emerges with a fundamentally transformed centre of psychological, spiritual and physical gravity in relationship with themselves and others.

Authenticity

The third principle is authenticity. Different than the innate, spontaneous genuineness of the child, authenticity is both an art and a developmental achievement. The genuineness of a child springs from a pure innocent well and emerges relatively untarnished into the relational field. In the simplicity of a child's genuineness there is little or no distinction between the feeling, the impulse and the action. All of this erupts seamlessly in the hungry cry, the frustrated tantrum, the affectionate reaching, or the satisfied bliss of being held. In counterpoint to this, the authenticity of an adult is a complex relational process between being and becoming, which requires that we contain our impulses and actions while we explore our feelings. As we contain and reflect on our feelings we gather enough internal data and self-knowledge to be capable of making conscious, authentic choices. In other words, we become self aware, aware of the people in our environment and our effect on them and responsible, that is, able to respond.

In modern society, most of us suffer from some form of alienation. We might understand this as different ways in which our attention has become imbalanced. If our attention is located too far out, we chronically lose ourselves in the demands of the other. If our attention is too far in, we maintain our connection with ourselves at the high price of feelings of isolation and loneliness. Authenticity requires us to be fully awake, perched on the crest of experience, engaged in the complex dance between the inner and outer world, responsible for our choices. Like a surfer, we ride the currents, balancing our attention between the ocean swells, the distribution

of our weight on the board, and our enjoyment, anxiety and curiosity about the ride. The wish to learn and practice the art of authenticity may be one of the underlying draws beyond immediate symptom relief that pulls clients into a therapeutic process.

Indeed, one might easily reframe all the diagnostic categories as different forms of existential alienation from ourselves, each other, society or our natural environment.

The Self as Process

The principle of authenticity leads us to the understanding that the self is a process, an evolving field of structure and possibility which is held together by intention. At the level of the personality, the self is not something we can ever quantify or capture like some eternal crystal. A deeply felt realization of the transience of the self can lead us into a profound experience of resolving back into the ground of creative being and possibility. This experience culminates in a realization of the emptiness or insubstantiality of the self. In spiritual practice this is often referred to as the experience of 'no self' or selflessness. It is important to note that this emptiness is the opposite of the schizoid experience of nothingness. It is shot through with the awesome magnetism of the life force. Buddhist psychology, mysticism and shamanism have a great deal to teach us about these deep strata of experience (Epstein, 1995).

When we attune ourselves to the creative ground of being, there are certain rhythms and inner currents which we feel drawn to and which we associate with a feeling of health and psychological wellness. If we listen to our intuition we can also discern when we are in a situation which is not truly optimal for our growth and happiness. One of the most important questions we might meditate on with our clients is the discrimination between those desires or aversions which are based on our conditioning and reactivity, and those impulses which come from an authentic connection with our inner guidance. If we are successful in living in harmony with the voice of our inner guidance and with the rhythms of this deep ground of being, we gain a progressively greater sense of mastery, centredness, and an ability to hold both satisfaction and frustration in a creative momentum which keeps us in touch with the leading edge of our growth.

The Reactive Mind

The fifth principle is what I call the principle of the reactive mind. This is the idea that there are forces within us which keep us on the surface of things,

out of touch with the movement of the life force and with our authenticity. Some of the ways the reactive mind has been thought of are character defences, body armor, the repetition–compulsion, behavioural conditioning, addictions of all sorts and the forces of attachment and aversion. It is useful to note here that it is the unconsciousness of the reactive mind which is most pernicious. To be sure, there are some ways in which we act out our reactivity that are so destructive that they absolutely must be stopped immediately if the therapeutic enterprise is to have even the remotest chance of success. Other defences are more subtle and can only be made conscious and modified over a long period of therapeutic work.

In confronting the reactive mind, we must always work in a developmental context and be sensitive to the function which it is serving in someone's life. Sometimes a defensive structure is maintaining a vital sense of order, coherence, or perhaps even helping someone to survive in a particularly destructive environment. These defences need to be left alone until the client has enough centredness to change and to confront his or her anxiety at sitting at the edge of the unknown. An observation that I have made in watching the work of a variety of master therapists is that the deeper the practitioner is able to ally with the authentic centre of the client through his or her quality of presence, the more leverage is available to unseat the reactive mind. The timing and knowledge of when to confront and when to support and the deep and efficient understanding of someone's structure and possibilities is an art which ripens over time.

The Functional Unity of Body, Mind and Spirit

The sixth principle is the 'functional unity' of our physical, emotional, mental, and spiritual life. This term was originally coined by Wilhelm Reich and is the concept that underlies body-oriented psychotherapy (Baker, 1980). Reich noticed that every character defence had a physical correlate in disturbances of breath, muscular tension or organ dysfunction. In a sense, he was re-discovering the holistic philosophy of such time honoured and effective healing arts as acupuncture, ayurveda, yoga and homeopathy. In the past two decades there has been a literal explosion of interest, research and practice of these modalities. The deeper a therapist can understand the current thinking in regards to our mind–body connection, the more capable he will be of providing a broad and integrated container for this level of work. Providing such a container will often mean working with a network of like-minded professionals. This network can become an exciting cooperative effort in which all participants deepen their understanding of the complex processes which cause human suffering.

Developmental Order

The seventh principle is the observation that there is a developmental order to the ways in which we meet life's challenges. Much psychological research, phenomenological observation, and speculative thought has gone into our understanding of the different ways human beings develop or get waylaid on the path towards being a mature adult. We might conceptualize the goal of development as the ability to access both an intuitive, apprehensive, knowledge of ourselves and our environment and the cognitive ability to comprehend theoretically and analytically and to create a constantly evolving, responsive map of our experience (Agazarian, 1993). The western psychological schools of drive theory, ego-psychology, self-psychology and object-relations have each attended to particular phases of development and provided their own unique perspective from which to listen to our clients (Pine, 1990) Transpersonal theorists such as Ken Wilber (1977) and Michael Washburn (1988) have extended these theories to include our spiritual and contemplative development. It would be a gross and damaging simplification to be wedded to any one particular school or perspective in our understanding of human development. Each client will call for a different theoretical mix to provide the appropriate container for his work. There is a great deal of conscious discernment, intuition and supervision that must go into creating this mix. Different therapists will also develop styles which are more or less appropriate for particular stages of development. Some people are more attuned to issues of longing and sadness, others excel at being able to dance with the volatile currents of hostility and conflict, while yet other therapists are uniquely suited and trained in working with the transpersonal dimension. Indeed, people who are committed to working their growing edge will probably need to work with different therapists at different stages of their life cycle or internal development. A depth of self-knowledge coupled with a theoretical breadth and sophistication can help a therapist to develop a sound, centred eclecticism and to know his talents and limitations.

Practising the Principles

There are four major approaches which have informed my practice of these principles. These are body-oriented psychotherapy, spiritual psychology, Systems Centered Therapy® and the psychoaesthetic approach to depth oriented treatment. Briefly, I would like to touch on the basic tenets of each of these orientations.

Body Oriented Psychotherapy

I began my working career as a massage therapist and healer. The training I received included polarity therapy, postural integration massage, breathwork, energy field work, neuromuscular massage and cranio-sacral therapy. Currently, I rarely work strictly as a massage therapist; however, the lens of body work continues to inform my therapeutic perspective and has immeasurably deepened my sensitivity to the non-verbal communications of my clients.

In working as a massage therapist, I had the visceral experience of my clients enfolded in many layers of magnetism, each of which contained information and emotional experience. I learned that it was virtually impossible to release the deeper tensions in the body without also addressing the person's emotional life and belief systems. This awareness, as well as my fascination with the complexity of the healing process, led me to enter a graduate programme in counselling psychology and to study and experience explicitly body-oriented psychotherapies such as bioenergetics and core energetics. As my own training in counselling deepened, I gravitated towards other therapists who also had a background in body-work and naturally developed my own synthesis. Particularly early on in my career clients would often come to me for body-work and then renegotiate their contract to include psychotherapy.

The major goals of body-oriented psychotherapy as I've experienced it are:

(1) To help clients become experientially aware of the functional unity of the body/mind/spirit continuum and to become attuned to the deep intelligence that runs through all the levels of our being.

(2) To unwind the organism and to create an environment in which a healthy pulsation of energetic flow through all the systems can be maintained. This process involves freeing up emotional and physical energy that has been bound or repressed in tense, numb, under or over charged areas of the organism.

(3) To deepen breathing and thereby to expand each person's capacity to experience and contain pleasure and other intense feeling states.

(4) To bring awareness to the different characterological attitudes which have become structured into the organism and which limit our fluid, unitary and fully alive response to our environment.

(5) To increase awareness of non-verbal communication and to foster a sense of congruence through all the levels of our communication.

(6) To ground and centre ourselves physically and emotionally.

Spiritual Psychology

Since my late teens, I have been committed to spiritual practice and involved with spiritual communities. For years I also taught Tai Chi Chuan and Taoist meditation. These life experiences and ways of being in the world permeate my energetic atmosphere and probably have a profound impact on my clients whether or not the issue of spirituality ever enters the therapeutic relationship.

Over the past 20 years, the interface between spirituality and psychology has generated an enormous amount of literature, practical innovation and philosophical debate. I would like to touch on three basic ideas which seem central to spiritual psychology. These are the distinctions between the Self, the psyche and the personality. This discussion will also further elucidate the principal of the self as a process.

Dr Tom Yeomans in his excellent pamphlet *Spiritual Psychology: An Introduction* (1992) describes the Self (capital S) in the following way:

> The Self is seen as the organizing principle of a lifetime, providing a context or container for the vicissitudes of experience and the development of the human being. It is that principle within a human experience that 'knows' the direction a particular life can take toward fulfillment and maturity, and which can guide this life according to this knowing. It is thus in a dynamic relationship with the other dimensions of a person's experience.
>
> The Self has no particular qualities, or attributes, but rather is the context for all of our attributes and characteristics. It holds and integrates the different dimensions of our experience, and can be seen as the capacity to hold simultaneously any polarity or contradiction in our experience. When touched directly, it is experienced as a pure beingness that is connected as well to all other beings and to an experience of larger life, Great Spirit or God. (Yeomans, 1992, p.10)

The Self is thus synonymous with the creative ground of our being. The energies of the Self touch our lives as we practise the arts of presence and authenticity. The Self is the space between all things, the magnetic tension that holds the fabric of life together and yet has no substance of its own. It is awareness itself, that something that exists before and after there was an object, the field of all possibilities, the eternal present, the nameless, the Tao. As such we are deeply and inescapably embedded in the Self. Although the Self touches and permeates every aspect of our lives, we can conduct ourselves in such a way that we become out of harmony with this creative source. The root of this disharmony is always some form of fear or

disconnection from the fabric of love. When this happens we experience a sense of soul starvation which expresses itself in a variety of symptoms and pathologies and in the violence which we do to ourselves and the planet.

The psyche is envisioned as structural and includes the conscious, the unconscious, the pre-conscious and the super-conscious. These dimensions are in a constant interplay with each other, transforming, digesting and processing psychic energy. The psyche is that which mediates the energies of the Self with the identifications of our personality in time and space. At the level of the psyche we are in touch with the collective archetypes of humanity as well as the specific patterns of our cultural group, language or family. These patterns rest in any of the various levels of the psyche and are potential containers through which the energies of the Self may be expressed. Rituals and initiations which activate these patterns and invite the energies of the Self to become embodied are powerful ways to move energy and to revitalize an individual or a group.

Yeomans conceptualizes the personality 'as a system of identifications that has developed in time/space to insure the survival and growth of the person' (Yeomans, 1992, p.14). As such it is the level at which we are most subject to the impressions of our environment, particularly our early familial environment. This system of identifications may be a more or less functional container for the creative energies of the psyche and the Self, and shifts and moves as we develop. It has both a superficial and a deep structure, as it is rooted in both the specific facts of our family of origin and in the collective energies of humanity. In the context of spiritual psychology the work we do on our personality is a process whereby we create a vehicle which can hold a deeper, higher and broader range of our potential energy which ultimately has its source in the Self.

These levels are somewhat arbitrary and have been addressed in different ways and called different things by other schools of psychological and spiritual thought. However, the experiences they point to are fairly universal and may be useful categories for a clinician when faced with the nitty gritty of human suffering.

Systems Centered Therapy® [2]

Systems Centered Therapy® is a relatively new approach which Dr Yvonne Agazarian has crystallized into a specific methodology over the past five years. Dr Agazarian was classically trained in group dynamics as well as a

2. SCT®, Systems-Centered®, Systems-Centered Training®, and Sysems Centered Therapy® are registered trade marks of Dr. Yvonne M. Agayarian.

variety of western psychoanalytic and psychotherapeutic methods. Systems Centered Therapy® grew primarily out of her enormous experience with groups. The dynamics and principles which she uncovered, however, are totally applicable to working with individuals. As a master therapist, Dr Agazarian has spent her life looking for ways to create the optimal environment to potentiate the healing process. Systems Centered Therapy® is the result of her life's work.

As my training in Systems Centered Therapy® has gained in sophistication and clarity, I have been using it as a 'metalens' to help me understand the interventions which I make on every level and in any modality. The following will describe the basic building blocks from which all the methods of Systems Centered Therapy® are built. The four basic constructs which define systems centered theory and practice are isomorphy, hierarchy, structure, and function (Agazarian, 1994).

Isomorphy is the idea that systems have a similar shape at any level, however they function relative to their context. An example of this is the way the internal system of identifications which an individual has at the level of his or her personality will reflect the psyche of his or her group or family. Similarly, the chronic tensions and characteristic postures of an individual will be isomorphic to their psychological make-up. A scientific example of this is that each cell contains within it the DNA patterns for the entire organism. Isomorphy is similar to the principle of a hologram in which the entirety of the larger picture is contained in each aspect.

Hierarchy is the idea that 'every system exists in the environment of the system above it and is the environment for the system below it' (Agazarian, 1994). Thus we can notice that the Self is the environment for the psyche, which is the environment for the personality, which is the environment for the body, etc. If we apply the ideas of isomorphy and hierarchy to therapy, we can observe that, if our interventions are isomorphic and congruent at a greater range of the hierarchy of living human systems, they will have a greater effect.

Structure is the idea that 'every system is defined by its boundaries in space, time reality and role' (Agazarian, 1994, handout). This refers to the observation that living human systems, like all things, arise and disappear according to certain boundaries. Therapy sessions last for a certain pre-agreed period of time, occur in a specific space, require that the participants function in specific roles, and that they cross the boundary from fantasy into reality in regards to these parameters. The boundary of reality also requires an individual to cross over from the fantasies and thoughts they are having about any particular situation (which may be generating very real feelings

that may or may not have any relationship to their actual environment) into the existential reality of their being in the present, in the particular environment they are in and with their feelings about that reality. No therapy can be truly effective until all the participants have gathered their energy across the boundaries of space, time, reality and role into the therapeutic container.

Function is the idea that 'systems survive, develop and transform from simple to complex, by the process of discriminating and integrating differences' (Agazarian, 1994). Difference is always both irritating and a call to growth. As human beings we have a natural tendency to join each other around our similarities and to split around our differences. Whenever we notice similarities in the apparently different we have begun a process of growth and transformation.

The reverse is equally true; whenever we notice differences in the apparently similar, if we resist the temptation to act out and scapegoat the difference, we have the opportunity to grow into the next order of complexity. An example of this is when a young adult leaves his family to go to college, he must face his anxiety about the differences between his high school environment and the university. As he notices that there are also similarities, he is able to begin the process of integrating his new environment.

Systems Centered Therapy® has a complex and sophisticated methodology by which it applies these four basic constructs to the therapeutic process. These include a well researched understanding of the phases of group and individual development, and a specific hierarchy of defence modification which is applied within the contexts of each of these phases of development. Given the limitations of this chapter, I would like to merely point the reader in the direction of the resources he or she would need to access in order to further educate themselves about Systems Centered Therapy®[3].

The Psychoaesthetic Approach

The heart of the psychoaesthetic approach is the observation that the creative process is isomorphic to the therapeutic process. Both involve the participants in a dance which has elements of frustration and gratification and which result in a creative regeneration of the participants' relationship with self, other and the environment. As large portions of this book have already provided an in-depth analysis and development of this fundamental idea, I

3. If you are interested in finding out more about Systems Centered Therapy® you may contact SCT® training c/o Mickey Rosen, 70 Boucher Drive, Huntingdon Valley, PH., 19006, U.S.A.

will not elaborate too much on the complexities of the psychoaesthetic approach at this time.

The essence of this approach is captured in the following paragraph from *The Artist as Therapist*:

> In therapy, patients and therapists alike are engaged in finding the artists within themselves. The therapeutic process for patients is an ongoing struggle to discover true inner representations and then give them form in terms of developing richer more congruent realities. Therapists tap the artist within in the ongoing process of maintaining the individual holding environments that will provide the space energy and impetus for patients to change. Together both parties create a matrix in which verbal and non-verbal communications come alive as both parties are touched by common experience. This complicated mode of interaction takes on a form similar to a symphony or work of art, where multiple levels of consciousness and meaning exist simultaneously. (Robbins, 1987, p.21)

Case History

The following case history is instructive in that it touches so many of the dimensions of working in a holistic framework. As this was also quite a long therapy (seven years), it is possible to clearly note different stages of therapeutic development, from symbiosis through *rapprochement* and finally into autonomy and individuation as well as the dynamics of trauma and the working through of trauma. This therapy was also somewhat unusual in that the client was originally referred to me for body-work, so that right from the start of our work touch was part of our contract. For therapists who are accustomed to working in verbal or even visual modalities this type of work may seem risky and perhaps even a little threatening. What I would ask is that the reader keep an open mind and notice that the similarities outweigh the differences in a therapy that includes body-work and touch. Indeed, using the Systems Centered® principle of isomorphy, one might hope that the interventions which a therapist makes through touch are congruent with his verbal communications.

Ellen was referred to me by her psychotherapist for 'emotionally oriented' body-work. Her psychotherapist had previously seen me for a brief round of massage therapy and was aware of my background and training in counselling. She had also done some emotionally oriented body-work during her own sessions and was comfortable with my ability to navigate the boundary between the non-verbal world of body-based, energetic

communications and the verbal world of emotional, psychotherapeutic processing. She felt that Ellen would benefit from the type of work that I did and that I would be capable of providing a safe container for her to address a level of healing which was difficult for her to reach in a verbal modality.

When Ellen first started to see me she was 33 years old and working in a local government agency as an administrator. She impressed me as a well educated, sensitive and intuitive woman who was attractive in an unpretentious, down-to-earth kind of way. Her mournful brown eyes had a waif-like quality and communicated to me a well of vague feeling that was intriguing. Her communication style was self reflective and I immediately felt engaged with her slow, thoughtful inner rhythm. I 'felt' her in my belly and solar plexus as she psychically pulled me in towards her and then energetically let me know when I had got too close. During her body-work sessions she communicated this to me either by tensing up against my physical pressure or, more often, by going numb and out of contact, which I felt as a kind of deadening or lifelessness in the energetic quality of her tissue.

Fairly early in our work we developed a good rapport. Her relational style had a strong pull towards symbiosis and merging which was resonant and comfortable for me although I was also aware of the potential mine fields that lay in store for us as we ventured deeper into her therapeutic journey. As we began our work, I allowed myself to enjoy the pleasurable rhythm of symbiotic mirroring and cueing which we quickly established. Each session we spent some time processing the emotional experiences which were evoked by the body-work. I felt centred, clear about my own boundaries, and warmly kind and contactful in my presence towards her.

Within the first couple of sessions Ellen told me that she had been sexually abused by her older brother between the ages of 10 and 12 and that she had been raped as a young adult while working overseas. She had also had an abortion in her mid-20s while in an unsuccessful relationship with an apparently immature and dependent young man. She had a checkered relationship history with men and had not been in an intimate relationship for the past five or six years. She struggled with persistent feelings of emptiness and disconnection from herself and others and felt that her life had no real grounding or root. She used the metaphor of living on the second floor of a house and suddenly noticing that the first floor had never been built out. She felt she had no deep foundation to stand on either in her relationships or her career. Although she had two masters degrees and a respected job, she felt as if she was still living a student life, uncentred and unfocused.

During the first six to nine months of our work together, Ellen continued to see her psychotherapist. Her psychotherapist and I were in consistent contact and attempted to create a container that would manage the splitting which Ellen was prone to do, turning one of us into the good therapist and the other into the bad. After about nine months it became clear that it was difficult for Ellen to psychologically and financially manage seeing both of us simultaneously. Her psychotherapist was supportive of Ellen seeing me more frequently as she felt that there was more 'juice' happening for her in the body-work. She felt that rather than fight against Ellen's tendency to split, it might be better for her to have all of her affect in one container. In hindsight, I wonder if we colluded with Ellen's defences by not confronting her good/bad split. On the other hand, we also seemed to be cooperating with an organic process and perhaps, after five years of working with her therapist, this phase of her healing had come to a natural end. As Ellen was 'birthed' into working with me as her primary therapist, we readjusted our sessions to include a good deal more talking and verbal integration, and eventually shifted over to a structure which only sometimes included work on the massage table. We also occasionally integrated several other forms of body oriented therapy into our work including movement, breathwork, Focusing and psychodrama.

Important Diagnostic Considerations in the Use of Touch

Before going further, it is useful to comment on some of the diagnostic indicators which a clinician who uses touch as well as verbal modalities might look out for in gaging the therapeutic usefulness of physical contact, particularly with clients who have histories of early deprivation and trauma. The benefit and danger of working with touch is that it tends to very quickly access the matrix of our primary relationships with our early caregivers, as well as unconscious traumas which our body has stored in 'cellular memory'. Very early and deep needs for fusion can easily be stimulated, and at times overstimulated. Certain types of character structures can become over-whelmed and flooded with primitive cravings for endless physical holding which also express themselves into the relational field with a host of toxic, perhaps even murderous, introjects. When this happens the client quickly oscillates between a blissful merging with the therapist and feeling aban-doned, terrified and enraged if the rapport is even momentarily ruptured or when the session is about to end. This roller coaster can throw the practitioner off centre and the therapeutic relationship can quickly become volatile and difficult to manage. All traces of the client's observing ego seem to dissolve into the primordial ooze of overwhelming cravings for endless

feeding and nurturing, or, on the flip side of this, a deep terror and rage at being abandoned.

These primitive affects attack or even seem to destroy the functional adult ego strengths and defences which the client has built up over time. Rather than being a regression in the service of the ego, a regression in the service of its own ruthless momentum begins to develop. If this persists unabatedly for more then a couple of weeks, it probably also indicates that the problem is more one of character structure than trauma, although characterological issues and trauma often exist in a complex mix that makes the clinical picture quite muddy and hard to sort out. If the client is working more at resolving trauma, my clinical experience is that there tends to be more of an ebb and flow to the regression and that the client is just as relieved as you are when his or her adult, observing ego returns.

In the case of severe characterological issues, even when the therapist is extremely present and nurturing, the client never seems to be able to reach a state of fullness or satisfaction, and the therapist learns, often only through hard experience, that all attempts to feed the client's hunger for contact only end in actually aggravating a kind of 'feeding frenzy'. The client has no centre into which he or she can digest what the therapist is offering. In these cases limit setting and a firm confrontation with the reality of the ruthless entitlement of the hungry infant inside are called for. On the other hand, if the client is able to retain a viable witness self from which he or she can notice these primitive affects and is able to regress and then re-compensate, accessing this early material or trauma can be useful and propel the client into a very productive period of therapeutic work.

Two highly effective ways to develop this inner witness are to work with mindfulness meditation or in a creative modality which involves the client in a process in which they have to balance the flow of emotional material which they are attempting to express with the frustration and gratification of working in a particular medium. Once a sufficient degree of mindfulness and centre have been developed, body oriented therapy at this level can be integrated and is rewarding for both client and practitioner.

Body-Work with Ellen

When Ellen first started to work with me there were large areas of her body that felt flaccid and unresponsive. Internally, she felt particularly out of touch with her pelvis and thighs, as if the electrical current of the life force had become no more than a trickle in the muscles in this area. She also felt uninterested and even afraid of sexual contact with men. When I worked with the muscles in her buttocks and legs during her bodywork sessions, I

felt like I was reaching through layers of cottony, stagnant magnetism which muffled the signal of her life force. Stirring her life energy in these areas was a tricky business because if the current increased too quickly she would invariably go numb or dissociate by pulling her energy up into her head in response to the increased voltage. These were unconscious mechanisms which Ellen had probably developed as a child in response to her brother's inappropriate sexual contact and which were reinforced when she was raped as a young adult.

For the first couple of months during her massage sessions I worked mostly with her hands, feet, head, neck and upper back and made only light, non-intrusive contacts with her torso and pelvis. Whenever I began to approach the core levels of Ellen's life force, my primary concern was to help her maintain a state of mindfulness and to study with her the mechanisms by which she defended against the sensations of charge and aliveness in her body. By creating an atmosphere of non-judgemental exploration, the fear and tension that was locked up inside of her tissues was encouraged to relax. Tentatively, she began the process of re-learning how to trust another human being (particularly a man) at a deep organic level. As I coached and encouraged her she was able to keep breathing and remain present as waves of old frozen feelings began to melt and release through her body. At times strong feelings of dependency and longing were evoked through the touch and she had fantasies that I might be able to totally nourish and take care of her like a parent or a life partner. Gently and firmly, without shaming her spontaneous impulse, we had to work with limit setting and helping her inner child understand that there were boundaries to my time and availability. In this process I was often thankful that Ellen had done enough work on herself to develop a functional observing ego.

Over the years of her therapy, we experimented with different body oriented modalities. As she became more comfortable containing a charge in her body, dancing to African drum music or Authentic Movement was often helpful in creating a safe space for her to celebrate her vitality. Deep breathing and stretching exercises from yoga and Bioenergetics also helped her to revitalize and detoxify her body. The most important thing about all of this was that I listened deeply to her non-verbal and verbal communications and found appropriate containers for the dynamics of the moment. In other words, I let go of my agendas and practised the arts of presence and authenticity with both rigorous discipline and spontaneity.

Ellen's Inner Dragon

Ellen certainly had a side of her that vehemently hated to be told 'no', was devouring, dependent and ruthlessly entitled. She called this her inner 'dragon'. However, she also had quite a developed inner witness which gave her an awareness of the destructiveness of this side of herself and of her propensity to break the therapeutic container. Diagnostically, the presence of a strong inner witness let me know that she had the capacity to hang in there as some of these powerful primitive affects emerged. Ellen also had a history of incest and trauma. Before her body–mind could integrate and transform some of the affects which she had locked away in her cellular memory she needed to have reliable access to her centre. In a sense this witness self became a 'co-therapist' in our work, which enabled Ellen to take responsibility for continuing her healing process outside of her sessions. One of the ways she did this was by writing in her journal or writing me letters about her reflections on her sessions. Early on in our work, Ellen gave me a copy of the following journal entry.

The Dragon

It does not want me to get well.

It does not want me to grow in trust...

It wants to control other people by mistrusting them, making them feel bad about themselves, killing with criticism.

It thinks to bind people, chain them to me, to please the unpleasable...

To keep endlessly devouring is to keep people attached – to get well, to trust, to let people go free is to lose...

I get injured and I hold onto being injured in order to blame and coerce and enslave...

There are other disguises too that may serve it [the dragon], the victim, the martyr, the long suffering, selfless heroine [these] bate the trap, draw people into the door of the den, make them want to take care of me...

What if I dropped the disguise and was authentic? I would be a human being, vulnerable, made out of flesh with a great desire to be loved. I would be very ordinary, not flashy. I would feel what it feels like to be in this body... Instead of feeling self-pity I would feel my feelings. There is no great emptiness when I drop the disguise, no great question whether I exist. I feel solid, too solid almost...

I am afraid for Michael because I don't trust myself. I could present myself as one who wants to be rescued but as soon as he draws near again become the roaring dragon, endlessly devouring...

Why does getting well seem like such a loss to me?

All of this is so manipulative. It really assumes that people won't give me anything unless I manipulate them into it...

The dragon is a defence. It assumes that if I am aloof and alone I will draw to me more love and respect than if I were available and able to receive. I ensnare people who want to help but I don't really receive from them...

There is a way to accept help in order to get well, and a way to refuse to accept help in order to manipulate the giver to keep trying. I do a lot of that.

Ellen had a recurring fantasy of getting into some kind of accident which then led to her being doted on and cared for by someone, usually an older man. She was savvy enough to recognize this as a defensive, manipulative way that her psyche was asking for love and caring. During the first years of treatment, she was able to explore the emptiness and inertia (a feeling of being almost 'too solid' and impenetrable) that lay beneath her defensive roles. As we descended into these layers of her psyche, what emerged was a silent, unrelated state in which she sought to soothe herself by creating dark womb-like environments. Often she would enact this by rearranging the furniture in my office or hiding underneath the massage table and barricading herself in with pillows. Silent and protected behind this barrier, she soothed herself by rocking gently back and forth. This state was often triggered by Ellen remembering the incest with her brother. These incidents, which occurred in the attic of her family's home, usually began by her brother asking her to role play a prostitute or his mistress and then progressed to his manipulating her into some form of sexual contact, usually oral. Ellen could also be thrown into this state if the therapeutic rapport was broken or she felt threatened by some unempathic or poorly timed confrontation. As she rocked and soothed herself, I felt how she had to bury a part of herself to defend against her brother's inappropriate and intrusive sexuality, or my intrusive comment which mirrored and unconsciously re-enacted this inner structure. I also felt Ellen's confusion, because in many other ways she had an affectionate and trusting relationship with her brother. When she was able to talk from inside her fortress she would let me know how comforted she felt to be able to explore her inner state so graphically in my presence. During these sessions, I would often sit quietly just outside the perimeter of her protective barricade and synchronize my breathing with hers. I felt like a protective, non-intrusive older brother who was respectful of her confusion and pain. As I waited patiently, I felt her slowly gather enough courage and trust to be able to come back into contact with me. Usually, the first contact was made through touch, when Ellen would ask me if I could reach through

her barricade and place a reassuring hand on her shoulder. During this period I was also aware of how important it was that all of Ellen's (and my) adult sexual energy remain outside of the room until Ellen's dissociated self could be integrated and contained.

During my vacations, particularly in the first years of her therapy, Ellen would often regress into this state for days. Again, writing was a way whereby she began to name and process her feelings. Often she would send me letters which we would discuss when I returned. The following is an excerpt from one of these letters.

> With you gone, the whole centre that I counted on, the anchor, the connection to the earth, seems to be gone. I feel so abandoned that I've put up very effective walls; the offerings of comfort or friendship that people give me I can't let in. It's like my heart is buried away somewhere way inside and can't be touched, it doesn't feel safe enough, it doesn't believe in goodness any more to let itself be touched.

After one vacation, Ellen marched into my office, asked me to stand up, placed a large pillow in my arms, and pounded on me, screaming 'How dare you leave me alone like that! I was so alone!'

In the third year of her work with me, Ellen was contemplating leaving the area to pursue a career possibility on the west coast. Although this never actually occurred, the possibility of her leaving therapy really began to heat up her issues around autonomy and dependency. During this period she wrote:

> Part of me doesn't want to go at all – why leave what is secure and familiar. Maybe I could find more life here, maybe if I just dig my roots in deeper...

> Part of me is quite disillusioned. She wants you to take care of me and to be the only one to take care of me. To her this adult effort to see you as only human feels very abandoning. 'Where will I hide' she says, 'Where will I go for comfort'.

> It feels like a betrayal of you too, to see you as anything less then she had believed. The adult part of me is trying to gather resources and gather strength, to pull together my ego, be decisive, take action, hold to vision. This part of me is trying to shore up resources to take care of myself.

> A part of me would much rather have you take care of me than take care of myself and feels a lot of loss – loss of that intimacy and comfort,

but also loss of the illusion that there is someone outside me who can take care of me.

It is hard growing up.

There is tremendous loss in letting go of my dependency on you, it is like saying good-bye to childhood, because, though I hope I will be loved and cared for again, it will probably never again be in that way.

My child doesn't feel ready; she wants to cling for more safety, more love, more dependence.

But I can't help but see that in the wider picture I am ready.

As Ellen worked her ambivalence around feeling autonomous and independent at deeper and deeper levels, she began to become aware of how furious she was at her own tendency to become dependent and at how much this had cost her in her life. In our sessions we began to get a clearer picture of her dependent, depressed mother who had a very difficult time supporting her in her moves towards individuation, and who had also emotionally and energetically abandoned her in quite profound ways, both as a young child and particularly when she was incested by her brother. As she became more convinced of my solidness and trustworthiness as her ally in her fight for independence, she was able to work her rage quite productively in the transference.

...Sometimes I am *so* angry at you, and it scares me to be so angry at someone so important to me. And even this, feels like the old stuff of being meek and not really saying what I think for fear of losing or destroying the other person...

I wonder if you have gratified my need too much – you give so much warmth – it was part of what I first loved. But now I feel like I have turned to you rather than to the world and feel trapped in a dependence that may not make my life better...

Was I that messed up?

Anyway, you are returning in my mind to Michael again, concrete and real and 'there' for me. I feel furious at my dependence, and the way it pulls me away from life. Then I feel the dependence come up, whispering that if I can just sleep in you the world will go away.

In the fourth year of our work, Ellen took a job for three months out of state as an advocate for women's rights. As part of her job she had to work with many abused women and adult survivors of incest. This time away from our work gave her the chance to 'try her wings' without totally leaving the safety

of the therapeutic relationship. The work with incest survivors also gave her a chance to see how far she had come. She wrote:

> I've started to read *The Courage to Heal* again [a book about healing from incest]. It is really amazing, the difference in me. Though I feel things, and insights occur to me, I'm simply not flooded by reading it the way I was before...

> ...it is really confirming to be able to read these books on incest and still be in balance. What was so toxic for me last year, as I thought about doing the survivors group, feels much more matter of fact this year.

As Ellen made these ventures and moves towards independence, she also began to shift the focus of her spiritual life. Because the nature of her new spiritual work was so close to my own, my sense is that this was also a way of further internalizing our work and taking me with her even as she separated. Ellen always had a strong spiritual focus in her life, mostly within the tradition of the Episcopalian church. In fact at one point she had considered becoming ordained as a minister. As she became more spiritually adventurous, Ellen started to take classes in yoga, meditation and massage. During one stage, Ellen seriously contemplated becoming a massage therapist and took a month long training programme in massage at a yoga ashram. She wrote to me from the ashram:

> Dear Michael,

> I am having a *wonderful* time; I really am grateful to myself for having earned this time for myself...

> I'm trying to show up here with my consciousness and awareness in much the same way that I show up in your office, making each moment count. I am *loving* doing the body work... And the yoga is great and so are the sauna's and the walks and the grounds and the food and the dance classes. It is very busy and active and I have lots of energy...I feel playful, energized spiritual, open, loving...

> ...I'm having a blast and I feel lots of your kind of spirit around me here, and I feel very integrated, my child with my conscious adult and my body with my mind... I feel lots of clarity, and keep expecting the clouds to come in, but they just don't.

> Love, Ellen

The Uses and Abuses of Spirituality in Ellen's Healing Process

As Ellen experimented with various forms of spiritual practice she discovered that there were times when her spiritual work helped her to ground and centre herself in deep and productive ways and then there were times when it brought her out of contact with herself and reality and left her feeling disconnected, spacey or lost in some other worldly bliss that made it very hard for her to deal with the nitty gritty of her daily life. These spiritual adventures and misadventures all became grist for her healing work. As we distilled her experiences together we discovered several things. First, those spiritual practices which were too unstructured or undirected seemed to give her characteristic ways of defending against life and relationship too much room to create a 'comfortable' dissociation or trance which was similar to the states of consciousness which she retreated into when she was incested as a child. For example, the stark purity of Vipassana mindfulness meditation, in which the only instructions are to follow the rise and fall of one's breath and to witness, without grasping, one's sensations, thoughts and feelings, too often encouraged her natural tendency to detach and enclose herself in a bubble that was unrelated to the world around her and ultimately also dissociated from the roots of her own aliveness. After these types of meditation sessions, Ellen complained that she felt anxious and unfocused, as if she were drifting inside with no internal anchor or sense of herself. It was crucial to distinguish this state from what the Buddhists talk about as the experience of 'no-self' or the quiet emptiness that is filled with the magnetism of 'all that is'. This was not a creative womb filled with the undifferentiated essence of the universe which Ellen had entered, but rather a movement towards a rather fragmented, disorganized state which threatened the very sense of ego and self which she had worked so hard to develop. Developmentally, Ellen was not ready to dissolve something she had just begun to master!

On the other end of the spectrum, Ellen also experimented with practices that deliberately and forcefully raised the energy in the body in a highly structured way. For very different reasons, these 'fast path' practices didn't work for her. An example of this was her experience with Kundalini Yoga. This practice involves rapid, intense breathing combined with particular yoga postures. This type of yoga can really shake up the body–mind and also affects the energy field of the practitioner quite powerfully. Unless one has quite a lot of stability both psychologically and physically the energy released can be overstimulating or disorienting. After a brief one day workshop in these practices, Ellen had a very clear sense that it would be more balanced for her to open these energies gently.

The spiritual practices which proved most useful for Ellen were Hatha Yoga and a Buddhist chanting practice which focuses on gathering one's life energy so that one can very concretely manifest one's ideals in life. Hatha Yoga with its gentle emphasis on stretching and alignment and deep, unforced breathing helped her tremendously in creating a vital and alive experience in her body. The Buddhist chanting practice kept her squarely in relationship with herself and her world and provided her with a container in which she could focus her life force on very practical issues as well as the more long-term goals of gaining clarity about her ideals and the qualities of consciousness that she was developing. The Buddhist organization provided her with a community of practitioners and clear, down-to-earth guidance as she worked with the practice. The chanting was also performed with the eyes open and focused on an ancient Japanese scroll which kept her oriented to her environment as opposed to her internal reality in which she so easily became ungrounded or lost in fantasy. Both of these practices worked against her tendency to 'trance out' and/or dissociate.

The world of spirituality is vast and filled with a wide variety of practices and paths to enlightenment. Depending on the developmental level that someone is working on, a particular discipline will be appropriate or inappropriate. There are no hard and fast rules that I know of to help anyone make this discernment. One might also expect that people will move from one discipline to another as they round out their spiritual growth. The important thing is that, as therapists, we help our clients to listen to their inner voice and help them to test the fruit of the particular practice they are exploring. It is crucial to let go of our attachment to any particular discipline or philosophy. It is also useful if we have at least some first hand knowledge of a variety of spiritual practices so that we can engage in an intelligent discussion about the possible merits and drawbacks of the discipline which they are exploring.

There are also many ways that spiritual practice may be directly experienced in the therapeutic relationship. The best and most common way this occurs is for the therapist to implicitly convey the magnetism of the spiritual dimension through their own quality of presence. More explicitly, the therapist may use guided imagery exercises which evoke spiritual guidance or work energetically to awaken the higher levels of vibration in the client's aura. Creative exercises which require that the client wrestle with issues of meaning or purpose can also bring spirituality directly into the therapy.

Ellen's New Feelings of Sexuality and Her Movement Towards Autonomy

During the fifth year of her therapy, Ellen began to hold more and more charge in her body. She rarely went dead or numb physically or psychologically. For the first time in her sessions she began to approach some genuinely adult sexual feeling. This was exciting stuff, as she noticed how different it was to feel her adult sexual feelings as opposed to the clingy, dependent feeling which she so often got confused with sexuality. Our work became more present focused and we spent many sessions simply following her moment to moment experience of her new found sexual charge in herself and in her relationship with me. As Ellen moved into exploring more genuine sexual feelings, touch became an interesting boundary for us to negotiate. Like a father with an adolescent daughter, I tried to celebrate Ellen's sexuality and flowering femininity without sexualizing our relationship. When this worked, I was able to communicate to her with a smiling playfulness how proud I was of her attractiveness and allow her to explore all of her new and unfamiliar feelings without intruding any of my own sexual feelings into the relational field.

This year, Ellen also moved a couple of hours out of town for a new job and began to cut back on her sessions and also to do some of her therapy over the phone. There was something organic and right about all this, and I felt like a father whose child had finally moved out on her own as I looked forward to seeing her every other week when she came to town. At this time, I remember filling up with joy and pride at the young woman I saw flowering in front of me.

During one session, Ellen presented me with the following dream which she had xeroxed from her journal.

> I had moved some place or was staying for a summer some place, a lovely brick townhouse, but lonely. I remember something really making me cry – some deep grief of my mothers or something. I was with someone who was trying to talk me out of it, but I felt, no, that I had to feel the grief in order to pray for it and turn it over to God. Then there was something violent going on, a fight scheduled for my apartment and I left.
>
> I went outside to some kind of conference. I went into a church, in my jean shorts, but felt uncomfortable there, so I left before the procession came in.
>
> The stars were wonderful – and there was a planet, like Jupiter with its moons seen up close. I was with a man who I was close to, and we looked at the planet for a while – he thought it was the sun.

Then a dust began to fall. First one child began to cry when a part of her face began to rot. Then it was everywhere, like snow and we ran away.

Then the guy I was with turned out to be Michael and we made love It felt so good to have him inside me, like I was complete. We hardly moved much, just rested with him inside.

Later on I saw him with his wife. He seemed a little uncomfortable with us together but I wasn't. I felt that the love and the rightness that I felt was its own justification. I expected that it would work out that he and I would be together.

Then Michael was doing a massage demonstration for the conference and I volunteered to be the subject. He used some kind of wooden contraption like a press with different planes of wood to match the different angles and thicknesses of each part of the body. It was very relaxing.

I was helped out of that [the wooden contraption] and asked to lie on the floor. I could hear Michael coming up the stairs with his baby and when he was looking for someone to hold her I took her. She was very odd, laughing very hard, a runty little thing with buck teeth that looked like an ape. He had brought her in swinging between his hands, laughing.

Ellen felt comforted by this dream. In many ways, the dream touched the themes of our work over the past five years. The images were symbols with a multiplicity of valences and meanings. The grief over the loss of her mother's support, moving away and individuating, the loneliness, finding a cosmic universal context for herself (looking at the stars), the child crying, the birth of her sexual feeling, internalizing me (quite literally), the oedipal fantasy that we could be together while another part of her was aware that I was married and had a young daughter, feeling supported by the structure and body-work that I gave her (the wooden contraption), and my giving her the child to hold which was also part animal and filled with instinctual life. These were some of the associations that we touched on as we worked with the dream. All of these images carried feeling tones which resonated in sonorous ways through the path of Ellen's growth.

Over the next two years, Ellen continued her process of individuation and began to make tentative forays into relationships with men. A couple of months before she met the man she fell in love with and eventually married, she wrote me:

Dear Michael,

What a lovely day I've had!

I skipped work – just called in and said I wasn't coming – and slept and ate and took myself out for a long cross country ski trip around an island near my house. It was so beautiful – the yellow sunset through the trees, the ocean with chunks of ice, the crystal clear moon in the blue sky, water and trees and sun and snow, a fog horn in the distance...

I was thinking about you. I have missed you, a little, and felt just a little lonely. But most of what I felt was proud, proud to be branching out, sending down my roots, building my life... It is a little like going off to college. It is sad because I am leaving something behind, but I also feel so proud to be able to move on in my life.

That's the way I feel. I feel really proud...

Soon after this letter, Ellen fell in love. She wrote:

I do want you to know that I am with the dearest, sweetest man in the whole universe; I had such good instincts when I set my sights on him last year. It's funny how you just know when it's right. The tenderness, intimacy, openness and honesty between us is just incredible. I think I see him pretty much for who he is and just really love him. He loves me very much too. He will say 'Do you have any idea how much I love you?' It is interesting how much more balanced and stable my life feels with two of us in it together. We aren't formally married of course, but it's just a matter of time...

Ellen was married about a year after she sent me that letter. She never formally terminated her therapy and still occasionally calls me for a phone session when she runs into a snag in her relationship or at work. She continues to keep up with her spiritual practices which she does for an hour and a half or more every day before she goes to work. As far as I can tell, with only minor bumps, she has been able to maintain a successful intimate relationship, and continues to develop her career in creative and interesting ways which give her a substantial amount of pleasure and satisfaction.

Conclusion

In this chapter I have explored the quality of presence in a therapeutic approach that explicitly touches the levels of the body, mind and spirit. The principles of working in this way are: a keen attention to the moment to

moment process of the therapeutic encounter; authenticity; an awareness that the self is a process which is organized by our intention; an understanding of the reactive mind which obstructs the natural flow of our mindful presence and authenticity; a clear affirmation of the functional unity of the body, mind and spirit; and a working knowledge of the various developmental theories which conceptualize the ways in which we achieve or get waylaid on the path towards emotional, physical and spiritual maturity. The four traditions in which I have rooted these principles are body-oriented psychotherapy, spiritual psychology, Systems Centred Therapy®, and the Psychoaesthetic approach to depth oriented treatment. I have also presented a case study in which all of these principles were applied in the concrete reality of a therapeutic relationship and which included therapeutic practices which addressed the physical, psychological and spiritual dimensions of the client's experience.

References

Agazarian, Y. (1993) *A Theory of Living Human Systems and the Practice of Systems Centred Psychotherapy*. Special Presentation at the 37th Annual Meeting of the AGPA, San Diego, CA., Feb. 15.

Agazarian, Y. (1994) 'The four basic constructs of living human systems in a nutshell.' Handout at the November intermediate training held in Philadelphia, PA.

Baker , E. (1980) *Man in the Trap*. London: Collier MacMillan Publishers.

Epstein, M. (1995) *Thoughts without a Thinker*. New York: Basic Books.

Hedges, L.E. (1991) *Listening Perspectives in Psychotherapy*. Northvale, NJ: Jason Aronson Press.

Pine, F. (1990) *Drive, Ego, Object, Self; a Synthesis for Clinical Work*. New York: Basic Books.

Robbins, A. (1987) *The Artist as Therapist*. New York: Human Sciences Press.

Washburn, M. (1988) *The Ego and the Dynamic Ground; A Transpersonal Theory of Human Development*. Albany, New York: SUNY Press.

Wilber, K. (1977) *The Spectrum of Consciousness*. Wheaton, Illinois: Theosophical Publishing House.

Yeomans, T. (1992) *Spiritual Psychology: An Introduction*. Box 82, Concord, Mass: The Concord Institute.

PART V

Therapeutic Presence
Within the Context of an Expressive
Therapeutic Stance

Therapeutic Presence
Within the Context of an Expressive
Therapeutic Stance

Listen to the Music of the Unconscious
Using Countertransference as a Compass in Analytical Music Therapy

Benedikte Barth Scheiby

Theory and Description of Terms

This chapter will focus on how music therapists navigate through psychologically complex clinical processes by using musically evoked unconscious and preconscious material – that is, musical countertransference – as a guide. The music therapist can develop an awareness of when he/she is present and centred or not present and un-centred in the music, by allowing images and emotions to become conscious when musical contact occurs in the session. When I refer to 'the music', this should be understood as including the musical expression of the client, the therapist's music, and the musical expression created jointly by client and therapist.

Let me first define my conception of musical countertransference – a concept developed over the 18 years that I have been practising as an analytical music therapist. I consider musical countertransference to be the sound patterns that reflect or evoke feelings, thoughts, images, attitudes, opinions and physical reactions originating in and generated by the music therapist, as an unconscious or preconscious reaction to the client and his/her transference. The medium through which these are conveyed is the music that is being played in the session.

I have primarily experienced two forms of musical countertransference, distinguishable in the following way:

(1) The first type consists of sound patterns that reflect the music therapist's own personal transference, which can be distorted and

projected onto the client, and can be harmful to the music therapy process if not detected.

(2) The second consists of sound patterns that reflect the music therapist's identification with the client's unconscious feelings or internal objects. When the meaning and the underlying emotional content of these sound patterns become conscious to the music therapist, they can serve as a helpful guide to the client's hidden inner music. You could call this empathetic musical countertransference.

I consider the phenomenon of countertransference as being an emotional reality even though the countertransference reactions may not be warranted by the actual events of the therapy session.

The treatment model which first described and discussed the significance of musical countertransference was that of analytical music therapy, developed by British music therapist Mary Priestley in the 1970s. In an early work, she described her approach in the following way:

> Analytical music therapy is a way of exploring the unconscious with an analytical music therapist by means of sound expression. It is a way of getting to know oneself, possibly as a greater self than one had realized existed. It may be very painful to admit the existence of some parts of it and to realize that they were once all that one hated or envied most cruelly in others. It may be very frightening to accept the challenge of other parts. Analytical music therapy is also a way of synthesizing the energies freed from repressive and defense mechanisms and giving them a new direction through rehearsal of action in sound. (Priestley, 1975, p.32)

The training to become an analytical music therapist involves a thorough post-masters training therapy by an acknowledged analytical music therapist, where the trainee is in individual music therapy, group music therapy and receives analytical music therapy supervision.

In a later article, Priestley (1995) defined the focus of analytical music therapy:

> Analytical music therapy aims at creating a time and mind-space in which the patient or client can feel safe enough to attempt the uniting of her thinking, emotion, action and the often unspoken spiritual side of her nature in order to produce a flow of being which can help her to move forward into experimenting, via music and sound expression, with rehearsals of different ways of approaching situations and

relationships and reflecting on the life she has led so far, in a relatively smooth way. (p.130)

The term 'analytical' refers on one hand to Priestley's inspiration from psychoanalysts like Jung, Klein and Freud. On the other hand, it also refers to the fact that, when needed, therapist and client verbally analyse and explore the improvisations which are often recorded.

One component of this training is to help the trainee to develop an awareness of being present for the client, both within the music in the other forms of relating, and also to be able to notice when he/she is not present.

What does it mean for a music therapist to be present? Making a commitment to music therapy means making a profound personal commitment, because one's personal feelings, life philosophy and values are transparent in the session, especially in the musical contact with the client. By its nature, music can not be sanitized or neutral – it is a mirror of what is going on inside and is consequently a highly subjective medium in which to work. One learns to listen not only to the outer and inner music of the client, but also to a deep place within oneself, where thoughts and feelings are acknowledged as they arise. Yet one must also learn to put these reactions aside in order to maintain attention to and contact with the client.

One of the ways of learning to be present involves becoming adept at handling musical countertransference as it arises, and also making use of the audiotaped music, in the session, if one suspects that countertransference reactions are being acted out in the session. Being present means having one's ears open for *transferential* and *countertransferential* material in the music. We will next consider how one identifies such phenomena.

Transferential music is discovered by hearing sound patterns that reflect the client's re-experiences and re-enactings of unfinished Gestalts from previous relationships or distortions of experiences of the present. The quality of the contact in musical transference is characterized by a 'child–parent' dynamic rather than as a relationship between peers. When the client is ready to take in such insights, the therapist helps the client to become aware of the significance of these sound patterns, either by listening to the audiotape or by reinforcing the sound patterns as they are occurring so that they become clearly apparent to the client.

Countertransferential music can have the following characteristics: it can be music that does not seem to belong in the musical context at that moment; music that does not seem to be appropriate from the therapist's perspective; musical expressions from the therapist that surprise him/herself; or a sense of not knowing where the music comes from.

Often the nature of this music is not detected until the improvisation has ended, but as the therapist develops more expertise in having a constant focus on the musical response to the client's music, it becomes possible to engage in a self-monitoring and self-adjusting of one's musical response and to use these reactions as a guide to subsequent interventions in the session. Often it is also detected in the process of listening to the recorded music, either together with the client in the session or alone or in a supervision context.

Being present also means *listening* with all of one's senses.

The therapist listens to all aspects of the client's music and his/her own music. This includes aspects such as the following: its intensity, emotional content, melodic contour, rhythmic contour, tonal/atonal language, sense of time, pauses, articulation, sudden changes/monotony, energy flow, patterns of tension and relaxation, wholeness/fragmentation, sense of form versus chaos, experimentation, spontaneity, spirituality, mood, antiphonal (dialogic) quality, timbre, polarities, choice of instrumental sound, analytical developmental level (oral/anal/phallic/genital music), repetition, flexibility, receptiveness, phrasing ability, sense of beginnings and endings, boundaries, symbiotic qualities, regressive qualities, structural components, musical scales, idioms, styles, pitch, and initiative.

At the same time as all of the musical qualities are being monitored, one also takes note of the images and feelings elicited by the music.

Being present means *intervening at the right moment or not intervening*. A musical intervention is characterized by a sound initiated by the music therapist, changing the focus of the music, changing the direction of the music, changing the dynamic between the two players, changing the parameters of the music, changing the emotional content of the music. It is an intentional act coming out in a musical expression that makes a change in the improvisation. By not intervening I mean respecting the musical expression of the client and not acting out of countertransference or the therapist's own needs.

Being present means *being authentic in the musical response* to the client.

Responses that are highly intellectually oriented and not integrated with the body and mind will not reach the client. The music will sound as if it is dissociated from contact with the body if it is inauthentic, and it will be apprehended as well in the body language connected with the playing activity. The person will seem to be occupied more with intellectualizing than with letting the hands and fingers play by themselves. Ideally, the music therapist has to be centred in the body during the music and also able to use the body as an instrument that resonates and that has to be tuned to be able to function.

A therapist who is present can observe how a client is using an instrument as an object to express things symbolically. Since they are objects that have form, colour, texture, smell, temperature, vibration and sound, musical instruments can help the client to connect to relevant emotional issues. This can be done in a variety of ways. The instruments can reinforce images, connections, and associations. ('The piano looks like a big mouth, that is ready to eat me up!') Instruments can help the client to get in touch with objects with which he/she is being confronted, either in the external world or in one's inner world. Clients can project any object or any idea onto the instrument. There are many important questions for the music therapist to consider in this regard: what might the symbolic meaning of the instrument be for this particular patient? How is the client holding the instrument? How is the client playing the instrument? Which instruments are preferred and which are avoided?

Being present means being able to listen to the music in the client's words and to the music behind these words. Also important is to be able to use words in the musical context, for example as a title of an improvisation or as poetry for a song.

Clinical Illustration

Through a case example, I would like to illustrate how musical countertransference can both be an impediment to the clinical process as well as a helpful aid when detected. In the description the reader will be exposed to my moments of not being present as well as being present.

The client, Erik, is a 29-year-old gay man, single, who is depressed and recovering from liver hepatitis. He expressed in his first session, a therapeutic interview, that he wanted to use music therapy to get rid of his depression, to get his old energy and ability to concentrate back, to sleep better at night, and to help him cope with the impending death of his father who is terminally ill. His motivation for choosing music therapy was a love and deep interest in music and a tendency to 'run away' from his feelings through intellectualization. The client had not had previous musical training, but was interested in improvising freely on different instruments as well as vocally. In the second session, Erik spoke in a quick tempo with an airy voice:

> I cannot at all think in music today, but I know that it is something about the piano. But in a way I do not have the power today to play it. I have a desire to play it, but I am afraid that I am going to use my head too much. I am afraid of the piano. I think that there is also a fear of performing in front of you, no matter what the issue is. The

piano is actually very much my father – the ability to be mastering something, I believe… That is amazing that I said that – I have really never been thinking of that before. I can suddenly see that.

I suggest that Erik let his fingers find the right instrument to play, and let them be responsible for what is going to happen.

Already at this point my countertransference had come into play. I did not hear the expressed fears of the client: fear of being split between the head and the rest of the body; fear of the piano (which was equated with his father/mastering skills), and fear of performing and the accompanying anxiety. Instead of staying with some of these issues and possibly exploring them musically, I suggested that we play without a focal point, leaving nothing to hold on to.

Erik answers that he feels an enormous heaviness in his whole body. Then he goes to pick up the cello. I ask him about how he wants to define my role in the improvisation: 'Right now I have a feeling that what I am going to play about is heaviness and emptiness, and you can reinforce me in that'. I choose to accompany Erik on the grand piano. His musical language in this improvisation is atonal so I accompany him primarily atonally, to meet him in his own musical language.

Erik starts out with very soft plucking, experimenting with the sounds of the loose strings. He is leaning forward over the cello like a person embracing a child. The musically evoked sound image in me is that of a three-year-old boy playing with a toy.

I meet Erik with very soft plucking on the upper strings of the inside of the piano.

Now he starts using the bow and plays predominantly on the lower string, making intermittent arrhythmic squeaking tones in the high register. I now play longer, deep tones on the strings inside the piano, resonating with the rhythm and sound quality of Erik's strokes. He changes to playing thin, fragile, very high squeaking tones that do not seem to be connected with each other, either tonally or rhythmically. I play short rhythmic motifs in the high register of the piano – they seem to come and go as if they are hard to grasp. I am depressing the sustain pedal, creating large, echoing musical space for both of us. I start making soft knocking sounds on the wood inside of the piano. I mirror and slightly reinforce Erik's sounds. There is no musical base or grounding in the piece – no holding point. We do not really seem to touch each other.

In my session notes I wrote the following: 'During this part of the improvisation, my inner image and feelings reflect a little crying child left

alone in a big empty space calling out and getting no answer. The abandoned child is asking to be held'.

Now Erik suddenly initiates a slow persistent rhythm, and the tone is clearer and in a louder, forte dynamic. I immediately welcome and support this initiative. I reinforce the rhythmic structure and pulse, making an extra accent on every second beat. The dynamic is forte with dissonant tones in the high register of the piano. The session notes report that 'I imagine myself accompanying a person who walks in a heavy way with no direction'.

After this I lay a 'sound carpet' that covers Erik's tones like a blanket. Our separate musical contributions are becoming more connected now. This spark of contact quickly dies away though, as if the music itself does not have enough oxygen to survive. Erik starts making high fragile trembling sounds on the strings, and then for a longer period abrupt dissonant outbursts follow. I have stopped accompanying and am only depressing the sustain pedal to continue to provide the open echo space. Session notes: 'Image: A child "cries out" for help but nobody responds'.

A long note on the deep cello string sings out and a few very soft plucks from Erik end the improvisation. Then a long silence follows. I noticed that I feel overwhelmingly heavy in my body and a big empty space inside. Erik's eyes look moist and he looks as if he is not really satisfied with the result. He sighs deeply and whispers: 'I have tears in my eyes. It reminds me of my past. When I was very lonely'. 'How are you lonely now?' I ask. Erik sighs deeply and answers: 'Nobody holds my hand right now. There isn't really anybody who knows me. There is only myself'.

Erik goes on describing the music while holding back his tears:

> In the beginning I played with the technique, and then in glimpses the hands had their independent life. That was very good, but it was not like that all the time, not at all. A balance and reciprocal action between what I want and what it (the music) wants. And then I think I made something elegant, something warm and big. A fantasy about being grandiose, being a soloist and getting attention. The adult. Look at me! I can make this! A lot of it sounded ugly, but that was good. It did not become ugly in an ugly way. What I call ugly is the 'broken heart' quality. I can feel it as emptiness. I think about when I was about 20-years-old and lived in a bad place – the worst half year of my life. I felt bad.

In my session notes I wrote about the improvisation as a whole: 'The transference of the music was the emotional expression of loneliness, deep sadness and the frustration of a little child calling for his parents, searching

for somebody to hold him, but getting no response. It also had an adult quality of a need or longing to feel love and intimacy, while, at the same time, expressing the absence of those qualities. Anticipation of father's death and possible traumatic childhood experience?'

Theoretical Integration

I would like to discuss now what happened in this part of the session in terms of countertransference.

I certainly reinforced the client's musical expression. However, I also got caught in my own unconscious reaction to the transferential music of the client. How did I realize that? By not providing an appropriate musical holding or supportive pattern which the client's music clearly asked for. It was therefore not possible for the client to get in touch with the deep sadness and to let go of the tears. I got stuck with the client in that depressed lonely empty space. As a result of my own childhood trauma, I am very familiar with this place.

My musical experience in this part of the session was also an anticipation of childhood experiences that the client got in touch with six months later in a session. This occurred through an authentic movement exercise where Erik moved to some of his audiotaped music and physically and psychologically spontaneously regressed to being a three-year-old boy who was abandoned in his playroom. He called for his parents and received no response, angrily throwing a teddy bear around the room.

The music that he had been playing in that session and that accompanied his movements had the emotional quality of a small child's anger and temper tantrum played out on the grand piano with a loud, powerful dynamic and quick changing clusters of tones in a variety of fast rhythmic patterns. This was a replay of frequent childhood experiences, where he was often left alone in his room calling for his parents without being responded to. His sense of isolation and non-response was reinforced by the fact that his parents divorced when he was four and the father moved to another country. Erik felt a profound lack of attention from his father and their contact was limited to infrequent visits.

What I also did not realize in that particular session was that my music not only was countertransferential, but it could also have been a non-verbal symbolic expression of an introjection of Erik's father. I could have unknowingly expressed the introject of his double abandoning father through the music. (I say double because he actually left him at an early age, a leaving that Erik was now re-experiencing through his father's imminent death.) This is especially relevant because Erik in the beginning of the session

mentions: 'The piano is actually very much my father'. He identifies the piano with his father. In subsequent sessions I noticed that at times I felt pushed in the music into the role of abandoning Erik – when I addressed that phenomenon verbally and Erik started owning these feelings it stopped happening to me.

In my supervision group comprised of creative arts therapists, I further explored the countertransference and transference issues in the music. I briefly presented the case and asked the group members, including myself, to listen to the music while expressing their experiences through a piece of art. The group members are predominantly art therapists and include one dance therapist in addition to myself. The group is led by an art therapist, Dr Arthur Robbins, who is also a psychoanalyst and psychologist. When one person is presenting, the work modality is in art, movement or music with verbal integration. It is neither group therapy nor supervision in a traditional sense. Robbins (1988) describes the complexity in the learning context:

> Within this dynamic interactive process, the presenter is encouraged to investigate the affective and theoretical issues involved in a case, as well as to receive emotional and cognitive feedback from his peers. Countertransference reactions are viewed as important sources of information and understanding of the patient/therapist interactions. (p.14)

I found that the art pieces that were made by the group members in my presentation were potentially helpful in that they were non-verbal illustrations of the different aspects of my own and my client's musical reality. I will let the art pieces speak for themselves. The titles and comments are made by the artists themselves.

Figure 8.1: Hollow yet heavy

Feelings about a dark, heavy, foggy inner landscape. The sun is very dim, producing an undernourished soul. It is a lonely place – an environment in which alcoholism and depression thrives.

Figure 8.2: Missed nectar

As I listened to the music, I had an image of a hummingbird desperately attempting to suck nectar out of a dry rock. The hummingbird was so out of balance, that his senses were damaged as well. There were flowers nearby that he was unable to smell and/or nourish himself with.

Figure 8.3: Sadness in space

I let the music guide my movements and forms in the drawing.

Figure 8.4: Cutting through the empty space

The title and the art work describe my experience of listening to the music.

Figure 8.5: A cry for help in the foggy empty space

In the beginning I saw a dark person surrounded by fog in a huge empty space. Then it changed into a ship sailing in fog, and the last image was two fragile people reaching out for each other in fog, not being able to make contact.

Figure 8.6: Lost in suspension

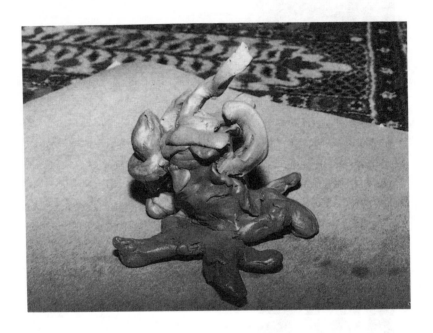

Figure 8.7: An ancient rooted tree

I just wanted to get the music grounded, to give the tree roots.

Figure 8.8: Between garbage and life
The foot kept moving back and forth between dipping in the water and staying on land.

Let us now return to the session, and hear how it ended.

I felt that it was important to bring the sadness and tears out in the open, if possible, and at the same time give the client an experience of being held, supported, and a feeling of closure. This was of course a part of my own needs also. I needed to gain my full presence again. So I asked if there was a certain musical way that Erik wanted to finish the session. He answered: 'I was thinking if you could play something for me. Something lonely. Bach, perhaps.' I chose to play J.S.Bach's 'Prelude in B minor' from 'Wohltemperiertes Klavier'.

Figure 8.9 Praeludium XXIV

The reasons for choosing this piece were as follows: this piece has a colour of sadness that can function as a mirror of the feelings that this client was experiencing. At the same time, it has a holding quality in the way it is structured. It has an ostinato (repeating) bass line, predictability in the tonality and the rhythm, rhythmic and melodic repetition, and the tones have an intimate relationship and dependency on each other. There is no change in tempo and pulse. The music is often played at funerals.

Compare the visual image of Figure 9 with Figure 3. They are almost opposites, structurally and formally.

I played the prelude slower and heavier than is customary and, after a few bars, Erik started crying very intensely and loudly. The crying had a singing quality to it that intermittently matched the melody in the music. I tried to pace the tempo in such a way that I could pay attention to Erik's vocal phrasing. I felt like a musical guide and I also felt, that I was back in charge of the therapy due to the choice of musical accompaniment.

After the music ended a long pause ensued. Then Erik said: 'My father is like that – it is him!' He looked relieved and touched. When I asked him for an overall title for this session, he said: 'Sadness on Absence'.

This session set off a very intense phase of grief related to his father, who died shortly thereafter. Erik's depression disappeared during the first four months of work. I consider the work with Erik as a whole as a very successful therapy process.

Conclusion

In this session I lost my sense of presence due to countertransference, but found my presence again by providing what a child with the childhood trauma Erik and I shared needs: an environment of holding, support, predictability, empathy with emotions, structure, and direct contact. The content of my countertransference provided helpful information about which issues could be anticipated in the course of the therapy. Perhaps I even contributed to eliciting Erik's musical transference. Kenneth Bruscia (1995) has some thoughts about this topic:

> As such, a therapist's countertransference can elicit or fire up a transference reaction in the client, or it may shape how the therapist reacts within the transference dynamic being presented by the client. Thus, it is both an activating condition and an outcome; a method of stimulating the transference and a method of understanding and responding to it. (p. 34)

The way I helped myself to gain presence in the session also facilitated the client's catharsis and connectedness with his father.

When the therapist becomes aware of being lost in the musical counter-transferential ocean, it is often also the situation of the client (lost in musical transference), and it is time to get the compass out and make a conscious decision about where to go from there.

A possible danger of working with clients with whom you have child-hood traumas in common is the *undetected* countertransference that might be evoked. At the same time, having the same traumatic experiences 'in the blood', there is also a chance of the music therapist being able to understand, empathize and connect on a very deep level which will greatly facilitate the client's healing.

My extensive experience as a music therapy supervisor has shown me that the use of music as a clinical tool can present certain dangers and opportunities concerning countertransference, because music in itself appeals to blurred boundaries and confluence and symbiosis. This is described by Mary Priestley (1994) very well:

> Music therapy offers the additional dimension of subverbal communication with loving meetings via sound patterns. The therapist offers a maternal holding to the client. He improvises reflectively on the more primitive themes offered to him, meanwhile mirroring her emotions as a good mother might. In the music the therapeutic couple can partly revive the memories of the emotion and kinaesthetic awareness surrounding the preverbal communication of the earliest stage of life, with its mysterious loving and incubating qualities. (pp. 119–120)

In conclusion, I would like to say that putting my musical countertransference under a microscope in a creative supervisory context has been a constant catalyst of personal therapeutic growth for me. As well, it has been a spur to my professional development and has enhanced my motivations in both realms.

References

Bruscia, K.E. (1995) 'The many dimensions of transference.' *Journal of the Association for Music and Imagery 4*, 3–17.

Priestley, M. (1975) *Music Therapy in Action*. London: Constable.

Priestley, M. (1994) *Essays on Analytical Music Therapy*. Phoenixville, PA: Barcelona Publishers.

Priestley, M. (1995) 'Linking sound and symbol.' In T. Wigram, B. Saperston and R. West (eds) *The Art and Science of Music Therapy: A Handbook.* Schwitzerland: Hanwood Academic Publishers, pp. 129–138.

Robbins, A. (1988) *Between Therapists.* New York: Human Sciences Press.

Further reading

Scheiby, B.B. (1991) 'Mia's fourteenth – the symphony of fate: psychodynamic improvisation therapy with a music therapy student in training.' *Case Studies in Music Therapy.* Phoenixville, PA: Barcelona Publishers, pp. 275–290.

Scheiby, B.B. and Montello, L. (1994) 'Introduction to psychodynamic peer supervision in music therapy – "Dancing with the Wolves" in the client–therapist relationship.' *Connections: Integrating Our Work and Play,* Proceedings of Annual Conference of the American Association for Music Therapy, pp. 217–223.

Acknowledgements

I want to thank Ken Aigen, my husband, for his editorial assistance and for support in the writing process.

A very special thank you to my supervision group and my supervisor, Arthur Robbins, who all encouraged me and helped out in making the creative parts of the article.

Last but not least thank you to Erik for allowing me to use material from his music therapy sessions for this purpose.

Ritual in Expressive Therapy

Vivien Marcow Speiser

This chapter addresses some of the functions of ritual in expressive therapy traditions, and describes some of the ways in which the author has worked with ritual in her expressive therapy practice. The use of ritual in healing derives from shamanistic tradition. Throughout human history, it has served as a mechanism for self and collective identity definition, as well as a bridge to the sacred dimension of existence. The use of ritual in expressive therapy practice is predicated on the assumption that the creation of a ritual in a therapeutic process is inherently healing. Within the therapeutic context, the creative process, individual and group process, the relationship with the therapist, and the ritual itself, all function as container and holding environment. This containment provides the client with sufficient safety to move into a transitional space that facilitates healing, growth, change and transformation. The therapeutic use of ritual encompasses planning and processing the ritual enactment, as well as the importance of naming and witnessing in the collective. Ritual allows for the creation of shaping, forming, meaning and naming of transitional events and forces. When ritual is enacted in a group situation, the group becomes a collective entity which acts as a mirror, reflection and witness. This function of witnessing in the collective is a critical aspect in the therapeutic use of ritual.

Expressive Therapist as Shaman

The use of expressive arts in therapy originated in the shamanistic and ritualistic practices of traditional and indigenous peoples (McNiff, 1992; Moreno, 1995; Serlin, 1993). In traditional societies, ceremonial rituals are held for individuals and groups as a way of dealing with illness, as a way of

marking life stage passages and as a way of dealing with people's relationships to the environment and to natural and supernatural powers. Music, sounding, dance, drama, enactment, symbolic visual expression and other art forms are often utilized in such rituals. The role of the shaman has been compared to the role of the contemporary expressive therapist. McNiff (1981) writes that

> Expressive arts therapists are more clearly associated with shamanism than traditional therapists because of the way in which they facilitate group expression as a form of artistic transcendence and celebration. Today's expressive therapist initiates a search for the lost soul of the individual and the collective soul of society just as the ancient shaman went on a journey to other wordly spheres to bring back the soul of a possessed person. (p.6)

Halifax (1982) attributes the power of the shaman to his/her ability to connect with the spirit world, and to mediate this connection with the ancestors of the collective, and with their spiritual beliefs and practices. The shaman is charged with maintaining individual and communal health and balance. The manifestation of illness in just one individual is thought to put the community out of balance, thus the community must be involved in healing acts. The shaman mediates between the issues of the individual in this world and the forces in the other world which contribute to the problem.

> This special and sacred awareness of the universe is codified in song and chant, poetry and tale, carving and painting. This art is not art for art, rather it is art for survival, for it gives structure and coherence to the unfathomable and intangible. By 'making' that which is the unknown, the shaman attains some degree of control over the awesome forces of the mysterium. (p.11)

Like the shaman, the expressive therapist can use ritual to access deep psychic forces and structures. Like the shaman, the expressive therapist first builds a relationship with the individual and/or the group and creates the potential for transformation and healing to occur. Like the shaman, the expressive therapist has gone through a period of training, exploration and initiation into the profession, and has a system of belief and professional practice that guides his/her work. As in the shamanistic ritual the arts become the container or form for ritual enactment – the symbolic bridge of connection and communication between inner and outer experience. Ritual enactment can be used to focus energy so that complex, powerful and sometimes contradictory energies and impulses can be accessed and transformed.

Because rituals are enacted and witnessed collectively, they enable both individual and collective healing.

Rituals and Identity

In modern society, living outside of the extended family structure, and often in non-traditional social configurations, the individual loses much of the social and familial context in which to identify developmental changes and fluctuations. Ritual serves the function of defining and re-defining the individual in relationship to his or herself and to others. In traditional societies, ceremonial rituals are held for every individual at every stage of life. These changes, being understood and witnessed collectively, become 'definitional', in the sense that both the individual and the group understand the relationship of the individual to the family, the clan and the collective. Barbara Myerhoff (1980) characterizes such opportunities for the individual to emerge and become visible as 'definitional ceremonies' where 'Any reality is capable of being made convincing if it combines art, knowledge, authentic symbols, and rituals and it is validated by appropriate witnesses' (p.25).

The unfolding process of life is such that the individual is continually facing what Bridges (1980) has called a 'lifetime of changes'. Rituals can mark these developmental changes by organizing past experience, delineating the present moment and moving beyond into new possibilities for becoming. In so doing, rituals offer individuals a new affirmation of their identity. Outside of prescribed events which are particular to the individual or to the culture, the individual can get separated from the wisdom and experience of the collective, which can be a source of support and sustenance, particularly during troubled times and periods of disease. For example, it is common to celebrate rituals of joining together, such as marriage, and less common to ritualize such events as uncouplings or divorces. Harold Littlebird (1987), who is a Native American storyteller, poet and balladeer, speaks to the power of ritual and ceremony when individuals tell their stories in community:

> In remembrance there is life, known in ways unimagined, but carried still in rich cultural tradition and ceremonies, given to all people for life, soul and breath, to share in wonder as gifts from an everlasting source to guide the essence of that which holds no name.

Ritual can help individuals begin to remember who they are, where they have been, and to discover their possible direction for the future. This requires a delineation of the boundaries of the self, in order to step beyond those boundaries.

Rituals and the Sacred

Beck and Walters (1977) define sacred as

> something special, something out of the ordinary, and often it concerns a very personal part of each one of us because it describes our dreams, our changing, and our personal way of seeing the world. The sacred is also something that is shared, and this sharing of collective experience is necessary in order to keep the oral traditions and sacred ways alive. (p.6)

The use of ritual in expressive therapy practice is critical in a society living without ritual, where people hunger for a connection beyond the boundaries of the self. Where the culture provides no opportunity, no opening, and no encouragement for the making of ritual, we have to invent our own, formed out of the fabric of our own lives. I believe that the use of ritual and ceremony in expressive therapy is inherently healing and encompasses the sacred dimension of our practice (Marcow Speiser, 1995).

Allen (1986) writes about the use of ceremony as a way of fusing the individual with the worlds beyond our own:

> The purpose of a ceremony is to integrate: to fuse the individual with his or her fellows, the community of people with that of the other kingdoms, and this larger communal group with the worlds beyond this one. A raising or expansion of individual consciousness naturally accompanies this process. The person sheds the isolated, individual personality and is restored to conscious harmony with the universe. (p.62)

In viewing ritual and ceremony in expressive therapy practice as a way of connecting the individual and the group to the 'worlds beyond this one', the expressive therapist is allied with both shamanistic and spiritual traditions. Cooper (1988) draws upon the Jewish Kabbalistic belief in Tikkun Olam, the repair or restoration of the world, as the province of psychotherapeutic work. Using Hassidic thought he writes:

> Individuals cannot find redemption until they see the flaws in their souls and try to efface them. But whether it be an individual or a people, whoever shuts out the realization of their flaws is shutting out redemption. We can be redeemed only to the extent to which we see ourselves. (p.xiii)

Ritual offers the individual the opportunity to make things 'right' between themselves and others, to go back and revisit the most painful moments of dislocation and loss, and to 'see' and express these moments in a symbolic

form. Ritual making facilitates and accesses the potential for healing and transformation. Ritual can be an important next step for a client who has done significant therapeutic work and is ready to move on, and it can also be used for a client who feels stuck to begin to move on. In witnessing such a ritual, a group can resonate with the individual in such a way that the individual can feel seen, heard and understood. In addition, the creation and enactment of a ritual, moves the individual beyond the personal into a transitional space which encorporates the collective, and the 'worlds beyond this one'. As such, it constitutes a movement into the space of the sacred.

Therapeutic Aspects of Ritual

According to Imber-Black, Roberts and Whiting (1988)

> Rituals are coevolved symbolic acts that include not only the ceremonial aspects of the actual presentation of the ritual, but the process of preparing for it as well. It may or may not include words, but does have both open and closed parts which are 'held together' by a guiding metaphor. Repetition can be a part of rituals through either the content, the form, or the occasion. There should be enough space in therapeutic rituals for the incorporation of multiple meanings by various family members and clinicians, as well as a variety of levels of participation. (p.8)

The use of ritual in therapy can be conceptualized as a part of an ongoing treatment process, where they offer an actual or symbolic opportunity for a client to move through, or transform some aspect of their experience. The preparation for and incorporation beyond the ritual itself are intrinsic elements of this process.

In his seminal work on ritual, Van Gennup (1960) has identified three distinct stages of the ritual process. In the first stage, the individual or group separates his/herself or themselves from others. The second stage is a liminal stage of transition when change is in process and things are not as they were. The third stage is a stage of enactment and reincorporation, for the individual and for the group. In many ways this sequence of events recapitulates the developmental process of separation/individuation, and may offer a mechanism for clients to come to terms with developmental deficits and/or losses. In moving into the liminal stage of ritual process, the individual enters a transitional space. In this transitional space, there exists enormous potential for healing, transformation and change. The holding environment of the therapist, the group and the ritual itself all serve as container for the

complexity of emotions evoked by this process, so that enactment and re-incorporation of the individual can occur.

Winnicott (1986) writes about transitional space as the space of 'cultural experience' which he describes as follows: 'Cultural experience starts as play, and leads on to the whole area of man's inheritance, including the arts, the myths of history, the slow march of philosophical thought and the mysteries of mathematics, and of group management and religion'. He locates cultural experience as starting 'in the potential space between a child and the mother when experience has produced in the child a high degree of confidence in the mother, that she will not fail to be there if suddenly needed' (p.36).

In moving through the transitional space of ritual enactment, the individual and the group enter into this area of accumulated cultural experience which contains all aspects of the human condition, and relationship to the secular and sacred dimensions of existence. Since all things are possible in this space and because trust is engendered, the individual can be reincorporated into the group following the ritual enactment.

In my expressive therapy practice, I have used ritual in several ways. In the first instance, I have run groups that have come together for the express purpose of creating a ritual, such as rites of passage groups for homogenous populations, such as mid-life transition groups, or divorce groups. I have found ritual a particularly effective tool for groups of people who are working on similar issues and life stage transitions. Additionally, I have used ritual with clients who have made significant progress in therapy, and who have chosen to create a ritual as a way of concretizing their changes. These clients have been seen in either individual or group therapy, and in both instances have enacted their ritual in a group, whether an ongoing therapy group or a group that has been convened specifically for the purposes of conducting the ritual. Lastly, clients have chosen to use ritual when they have felt stuck or blocked in therapy. It has been my experience that ritual offers a powerful tool for clients and clinicians to facilitate growth and change.

When clients choose to create a ritual for themselves, there is a preparatory phase of gestation where a creative process of generating possibilities and narrowing choices occurs. In this phase the client chooses who s/he wants to attend the ritual, and orders the elements of the ritual itself. S/he chooses artistic modalities, and creates through words, images, sounds, gestures, symbols, and movements, the sequence of unfolding events to be utilized in the ritual itself. This preparatory phase helps the client to sort through and separate out intrinsic and peripheral elements and feelings, in a process of sifting, clarifying and refining. In many ways there is a recapitulation of developmental process and a re-ordering of past events and experiences.

In the enactment phase of the ritual, the client enters into liminal or transitional space where things are not quite what they were, and not quite what they are yet to be. This is a time for the client to tell his/her story, to be present, to be seen and to be heard. It is also a time for feedback and reflection on the part of the group members, a time to be witnessed and a time for witnessing. This transitional space is a powerful place where transformation and healing can occur. Since the ritual enactment takes place in a group, this liminal or transitional space holds and contains the projections, and feelings of all the group's members.

In the reincorporation phase of the ritual, the individual is reincorporated into the group through reflecting, mirroring and amplifying response and feedback. In follow-up sessions, the individual is able to assess the effects of the ritual, and evaluate his/her present status and relationship to self and others. As therapist, I see my role as facilitator to the ritual process. As an expressive therapist, my familiarity with multiple media of expression helps me to steer clients in appropriate directions in terms of their aesthetic and modality choices. I believe that clients themselves know exactly what it is that they need to do with the ritual they create, and that the therapeutic engagement itself provides both the sustenance and the challenge that fuels creative endeavour and encounter.

In the presentation of rituals that follow, I will describe a ritual process where an individual has chosen to construct a ritual within the context of an ongoing therapeutic alliance with their therapist. It is important to recognize that this discussion is focused upon a specific use of ritual in expressive therapy practice, and is not meant as a blanket endorsement of all rituals as having inherently therapeutic outcomes. In a society where there is a hunger for the connection that ritual can bring, rituals can be misused, particularly in instances where groups are brought together to enact group rites of passage. Like the shaman, the expressive therapist as ritual master holds enormous power, and this power should be channelled so that meaning is not superimposed but derives organically from the unfolding of the ritual enactment itself.

In the case vignette that follows, the preparation, enactment and reincorporation process will be described. I have changed names and identifying information.

A Ritual for Coming to Terms with the Past

Margaret was a member of a women's therapy group, where members were working on identifying and naming life stage issues. Margaret was in her late 40s and had not married, and was dealing with this issue as well as the fact

that she would not have natural children of her own. Margaret had grown up in a small town, as the middle child in a family of five children. Her mother, who is deceased, suffered with cancer for many years before she died. Margaret's father was approaching 80, and this birthday became the focus of the ritual.

When Margaret was an adolescent, her father had an extramarital relationship that became known in the community. For a while the father maintained two households, but eventually divorced his wife and re-married the 'other woman'. Margaret was deeply humiliated by this experience, and had never forgiven her father. Moreover, she blamed him for her mother's cancer, and only achieved a small measure of reconciliation with him, after the death of her mother, when Margaret was in her early 30s.

In therapy, Margaret identified a need to find some way of coming to terms with her past, and for finding a way of being in a relationship with her father so that she could make her peace with him while he was still alive. As preparation, she invited her siblings to join her for a weekend where they could revisit the small town they had lived in as children. She explained to her siblings that she wanted to create a ritual for herself, using their father's eightieth birthday as an occasion for healing. She wanted both to be able to build a better relationship with her father, and to achieve some measure of internal reconciliation with the losses she had endured in her childhood and adolescence.

During the weekend the siblings talked about the events of their childhood and listened to one another as each described the impact of their parents' divorce and how it had affected their lives. It was Margaret's wish to create a videotape together which would be presented to their father on his birthday. On the videotape which was created, each sibling told their father what they felt it was necessary to say to him. Margaret spoke about her pain, her losses, and her need both to move beyond the events of the past and into a new relationship with her father, and into an acceptance of her own life. The video was presented to her father on his birthday and became an opportunity for an expression of feeling within the family.

For her ritual, Margaret created a ritual of self-affirmation. She asked the group to sit around her while she danced in the centre of the circle. She performed a dance which she had created for the occasion, to the accompaniment of flute music she had recorded on tape. This dance traced her developmental history up to the present and concluded with images of strength and affirmation. In her dance, the group could see the frightened child, who knew that something was not quite right, as well as the humiliated adolescent, whose sexuality became repressed because of the shame she had

attached to her father's affair and his rejection of her mother. The dance proceeded from small, tentative bound and repetitive movements that became increasingly expansive as Margaret moved on to her early 20s and college years. The movements of early and mid-adulthood depicted unsuccessful relationships with men, as well as a stabilizing and rewarding career in human services. Margaret represented both the losses and joys of adulthood by gathering and scattering movements as she named the losses and the joys of her life. She ended her dance by reading a vow of self-affirmation where she promised to honour her pain and sorrow, because they had become the basis of who she is today. She promised to take all of her experience into account, to never forget what had been in the past, but to move on now that she could accept all that had been, and find some degree of forgiveness towards her father. In closure to her ritual, she asked the group to light candles and to honour her with blessings for the future.

In subsequent sessions, Margaret was able to share with the group that the enactment of this ritual had freed her up emotionally so that she felt more capable of self-empathy and more accepting and tolerant of herself. She was able to find some measure of comfort and relief in past decisions, and in her choice of a career that brought her into daily contact with young children. The creation of the ritual had enabled her to 'step into her own shoes' and become who she is. She had recently begun a new relationship with a caring man and felt hopeful and optimistic about the future.

Margaret's ritual encompasses three distinctive phases: preparation, en-actment and incorporation. It illustrates how ritual can bridge the past and the present, and how complex and contradictory feelings can be embedded, expressed and contained in the ritual itself. In this ritual, Margaret could mourn the losses from her childhood, at the same time that she could express her anger towards her father, as well as her wish for reconciliation. In her expressive enactment of these events and feelings, Margaret used music, movement, words and visual images to form the ritual. Margaret's own creative process, the therapeutic process, the group process and the use of the arts themselves all served as container and holding environment for the emergence of the ritual. The wisdom of her own psyche came into play in the evolution of the form of the ritual.

Naming in the Collective

Another significant aspect of working with ritual in expressive therapy practice is the process of naming. Serlin (1993) has identified this aspect as follows:

Dance therapy places an emphasis on naming the action. As vague movements crystallize into form, the therapist helps to clarify them into clear statements of emotion, intent or image. Making the unconscious conscious is a central aspect of the dance therapy process; at these times, it is possible to hear echoes of the early magical and naming practices of sacred dance. (p.66)

In creating a ritual which explicitly names an issue, the individual is afforded the validation of being accepted in the community as s/he is as well as the possibility of moving beyond that definition in that moment. In many ways, the group becomes a mirror, reflecting and containing the protagonist, as s/he becomes who they really are, at the same time that they are afforded the possibility of moving beyond that moment. This is another of those complex contradictions that ritual can contain. For example, in creating a ritual to move from darkness towards the light, not only am I acknowledging the darkness, but I am moving beyond that, into the light.

In creating and enacting a ritual in a group context, the individual moves into a space which is collective, in the sense that the people have gathered together for a specific purpose. I would suggest that the function of the collective is critical to the enactment of a therapeutic ritual. A ritual may be enacted within the context of any group that the protagonist chooses. The power of the ritual is co-created both by the individual and by the collective experience of the entire group. Thus the ritual accesses multiple levels of projections, interpretations and meanings, which in turn become part and parcel of the emotional fabric and content of the enactment as the group holds, mirrors and reflects the experience of the protagonist.

In the vignette that follows, I will describe a ritual that makes use of naming and enactment within the collective. A couple whom I shall call Peter and Susan were seen together in couple's therapy. Peter is a Vietnam veteran who married Susan after his return from Vietnam. They have two children. At the time that therapy began, Peter had been reprimanded at work for his lack of collegiality, and he and Susan were experiencing marital difficulties. In addition, Peter is a recovering alcoholic and both he and his wife attend support groups for alcoholics and spouses. Peter felt that who he is has been largely determined by his experience in serving in Vietnam. As well as carrying his memories from combat, Peter still carried some emotional residue from his return to the United States after his release from combat duty, where he had to 'fight a second war'. In many ways, Peter was continuing to fight with his closest friends and colleagues as well as his wife. Both Peter and Susan wanted to establish a cease-fire in the hostilities and

Peter wanted to reach out and make amends to family, friends, his colleagues and his children.

In creating a ritual around these themes, Peter decided to gather together a group of people which included his parents, the therapist, friends and colleagues, and family. His ritual consisted of two parts: reading from a text, and the creation and performance of a movement piece. His wife, Susan, accompanied him on the piano.

The Butterfly Emerges from the Chrysalis

Peter began by describing to the assembled group what the purpose of the ritual was, and how he hoped that, in so doing, he would in some ways make amends for behaviours that might have created pain and discomfort for others. He read from a text he had created, which encapsulated some of his painful memories from military service. He also read from a series of poems he had written from the vantage point of a 'monkey' who had observed the carnage. What the monkey had seen was men who were senselessly slaughtering one another, at the same time that they tried to hang on to some semblance of human decency and connection. He spoke about a trip he made while he was on leave and how he gave candy to children he met along the way, and how much that had meant to him to still be able to reach out to children. He spoke about his own love for his children and how that sustained him in the face of recurrent and awful memories from the past. He then took the opportunity to apologize for all the times that the residue of pain and anger that he carried might have been inflicted upon others present in the room. At this juncture, there was much expression of feeling and emotion in the room and many of the assembled group members responded by telling Peter how they felt about him and about what he had said. What emerged in the sharing was a variety of perspectives about how people felt about Peter, and many of the ways in which he had given to and nurtured others. This collective sharing allowed for the emergence of a more balanced and complete individual with strengths and weaknesses, virtues and values.

After a short break, the group was invited back to witness the performance. The performance began with Peter wrapped in a costume which he had created out of yellow fabric which enclosed him in a box-like shape. Within this covering, Peter began to move, at first creating cocoon shapes that enclosed him as he whirled slowly around. Then he ceased to move for some time. After the pause in movement, he began to move again, and gradually the movement began to increase in momentum as he thrashed about and writhed on the floor. The movement began to progress from formlessness towards form as the figure within began to assume a standing

posture. As the music ended, Peter pulled off his covering and stood solidly in his combat uniform. 'Please accept me as I am', Peter asked of the assembled group. As conclusion for the ritual, Peter asked the group to stand and sing 'Amazing Grace' together.

By explicitly naming his issues in the group, Peter was able to use the group to create a more balanced representation of the totality of his experience. In subsequent sessions, he and Susan were able to process the feedback they had received and to see themselves and one another in a more balanced light. Peter was able to achieve some reconciliation with friends and colleagues from whom he had become alienated and he and Susan were able to re-affirm their love and commitment to one another. In naming and enacting the process of a butterfly emerging from a chrysalis, Peter created for himself a symbolic new beginning. The collective responded to and mirrored back to him both the fullness of who he is as well as his potential for change and transformation.

Witnessing in the Collective

The concept of witnessing in therapy derives from the practice of authentic movement, a form within dance therapy. Adler (1987) writes about the function of the witness where 'the inner reality of the witness appears to be as vast and as complex – and as essential to the process' (p.21). Adler believes that witnessing in the collective engenders a shift in consciousness towards the transpersonal realm, which includes all of the emotional aspects of human experience. In this transpersonal realm the ultimate polarities of life and death, and good and evil, can co-exist as the contradictions and complexities of the human psyche are expressed and contained. This then is the space where ritual happens, where all or nothing is possible, where what was done can be undone, and where what was not done can be done. This 'doing' can happen on an actual or a symbolic level. Witnessing in the collective allows for the expression and containment of all the joys, losses and sorrows of the human condition, thus it affords the possibility of finishing up with pieces of unfinished emotional business, as well as entry into the province of 'the worlds beyond this one'.

The power of ritual within expressive therapy is that it mobilizes the energy and force of the collective by bearing witness to the journey of the protagonist. This is the proper territory for the enactment of all that is and will ever be. Ritual allows for the meeting of all the arts where all avenues of expression are brought into play, as being and becoming merge in the moment of enactment.

The following vignette illustrates a way of completing a cycle of loss through witnessing in the collective.

A Memorial and Naming Service

Catherine came into therapy because she was still mourning for her son, who was still-born several years previously. She had two latency-aged children at the time of the birth of her son. When Catherine was in the seventh month of her pregnancy, her husband had left her and the couple had subsequently divorced. When the child was still-born, Catherine attributed this loss in large measure to her desertion by her husband. She was left to grieve the demise of a marriage, followed by the still-birth. Catherine had resolved many of the painful and residual issues related to these major, consecutive losses. She was a nurturing and loving mother to her two children, a successful professional, who wanted to try and find some way of putting the past into a perspective and gain a sense of resolution. She began to work on the ritual by visiting the grave of her still-born infant who had not been named, and whose tombstone bore the name 'baby'.

Catherine decided that she wanted to create a naming ritual for her son, so that she could erect a new tombstone with a given name. She contacted her ex-husband, who was unable to participate in the process or in the ritual. However, her children became engaged in the process, and together mother and children selected the name David. On the second anniversary of David's death Catherine held a memorial service which was conducted by her pastor. She invited friends and family, as well as the congregation to which she belonged, to join her for this ritual.

The invitation to the event was drawn by her children, and hand lettered by Catherine. All of the elements of the ritual were carefully orchestrated by Catherine, who chose the music and the text. Catherine and her children read aloud from letters that they had written to David welcoming him into the world, and expressing their sadness over losing him. Catherine spoke about why and how it had taken her so long to be able to do this, and her joy at finally being able to both 'hold' and acknowledge David by naming him, at the same time as she was saying a kind of farewell. She spoke about her anger and pain at losing him and told him that he occupied a special place in her heart, which she touched every day, which was a 'hole with no memories'. Catherine related that she still felt some guilt that her preoccupation with other painful issues might in some way have contributed to his death, but that in coming to terms with his death she was also acknowledging his life, which she felt was the beginning of a healing for herself. She welcomed David into her family by describing his siblings and grandparents

and promising that he would never be forgotten and that she would love him without reservation forever.

In follow-up sessions Catherine spoke about her feelings of peace and resolution. She was able to erect a new headstone and created a ceremony at the grave-site which was attended by the immediate family. Catherine felt that the participation of her family, friends and congregation had created a sacred space for her, where she felt that she had put her baby 'safely into God's arms'. The creation and enactment of this ritual brought some closure to her process of grief.

In concluding this ritual and this chapter I wish to affirm the healing power of ritual as an aspect of the expressive therapy tradition. Ritual utilizes all of the arts, and is a meeting point between the individual and the collective, bringing them into a space beyond the boundaries of the self and others. In this space, all potentialities are accessible, in the continuity of collective wisdom across the generations. As an expressive therapist, I take my place in the interstices of this work which straddles the secular and the sacred. In the creation and enactment of ritual, what cannot be otherwise said or done *can* be said and *can* be done. What is enacted is what Elizabeth McKim (Marcow and McKim, 1990) calls the 'heart of the matter'.

References

Adler, J. (1987) 'Who is the witness?' *Contact Quarterly 12*, 1, 20–29.

Allen, P.G. (1986) *The Sacred Hoop*. Boston: Beacon Press.

Beck, P. and Walters, A. (1977) *The Sacred: Ways of Knowledge, Sources of Life*. Arizona: Navajo Community College Press.

Bridges, W. (1980) *Transitions*. MA: Addison Wesley Publishing Co.

Cooper, H. (1988) *Soul Searching: Studies in Judaism and Psychotherapy*. London: SCM Press.

Halifax, J. (1982) *Shaman: The Wounded Hero*. New York: Crossroads.

Imber-Black, E., Roberts, J. and Whiting, R. (1988) *Rituals in Families and Family Therapy*. New York: W.W. Norton.

Littlebird, H. (1987) *The Road Back In: Songs and Poetry of Remembrance*. Santa Fe: Littlebird Studios.

Marcow Speiser, V. (1995) 'The dance of ritual.' *Journal of the Creative and Expressive Therapists Exchange 5*, 37–42.

McNiff, S. (1981) *The Arts and Psychotherapy*. Ilinois: Charles C. Thomas.

McNiff, S. (1992) *Art as Medicine: Creating a Therapy of the Imagination*. Boston: Shambhala.

Moreno, J. (1995) 'Ethnomusic therapy: an interdisciplinary approach to music and healing.' *The Arts in Psychotherapy 22*, 4, 329–338.

Myerhoff, R. (1980) 'Telling one's story.' *The Centre Magazine*, March 22–26.

Serlin, I. (1993) 'Root images of healing in dance therapy.' *American Journal of Dance Therapy 15*, 2, 65–76.

Van Gennup, A. (1960) *The Rites of Passage.* Chicago: University of Chicago Press.

Winnicott, D.W. (1986) *Home Is Where We Start From: Essays by a Psychoanalyst.* New York: W.W. Norton and Co.

The Field of Wings[1]
Puppetry as Therapy from an Object Relations Point of View and Incorporating Field Psychology

Felisa Weiss

My Symbolic Journey in Puppetry

Ever since I was a child, I have been attracted to puppets. They inhabited my fantasies, becoming alive in my head by donning the disguises of other wee folk, such as faeries, elves, gnomes and mythical creatures. The aesthetics of these inanimate characters enchanted and infatuated me, for they were magical and mystical to my young mind. This was a world quite comforting to me, as I was obsessed with fantasy and science fiction. Such a surreal dream world was more alive than reality, because my childhood reality was less than magical and delving into surrealism was a crucial coping mechanism I needed to survive emotionally. Retreating into an alternative reality, I became more connected to inanimate objects and fictional characters than I did to people. Puppetry seemed a natural extension that came into fruition in my adult creative growth.

Through narration, story telling, books, poetry and puppetry, I was able to create my own worlds and have the control over them that I was unable

1. As therapists, we learn a good deal both from our patients as well as our supervisees. This chapter has been written by a young professional who courageously describes to the reader her personal struggles that have been organized and expressed through the art form of puppetry. Art provides for this young professional a bridge for mastery. Part of the unsolved question to this chapter pertains to the mastery that comes through an art form and its relationship to identity formation that must be tested out in real life situations. This chapter represents an extraordinary creative expression of Felisa's relationship to puppetry and her attempt to make this modality an authentic expression of her therapeutic presence.

to have in my own life. I chose to pursue puppetry as it can incorporate many different media, not only on a three-dimensional level but in a complex multi-dimensional arena that includes time, space, gravity and interconnection. More than any other modality, puppetry provides me with the sense of giving birth to a life force through form and movement; an artistry that infuses spirituality and culture which provide meaning and food for my primordial self. However, fantasy became insufficient for me as I grew older. I had a desire to interweave and link the dreaming with the waking. Those who live in the land of Morpheus, deep within the underworld, shall walk with the living in the realm of magic realism. For me, puppetry has become that link, that bridge between both worlds because of its shamanic roots that conjure the abstract with material objects.

The best way for me to describe my relationship with my puppets is through metaphor. Creatures that I create play a large role in my life. The symbology of puppetry helps me understand my art, my projected self, myself and universal self that is linked to the collective unconscious. Within the story of 'Shadows Lie Deep' is the Gestalt of the way I view puppetry in general. This is included to assist the reader in understanding my position and my art without having to reiterate an intellectualized analysis of myself and of puppetry. My reasoning behind writing the story was to gain a better understanding of my relationships with my puppets as well as working out my issues of power, control and dominance through an allegory. 'Shadows Lie Deep', the fairy tale that I wrote, explores the relationship between the self and other, the creator and the created, and the root of the relationship of the puppeteer and puppet. It explores the power struggle between the puppeteer and puppet, which is a metaphor for the artist's struggle with life, God(dess), authority and structure. Through storytelling, I play out my issues that I deal with in puppetry. Puppetry in itself is a dynamic three-dimensional modality of storytelling, a modality that many puppeteers as well as myself use to communicate the struggles of being a mortal human controlled by the whims of an omnipotent being.

Whether dealing with the above mentioned fairy tale, my illustrations or my puppets and dolls, certain themes keep cropping up. I am haunted by blue faeries and gargoyles. Neither cute nor evil, these impish little folk populate my dreams. Such dreams manifest themselves in my waking thoughts, as I sketch and design these creatures that come to life underneath my fingers. Through my process of creating them, I designed a large body puppet resembling a water fairy. The creatures remained distanced from me to a certain extent as there was little body contact; once I entered the body of one of the faeries, I was able to clarify the meaning behind its existence

as well as its resentment of and dependence on being controlled. After this exercise, I was able to formulate the issues and themes I deal with in puppetry and solidify them through telling a story that will eventually be formed into a play. Each process feeds off each other, completing the cycle not in a solid circle but in an ever revolving and forming spiral. For the passion and obsession to create more lives, to understand my life story turned fairy tale drives me to continue my process. However, puppet obsession and determination to explore one's own existence, spirituality and psyche through puppetry is not unique to my situation; this is often a universal cry and hunger among many puppeteers and artists who use puppets.

In therapeutic puppetry, the puppeteer relives issues from the past and reconnects it to the present, so there is some sense of control of the future. Through this journey, I pulled out certain themes that I thought may pertain to other puppeteer, puppet artists and clients who use some form of articulated performing object. Themes festered into questions I had for other puppeteers, which I organised into a format for interviews. Just as my story comes from my 'puppet's' point-of-view, in many of the puppet interviews, I question the puppet before I direct my attention towards the puppeteer. By selecting a nondirective approach both for myself and other artists, the exploration is not as threatening as the puppet acts as the intermediary, the projective object that absorbs both interviewer and interviewee's vectors.

So the following story begins with the water fairy in her natural environment, a state synonymous with my dreaming primordial self. Marinia's struggles and frustrations that result from leaving her natural state reflect my issues in attempting to discover myself as a puppet maker and puppeteer. While this is not an adaptation of Carlo Collodi's Pinocchio, there are some universal themes that tie both of the works together. Through acting out the character of Marinia, writing the tale as well as illustrating it and interviewing other puppeteers, I have discovered various issues and themes that I confronted within the world of puppetry; an exploration that can be of great value to others who familiarize themselves with this media either professionally and/or therapeutically.

Shadows Lie Deep

Her left knee throbbed. Marinia glanced down and saw a small shark nipping at her as if she was a tasty piece of sautéed seaweed. 'Shoo! I have no time for this', she said, shaking her finger. 'Hoink! Hoink ho?' the shark replied. Swimming past the bored water mammal, the girl flipped and somersaulted deep into the sea water. Deep diving, Marinia was searching for orbs, babbles and shells for the upcoming Festival of the Breaking of the Ice, the annual

pageant for the spring. Excited, the young changeling already felt the warming of the water on her wings. Fluctuating temperatures during this time of the year always flip flopped her heart. It gave her a sense of freedom and change; she never knew what to expect when she woke up from her bed in the Deep. As the liquid breath grew tepid, Marinia was able to lift and fly farther Above. Pushing past the tender tendrils of the coral, Marinia swam farther and farther than she ever did before. Her parents had warned her never to pass the surface where the water and air met, yet the girl tested the edge with the tip of her toe. The elements of Air, Fire and Earth were an enigma to her. Water she knew with the groove of her feet. Not drinking or swallowing, the youth breathed and was the sea. Cradled within the watery rhythms, the girling moved to the beat inside the belly of the Earth. When not moving, she would rest on something solid or curl like a foetus of a brine shrimp. Below, which could never be too low for such a flipper and flyer as she. Few have met the catfish that crept along the edge of the world with feline grace, except for Marinia and the elders. Marinia wondered if her fanned out muscle wings would be able to pull out of the wet surface into up above. Her adolescent fantasies flamed even though she knew the other dimensions to be forbidden.

'Akwa Marinia! It's almost time,' her mother called out in the distance. Her family thought the girling to be the dreamer of dreamers, the maker of things to come, who needs to be reminded of mundane chores. Mother knew her spawn was of a special breed, even for a water faerie. Marinia was exceptionally talented with other sea creatures, hallow harp singing and aquarial acrobatics, but most of all she was gifted in life, taking pleasure in the littlest things that others took for granted.

Marinia's naked turquoise body twirled midwater. Lean muscles strained as the girl held her small satchel of spiraled ornaments. Resting on the back of a sea turtle, Marinia mindlessly rolled the rounded smooth surfaces inside her satchel. Her keen, deep set eyes spotted a motor boat several metres away. 'How odd, those floating motor bugs never come this closely,' she murmured. Waves lapped and carried the boat into a rough, swirling current. The human who was in it moved wildly. Inside the marine vehicle, the young man yanked at the stern. A crest from the water world swept over the boat and pulled it under.

Without thought or any notion, Marinia reacted quicker than a dolphin. Iridescent and translucent wings swept her up and split the quickening current. Spindly green arms grasped the deadening form of the pale young man. Long kohl grass grew out of his head and found its way into Marinia's mouth. 'Blauuch! Funny how this long moss grows on his head,' she thought.

Wrapping her arms and legs around the man's torso, the wings propelled the young water faerie as she torpedoed through the salty licks. She knew she had to bring this land creature to a resting place in the air.

In the hug fasting embrace, the girl felt the human's skin as soft as hers. This surprised her, for she thought land creatures would be hard to the touch. Despite the young man's density, he was surprisingly light and easy to carry. Does living in the air lighten such a creature who is rooted to the earth? From the whispers of other water faeries, Marinia gathered that such human beans were tied to the land by some magical magnetic force. It was rumoured that these weird beans built wondrous contraptions to keep them afloat in the air and cut beneath the ground. These possibilities were beyond her imagination, for they shook everything the girling knew. How the other faeries collected such winds was from the gossip from aerial faeries that visited the in between the hydrogen that separated the two races of faeries.

Wings cut through, slicing distance until Marinia zeroed in on land. Man's pale flesh started turning a light blue and the girling panicked. He is becoming part water! I must hurry! She throttled, skidding above water and driving into the land. The force separated the two; the young human body dug into the earth, and the faery was thrown in the air and slammed into a tree. Her head met the ridges of the bark, and the space grew dark quietly.

Time broke the space, throwing slices of light shivering through eyes. The thin atmosphere revolved; it was painted thin upon Marinia's skin. She did not stir. Her dreamscape sucked her into her world, away from this unknown world. Mind rode the waves, swimming deep into home. Shells clapped over greenblue body as it was tucked into bed. Sisters giggled, brothers cried in their sleep, and the parents attended their slumbering brood. Girling's astral self was with her family, but she was unaware that her green self lay unconscious on the flat bay under a tree.

As the flaps over her eyes crusted over, air seeped into the cracks and gradually pried them open. Black became gray became light. Flashes of sea urchins danced behind the darkened eye flaps as the sun shone into Marinia's unconsciousness and roused her into groggy consciousness. Ebbing to the beat of blue blood burning in her brain, the girling's head swelled and throbbed in sharp spasms. She felt something hard and pointy jabbing her. Marinia screamed.

'Oh, I'm sorry. I did not mean to hurt you! I did not know you were alive,' a voice wafted above.

A hazy shadow of a large face loomed over the horizontal body of the girling. Marinia's fingers reached up to adjust her eyes. As the picture

brightened and came into focus, the water faerie was able to identify who the voice belonged to.

The young woman before her sat down. Long curly reddish brown hair hung down to her waist, framing her very light brown skin. Her eyes were the only thing familiar to the sea creature, as the human's eyes reflected the water in the same shade of green. For a human woman, she was short, small boned and quick looking, as if it was possible for the girl to disappear and reappear several metres away in the matter of seconds. The lips were full and twisted in a wry expression. While the temperature of the outside air was warming, the Gypsy wore several layers of clothing; the outer layer being a long sleeved silk blouse, an embroidered vest, and a patchwork skirt that hung to her ankles. A scarf was tightly secured over hair and her shoes were worn and thinning, barely clinging on to her feet. Near her feet lay a bulging backpack with a bedroll and a black metal rectangular box with a handle. Alena Trenkiki, a young Rom woman, travelled alone after being banished by her family several years ago. She supported herself by performing theatre with her puppets, and she did all the manipulating as well as the singing, the character voices, the choreography, and playing the instruments that accompanied the performances. Her story-telling and singing through her little creatures enchanted audiences, but only a few would stay long enough when she passed her hat around.

Alena dreamed of becoming a well known troubadour, performing for palaces as well as the street kids that reminded her of herself when she was first excommunicated. If she built the most exquisite puppet that would inspire mastered plays, perhaps then Alena would find her niche on this island where she lived. Using the combination of dancing her puppets in the Saint Vitus dance to the songs that cut to the soul, Alena's stories spoke of sorrow and irony for the hierarchical structure of the new land. Little children and crones exalted her puppetry; yet, the bobbies, store owners and priests would stone her if she set up shop near their domains. They believed she acted like a provocateur who mocks the system with her gods and goddesses, the system that they held dear to their hearts. In their eyes, every busker, be it puppeteer, minstrel, troubadour, trancer, reader, contortionist or geek, was considered a charlatan and marked by the fallen angel. Insults were thrown to the girl, and the patriarchs cast off words such as witch, Satan's breed and glove lover. Her face reflected the stone thrown, taking on its alchemical qualities that held the chips of granite together. She vowed vengeance, plotting political mockery and uprising through her art form. Still, a seed grew. A seed that festered and told her that her puppets and shows were incompetent and encouraged the heckling from the patriarchs. If only. The

ultimate project, her prodigy, her exquisite child. This thought obsessed her, barging into her waking thoughts and making it difficult for her to feel the ground under her feet. Gravity loosened its hold on the Rom girl, which caused her to careen and bang into people, lamp posts, mail boxes and annoyed poodles.

Alena placed her smudged hand on the sand, creeping it towards the faerie like a crab. Despite Alena's visions of ghosts and various sprites, she had never seen a water faerie before. She did not know it was a faerie, for the creature's wings were missing and the girling's head had swelled up to twice its size. The colouration and diminutive size of the faerie made Alena erroneously think that Marinia was a well crafted doll left behind by an absent minded crafts person. She poked at the turquoise thing. After Marinia screamed in fear and pain, the Gypsy figured that the little one was quite alive and injured. She took it for an abandoned goblin whose mate had deserted it. Lightly lifting the girling faerie, she cradled it in the cloth satchel she pulled out of her sack.

'Don't worry. I'll fix you up and give you a place to rest,' crooned Alena. 'You have a name?'

'Marinia,' squeaked Marinia. The air dried her vocal chords. Her normally strong, vibrating voice that floated far into the water sounded weak and high pitched in this atmosphere.

'What did you say? Well, I guess I'll call you,' the young busker scrunched her forehead, 'Papusza, mia puppen.'

'No.'

'Don't worry, shana madella.'

'Hey, whatcha doin'? Go away human head.'

She picked up the faerie, who had shrunk from dehydration. Still, Marinia squirmed from Alena's grasp and nibbled at the girl's thumb. With a yelp, the human released the sea creature.

'Gotten Heimel! Oh no you don't,' the young woman swore, 'I've got to fix you. You are too weak to run off on your own.' One hand held the girling down as the other fished through her bag. Finally, she got a hold of a silken rope that snaked out of the bag. Looping the rope around Marinia's thin waist, she secured the leash that connected the faerie to herself.

'Now we'll always be together.'

Staring at the water faerie, an idea festered in the black of Alena's heart. She smiled and thought, 'You will be my best creation yet.'

As days passed, Marinia's skin hardened. Stone texture crusted over her shrinking twig-like body. Alena worried. She fed her water, soup, and fresh goat's milk from the market. Thirst consumed the girling as she greedily

sucked every bowl of liquid set in front of her. It comforted her and eased her pain. Delirium disintegrated with each sip. Yet, Marinia did not retain her natural form. In the next several weeks, the faerie's body diminished more and her head swelled from the life force that she fed upon for her nourishment.

They practised performances. Alena integrated her other puppets into the pieces and invented more stories. With the faerie's assistance, she started to attract the attention of the island's inhabitants. Marinia's bluegreen presence became a curiosity. The enslaved water faerie became the spokesperson of the oppressed, championing the tomfoolery that grew inside the empire. Even though many islanders regarded this girl with Jewish, Czech and Turkish ancestry with suspicion, they were intrigued with Alena's brand of sorcery and fell under its spell. The patriarchs that reigned over the land became nervous and worried that this female puppeteer would usurp their church's authority that contained and controlled the people. Puppetry was considered the ultimate sin, a human playing god over articulated idols and manipulating unknown forces. What was even worse, a young unmarried woman was in charge. It was bad enough that they had to contend with bands of men who travelled in troupes; the men were suspected to be fey (for who has heard of a group of unmarried men playing roles of gods, daemons, men and women in the guise of masks and playthings). A woman, however, has the power of moonblood flowing through her, a power that can bewitch even the most noble of men. Action needed to be taken. The powers that be elected a young duke to dismantle Alena Trenkiki's perform- ance and kill her if need be.

Meanwhile, Marinia stiffened and her muscles cracked and were no longer supple. She cried with each step, sucked her breath with each dance. In order to keep the faerie's head above ground instead of sinking in its leaden weight, the puppeteer attached eye hooks on her body and latched strings that the crossbars maintained taut. Rockers made Marinia jig, and the hand bar detached from the main control so the faerie could wave and pick her nose at will. Gnawing at the strings, Marinia attempted to loosen the omnipotent presence that tied her, and almost succeeded until she felt an angry tug from above. Alena insisted that they should practise longer, going over movements, voices and expressions that would captivate audiences. Their craft improved as Marinia's will faltered and she dreamt of the sea long ago.

Night terrors tied the two together. Alena levitated in the sky at night, and when her stomach dropped from the height, she crashed to the ground, waking up with a jolt. They entered each other's dreams; Marinia heard garbled Romani, Yiddish, Turkish and English and flew above mosques, a

temple and settlements of a different land. She saw tribes of people that resembled her master. Cries of a young child in the past infiltrated the faerie's psyche. Alena's night vision zeroed in on her papusza's watery memories: of the deep blue nothingness that cradled the sea sprites like the earth's embryos. She heard the sharp cry of longing and belonging. Many times the puppeteer awoke, seeking canine wisdom from Polaris above.

'Wake up, you schlepper. We have work to do, mien puppen,' said Alena, as she roused the stony creature beside her.

'Oy!' Marinia moaned.

'C'mon!' She jabbed. She poked. No movement. Impatient, the creator of ceremonies took the controls and manipulated the rigs above. Marinia warbled up and fell down again. This occurred again and again. Her head was the size of a small boulder and the vectors of gravity yanked the faerie off centre. Alena pushed, twisted and pried her rocky creature off the ground. They fought against each other, cursed, and they both sat stubbornly on the earth. A source of gravitational waves spurted out of the left aorta of the Earth, sucking in Marinia. The faerie was held down, deeper and deeper. Maddened, the puppeteer twisted the ear of her little folk.

'You stupid cow. Why don't you listen to me? You make this so difficult!' Furious, Alena viciously shook the wingless creature, rattling out answers and shifting bones. And the faerie could not cry, for she had gone dry as dust.

'I'm sorry. I'm sorry, I'm sorry.'

Slowly, Alena learned how to balance the walk of her prodigal puppet. They headed towards the next village, which was just over the next hill. After exerting enough strength, the young puppeteer figured out how to walk her puppet in the most naturalistic way.

'If only I had my wings,' thought Marinia, 'I would have no problem.' Squeaking in her high-pitched nasal voice, the water faery called out to the sky to help her. Marinia wished for everything to end. She wondered why her master could not see the pain in the execution of the dramatic dances she put on for the amusement of others.

They were to perform in the street fair that day. Wind of the puppet show travelled around the surrounding villages. Hearing of the most publicized appearance of the female busker, the patriarchs dispatched the young duke, Carlo Lorenzo, so he could make the young woman vanish after the show.

King Giuseppe Giuliani had called a meeting for his advisory board earlier that week. Concerned about the increasing crime on the island of New Amsterdam, Giuseppe planned immediate action.

'This vagrancy must end!! The egg throwing, tomato kleptomania, potato larceny, children farting in classrooms…when will this ever stop? You know who started this moral indecency? Those street people. Begging in the guise of performing, asinine obscenities, corrupting the good, the innocent…' King Giuliani said.

'Uh, Uncle, what about spousal abuse, foster children and people with AIDS? What about the crimes unseen?' questioned Carlo Lorenzo.

'Yeah, and what about your toupee, sire? Isn't it a crime to kill furry animals?' said Kaspar, the court jester.

'Quiet! Order, order! Those are not the priority, now. All funds are frozen for your concerns. Alas, I cannot even afford rogaine with menoxidal, let alone electrolysis. So stop your snivelling. Ahem, now where were we talking about?' the King said.

'In the castle, your royal hiney,' said Kaspar.

'You were talking about the vagrants on the streets, your royalness,' said Potakis Dodopalus, the king's primary adviser. Potakis removed his triangular, three-cornered hat and scratched his head.

'Yes, yes! Well, the worst person in this provocative revolution is that female puppeteer, whatsername…'

'Alena Trenkiki,' said Potakis.

'What's that?' asked King Giuseppe Giuliani.

'The girl,' said Potakis.

'The womyn,' said Carlo.

'The endangered bird from Tasmania,' said Kaspar.

'Shut up! All of you!' the king commanded.

'Well, your majesty, it's true,' said Mr Duttel, the castle's attorney.

'What, the bird or the lawsuit?' said the confused Giuliani.

'No, the girl – Alena Trenk – whatever. She's a nuisance with her puppets. The cobblers from the far-off land of Enzo are complaining that she sets up shop near their stores and disrupts their business. Plus, she doesn't have a license,' informed Mr Duttel. They all gasped.

'Well, Uncle Holiness, why would she need a driver's license on this island? You can basically walk everywhere,' said Carlo.

'To perform, you knuckle! Now, who is going to kill her?' King Giuliani demanded.

Silence.

'Anyone? Anyone? Well, howsa about a Scooby snack?' Kaspar asked.

'Alright, alright. Carlo, you go kill her and bring the head to me. You might as well do something useful here besides moon over your poetry and books.'

The young duke was doodling on his tablet, zoning out. So he said, 'What? Can't we just reason?' He loathed these meetings. At times, he wished he was a commoner instead of royalty. Then he would have time to go to the cinema and theatre and read and write, soaking every bit of knowledge under the moon. Alas, his uncle only let him count money till his fingers bled from paper cuts, attend meetings and watch pigskin games. What a dull, dull life a duke leads.

'Absolutely not, you abgchu!'

'Bless you, sire,' said Kaspar.

Looking measly at the jester, the king added, 'And you, you fool. The trickster should go with Carlo just to make sure everything goes smoothly.'

'Uh, King, I can't make it, I've got a Persian golf match going on,' said Potakis.

'Alrighty. Kaspar, you better go with the romantic young fool. Just don't get any funny ideas,' King Giuliani ordered.

'No worry, your royal cheeks. I'm always serious,' said Kaspar.

At dusk, Carlo gravitated to the flickering candles that lit the stage for the puppet show. His black hair fell into his face as he moved quickly. His elders warned him about the puppeteer, and told him of her beady eyes and wicked ways. He coughed, and pushed through the crowd to see her up front.

Clad in black, Alena bowed to the audience. She stepped behind the makeshift stage. Candles cast shadows over the faerie's feet when the curtain was pulled back to reveal her form. Drawing in Marinia's cavorting body, Carlo sucked the air between his teeth. His hands were jittery. The dance recalled his dreams, and the skill of the manipulation captivated the young man. He studied the puppeteer's profile, trying to remind himself of his duty.

'She's one hot potato, isn't she, my master?' Kaspar squawked.

'Shhhh…' said Carlo, staring at his companion.

'You want to get into zee sack? I can call on my buddy Yipzti Putzki,' Kaspar insisted.

'Yo, you up front. Be quiet or I'll slap you silly.'

Carlo sighted a daemon in the distance. He said, 'I told you never to call that name. Remember what happened to the honourable doktor.'

'Putzki Yipzti! Vat about Thanatos? I'm in thick with him,' said Kaspar.

'Sigh,' exclaimed the enraptured duke. He tuned out his friend and focused on the performance.

Tin soldiers marched on the stage. They aimed cocktail umbrellas at the faerie who was acting as a golem for the night. Alena roared for Marinia and made her charge at the army. Tin scattered, little men flew out into the

audience, seeking refuge. People reached up and grabbed the parachuting men that were raining down on the ground. The golem faerie pivoted in a victory dance, grasping silk scarves held fast in fingers; the scarves puffed in the catching wind and made a whirlwind cloud of ever changing colour.

As the applause died and Alena packed up, Carlo went over and tightly wrapped his fingers around the woman's arm. She shook her arm loose and stared at him suspiciously.

'Uh,' he could not think of what to say, 'you look familiar.'

Alena snapped. 'What do you want?'

The young Lorenzo patted the green puppet on her head. Eeeeekk! 'What? Hmmm…' he muttered, 'Curiouser and curiouser.' He inspected the inflamed head, touched the grooves that faceted the faerie like a gem. Tracing the sore stubs on Marinia's shoulder blades, faded images churned inside him. Lying on the stage, Marinia regurgitated her morning stew.

'Eeeuuw. Papusza, stop it!' Alena complained. She wiped up the bile with her handkerchief. Carlo rustled through his bag. Extracting his hand, he held wings that reflected the candlelight; wings that were a cross between a flying fox's levitation and an arachnid's gossamer. A webbed hand shot into the air and snatched the wings.

'Listen, little one, give the man back his butterfly,' said Alena.

'No!'

'No,' said the duke, 'she may know what to do with it.'

'They're mine,' insisted Marinia, 'Why did you steal them?'

'I didn't steal them, young foundling. I fell asleep on the beach a while ago and woke up with a headache and this shiny pair beside me,' explained Carlo.

'You understand her? Who…who are you?' asked Alena.

'His royal pinkie,' said the plucky Kaspar, 'He loves his little finger.'

'Kaspar,' steamed Carlo, 'Why don't you go be with a tree and take a leak?'

'I'm Carlo Lorenzo.'

'The heir to the animal farm Lorenzo's Llamas?' Alena said. Carlo groaned at hearing about his deceased parents' farm. He despised that smelly place.

'The nephew of King Giuseppe Giuliani? No wonder you're wearing purple velvet,' said Alena, touching his shoulder. She pulled away when she found herself stroking the soft fabric.

The Rom did not want to trust this royal man. Yet, he helped her little disciple, seemed genuinely concerned and understood the language of the faerie. So even though she knew the patriarchs thought lowly of her, Alena let him stay on to assist in healing the sickly creature.

He slept in the hills with the puppeteer and her puppets. Kaspar nested in a nearby tree. They grew close as Carlo told the woman that he confided in the moon and kept his conflicting beliefs and feelings towards his uncle's will silent. Warning her of the patriarchs' intentions towards the buskers, he admitted that he was ordered to kill her. Now, making the decision to be with Alena, he could not go back; otherwise, he would be done for. Alena reminded the puppy-eyed Duke of Queen Vashti, the fiery, independent queen who was beheaded in Persia many years ago. She told him of her past, and that she toyed with the idea of looking for the family that abandoned her years ago. Alena thought of Carlo as lovely to look at, but swatted his hand as it fluttered on her lap. She feared that he would penetrate her aura and get too close to the core. Carlo had to be satisfied with playing with his own puppet at night, but he could not help but wish.

The humans attempted to take away the wings from the water faerie. Marinia screamed and stubbornly held fast. Her head throbbed more and her body diminished to the size of a locust. Skin thickened – it was rock layered over a dying thing.

Under the dog star, the two concocted a broth. This time, the liquid was placed in a large wooden bowl, big enough for Marinia to swim in. They bathed the little faery in it. After days of silence in the watery bed, the girling began to breathe again. Her limbs elongated and filled out; her head shrunk to almost her normal size. Rock became flesh and the water creature loosened her grip on her wings. When the faery was well enough, Carlo plucked the wings from the bowl and sewed them back on her. The suture succeeded, and Marinia flexed her wing muscles to the point of floating out of the bowl.

'I want to go.'

'But why?' Alena nervously asked.

'I have to go.'

'We've just begun! How can you abandon these morality plays we worked so hard on?' said the puppeteer.

'They were never mine,' Marinia explained, her voice full of water and comprehensible, 'it's my time now.'

Alena's palm landed on the controls, but Carlo squeezed her hand. He said, 'Don't you see what you are doing? Please, cut the strings…she was never meant to be.'

'My ultimate creation,' cried the young Gypsy. Her most beloved puppet strained out of the bowl. Picking up the bowl, Alena walked forward, heading to the edge of the island. She spilled the contents into the water. 'When will I see you again?'

'I don't know,' called out Marinia. Diving into the undertow, the water faerie pushed herself deeper. She was Above, and now Below. The foam of her home.

'So now what?' Alena asked the wind, asked the moon, asked Polaris.

'Start over.'

And so she did.

Analysis

In the story, there is a split for me. Characters play multiple roles; they are symbols on various levels and therefore the characters are dynamic rather than flat. Each person is a different aspect of my reality, and together, they make up the Gestalt of that universe. I did not just identify with one character. Both Marinia, the water faerie, and Alena Trenkiki represent the two polarities that I struggle with inside of me. This dyad, the union between creature and creator, represent the power struggle that I have in my role in life as an artist and healer. The water faerie is the heroine, the searcher and dreamer that is made victim by the alien environment and the puppeteer that controls her. While Alena is wise and searches for knowledge and a niche in society, family, environmental, financial and political circumstances have transformed this sensitive and talented young woman into a cynical, bitter, disillusioned, angry young person who seeks to strike out against her oppressors and the ones close to her. Feeling helpless and unable to control her external situation, she focuses inward and manipulates and controls her puppets and water faerie to give her a sense of mastery, peace and control over something smaller. Over identifying with her enemies and becoming cruel and omniscient, Alena's pure spirit becomes corrupt as she focuses on her greed to earn more money and become successful. My external self reflects the role of Alena as a jaded puppeteer whose whole world revolves around the puppets, masks, books, paintings, movies, poetry and stories that I use as my talisman to protect me from those who may invade my world. My objects are the gargoyles that act as barriers against foreign energies from my external reality and other people. The water faerie exists within my centre, hungering to break out of the prison that my controlling artist self has created. I am encaged, enraged by all that I see and feel. I feel as if my trueself's wings are clipped, which hinders me from flying and truly being the enfant savage within my civilized self. If only I can find my wings, the missing piece held in the mirroring other's hands, then I will truly fly and live in my natural environment.

Writing this story has helped me get a perspective on issues that I am dealing with in my life. While the story is quite fantastical, the main themes

reflect my reality. The battle between the water faerie and the puppeteer parallels my struggles as a puppeteer and artist. Many of my puppets and dolls are faeries, gargoyles and freaks of nature. In sculpting them, I control their destiny, and I surround myself with images of them. Unlike my circumstances and the people in my life, I am able to have control over the puppets and thus gain a sense of empowerment that I do not normally have. Through puppetry and through my story, I realized that my feelings of victimization in my life and the hunger for power and control has created for me a very bitter and lonely existence as an artist. At the very least, my winged puppets assuaged some feelings of isolation by being mute companians of mine. These life forms became my children who lingered around even when I did not have consistent human intimacy, and so provided the creative energy that I needed.

As I was trying to make sense of them, a friend commented that she would never be able to sleep in the same room with puppets and dolls, as she would fear that they would come alive and they would seek revenge on their 'master'. I laughed at this concept, as I did not see my creatures independent of myself. I was so intricately fused with my puppets that I had difficulty separating from them, especially when I was at the stage of completing my puppet forms. The idea of the puppets having a completely different identity than their puppeteer seemed romantic and fantastical, which appealed to my aesthetics but not to my rationality. Yet, that idea grew, and germinated into this story.

On the day I acted as a client telling the story about my boulder illustration, I wore my faerie mask/body puppet to get into the role, as it is difficult for me to be in character without props. Surface qualities of the mask reflected the angles and grooves of the boulder, and so I enmeshed the two and took on the role of the boulder, in being represented as a watery faerie crusted with rock formations over my skin. The conflict of the story came out of the notion that the faerie was in a maladaptive environment. The origins of the water faerie, which is the sea, represents the womb that cradled me at birth. My spirit self is very much at home in the belly and becomes weak and disassociated when pulled out to exist in reality. In dreams and fantasy, the spirit self is free. In waking thoughts, I am unbalanced: my head swells with knowledge from books and art and my body separates and shrinks and becomes difficult to feel. This comes from a decentred state. Often, I feel like I am levitating or spacey, and it takes effort to ground myself. This constant battle of gravity, of balancing between earth and sky, is a major theme in the story and in my life. Alena, the Rom and puppeteer, is my external self that fights to keep up appearances by upholding responsibility

and deals with my art and inner self with control in an inhibiting, sadistic, masochistic and self-destructive way. I wear myself down in this war; I deplete myself of energy and possibilities. It is only when hope appears in the guise of a knave, be it a person in my life or inside myself, that I complete my image of a faerie with wings and am free in my dreams. When that occurs, it is then my head and body will be in proportion with each other. Synchronized, I will be able both to fly and to feel connected to the ground.

A holding environment for a faerie is not an easy thing to find. If one holds it too tightly in a hand, it will suffocate and try to bite the nearest finger in order to escape. Left on its own, the water faerie will fly out of sight or swim to the deep, out of the sight of a creator. Kept in a cage or behind glass, the imprisoned faerie will become deformed and shrivel up. To contain this wispy spirit is to fashion a story, a play and illustrate it with pictures or puppetry. By writing this story, I made the aspects of myself and my faerie more concrete. The story is the container, the boundary and structure that helped form and solidify the abstracted aspects of myself that are often in conflict. Visualizing this duality, I am able to see the struggle I have as a puppeteer more objectively. It allows for me to express my pain, anger and sado-masochistic tendencies within the safety of a puppet-oriented story. For I am all the characters, and I am none, just as the master puppeteer in the movie Lily is all of his puppets yet is his separate self. Within this puppeteer, as well as within myself, there is a sense of hiding behind the screen of omnipotence to protect oneself from existential loneliness and feelings of isolation. The ways of connection through puppetry can also be a trap if this connection is not linked to external reality and the ability to see others as having their own centres and spirits. The need and inability to control the environment and other people can lead to intervention on the part of the artist. I am aware that I can be in danger of overidentifying with my puppets and objects; this is not necessarily a healthy object relationship, for if there is not some separation between myself and the puppet-object there can be no movement, as one needs two separate objects in order to have a relationship. The pull to fuse with the puppet is often very strong in myself and in some puppeteers, because the puppet's personality and gestures result from a crossing of fields between the puppeteer and puppet; yet there needs to be a clear distinction between fantasy and reality.

This contradiction points to my identification with my puppets, but also to my individuality and separation from my projective objects, my alter egos, my puppets. Their will is dictated, but within these roles they define their lives and their personalities. My children, my characters, can breathe and

express the feelings and thoughts I dare not experience or admit. My puppets live through me and I through them, and, I too, will start over again.

The Therapeutic Value of Puppets

Despite the interconnection that puppetry has with creative arts therapy, it is remarkable that the relationship between these fields has been so little explored. In my research in puppets and therapy, I have discovered only three books that exclusively discuss puppet therapy, one of which, *Puppets and Therapy* (Philpott, 1977), was published 20 years ago. While there are a number of interesting studies and assessments in the book, most of the articles were written in the 1950s and 1960s. *Play Therapy Techniques* (Schaefer and Cangelosi, 1993) describes a puppet therapy assessment and *The Puppet Book* (Wall, White and Philpott, 1965) describes puppet therapy and art education using puppetry in archaic terms. Despite the difficulty in finding correlating literature, there are many rich aspects of puppetry to be explored through creative arts therapy techniques.

In several puppetry books, the author seems to express a fear that puppetry might be dangerous if used therapeutically. David Currell (1974) addresses puppetry in therapy as a good field to explore, but comments on the lack of literature available. He expresses concern that 'puppetry as therapy can release some very powerful forces, the implications of which are not very understood. There is too much loose talk about puppets in therapy and too many people who dabble in it in an undesirable way' (p.55–56). His concerns are very valid, as, in the past, people may have attempted to do some sort of therapy with puppets without understanding its implications and without providing a proper container. Nancy Cole, the therapy consultant of Puppeteers of America, has expressed similar concerns that people who use puppetry as therapy should have adequate training both as a puppeteer and as a therapist (Cole, 1993). Puppet artists who have no education in therapy and psychologists and therapists who have not explored this material on their own may not understand the impact and affects puppetry has on certain populations.

Creative arts therapists are in the unique position of being educated in art, therapy and development, which is crucial to puppet therapy. Various materials and media bring up varying issues in many different populations. In exploring the relationships between the 'professional' puppeteer and her/his puppet, there is a better notion of how clients' process with puppetry may occur. Foster children, autistic children/adults, schizophrenics, drug addicts, people with AIDS, the elderly in geriatric wards and depressed people may all react very differently under the directive of puppetry. For

those who have experienced many losses through death and separation, puppetry is a powerful and useful tool to access feelings in a nondirective way. Children and adults who lack relatedness with other people may find it easier to connect with puppets. In *Dare to Dream*, Diane Dupuy (1988) was able to facilitate a group of developmentally delayed adults into a professional black light puppetry theatre troupe. Despite the interrelationship difficulties that Dupuy's Famous People Players first had, they were able to collaborate through puppetry and gained self esteem and social skills due to the experience. One of the most enriching and impressive aspects of Famous People Players was the fact that the puppeteers performed at a professional level and were quite skilled and did not exploit their disabilities; the puppeteers' disabilities were secondary to their abilities. Still others may have difficulty in dealing with anything that seems new to them and approach puppets with trepidation and fear. It is extremely important to know your population before introducing puppetry. For some, puppetry may be too volatile to explore under short-term therapy; for others, the way the therapist introduces and explains puppetry may have a great effect on whether the clients are able to create and perform it and are subsequently able to process the experience.

Puppet therapy is not limited to child populations. In working with adults, some higher-functioning adults may consider puppetry to be juvenile. The way that puppetry is introduced is important to convey the possibilities of working with such a multi-faceted modality. Presenting the different types of puppetry as well as exploring multi-cultural topics and issues helps more intellectualized populations to see the sophistication of puppetry. Expanding the definition of what is puppetry is also beneficial in working in a therapeutic setting. In my field experiences, I have used puppetry with HIV positive adults, foster children, adolescents, children in special education and psychiatric wards and children between the ages of three and twelve in private art classes. Depending on the population, ability, attention span and time restraints, I have modified puppet projects to cater to the needs of the clientele. Papier mâché and sculpting were among the many options. Found objects and collage were also spontaneously converted into puppets. As Bill Baird said, 'How does a puppet come into being? It happens when someone sees an image of himself, or some aspect of the world, in the crooked glass of his imagination and gives it form, movement and sound. Someone has the urge to bring his drawing to life' (Baird, 1965). My main concern in working as an art therapist in puppetry is to guide people to animate their art through movement and characterization. By bringing the art to life through sound, movement, light and different sensations, the multiplicity gives art and

therapy numerous dimensions to develop, a cluster of vectors that result in puppetry.

During various stages of the puppet building and performances, various developmental issues may arise. In exploring the process of puppetry as a puppeteer, I have expanded upon the issues and struggles that a puppeteer may experience that come up as a result of building the puppet as well as performing. By studying the development of a puppet that a puppet artist goes through, there can be a better understanding of how the modality of puppetry can affect various populations. I have interchanged the term client with puppeteer as well as interchanging audience with therapist to integrate and compare the fields of energy in puppet building and professional performances in the context of the creative arts therapy. Depending on the issues the artist/client may be dealing with, the person may have difficulty and struggle with a certain stage of the process. At times, a need to destroy the progress, the creature forming underneath the hands, may be difficult to suppress. In these areas where the wish to obliterate becomes intense, it is important that the therapist/mentor provide a container as well as guidance for the protégé/client.

In order for the reader to understand these theories and issues better, I have included clinical vignettes. I have worked in a multitude of placements and populations using puppetry as a modality during the course of the past several years. Depending on the population and environment, goals and treatment varied. When I have assisted in puppetry workshops in schools and presented puppetry from more of an educational standpoint, I did not explore personal issues with the people I was working with. While I had the capability to contain certain themes that may arise even within a 'normal' educational setting, I sensed that it was important to be objective and globalize themes instead of doing exploratory work, which may only be valid within an individual therapeutic setting and not in a group-oriented academic arena.

After performing with Bread and Puppet Theatre last year, I was inspired to create a series of neutral wooden puppets that I later slightly embellished. At the day treatment centre for people with AIDS and who are HIV positive, we had an open studio setting in the middle of the main day room. Despite the distractions and other activities that surrounded the milieu where the art therapy was done, there was a chaotic and excited energy that was a part of the art process. Many of the clients who happened to be very talented artistically had difficulty in not viewing puppetry as a juvenile activity, despite the fact that I brought in books that had examples of more adult-oriented and/or traditional puppetry. Yet some of the other clients were

quite playful in their approach to the creative process and were open in experimenting with materials.

One young woman, who subsequently made her own paper butterfly puppet as well as embellishing on pre-made children's toys, became very interested when she saw me create the puppets out of scrap wood. Without being prompted, she began playing with the puppets. Picking up two puppets, 'Jill' automatically named the puppets Bert and Ernie, associating the puppets with well-known Muppet characters. As she played with them, Jill began to connect with them and started developing more individualized personalities for the puppets. Being very playful and quickly gravitating towards toys, Jill was able to become very involved in acting out a repetitive, cyclic scene with the puppets. Her energy intersecting the puppets was at times intense, but then appeared cut off as she tried to downplay the significance of her performance. Her fusion with the puppets and inability to break away from repetitive roles and play signified her borderline tendencies and difficulties in relinquishing cryptosymbols, as Jill had been previously diagnosed as borderline personality disorder with a tendency towards self-destructive behaviour.

Renaming the puppets Tom and Jerry, the young woman held the 'cat puppet', Tom, flat on the table and said that he was a mouse trap. Tom's movements remained stilted and gravitated towards the ground. Jerry, the more dynamic 'mouse puppet', ate the cheese in the trap and died. She kept repeating this story over and over. When asked why the mouse died by eating the cheese, Jill said the cheese was poisoned. What was significant was the urgency with which she acted this out and her inability to stop her compulsivity and destructive tendencies towards the mouse puppet. By taking on the voice of the mouse, I intervened by verbalizing the mouse puppet's sadness and resentment at dying; yet Jill continued to rationalize with the mouse by telling it that it had to die.

This story was quite reflective of what was going on in her life: unconsciously angry at men for making her HIV positive, Jill got revenge by having unprotected sex with unidentified men. Cat and mouse games represented manipulative courting rituals, where one is always the perpetrator or the victim. The poisoned cheese, the bait, symbolizes the tempting sex that is tainted with the AIDS virus. Just as in my story, 'Shadows Lie Deep', the underlying theme is that the perpetrator victimizes her partner, creating a codependent relationship between the controller and controllee. The nourishment, which in my story was the liquids and in Jill's the poisoned cheese, does not sustain life and energy, but instead brings about the victim's demise and introduces Thanatos, the destructive force. The cheese becomes

a trap for the mouse puppet, chaining Jerry to Tom, just as Marinia was bound to Alina in my tale; therefore, the cheese represented the gravity that pulls down and ensnares the mouse puppet. Interconnection between the puppeteer, Jill, and the two puppets and her audience – me and the other art therapist who later videotaped Jill performing the same scene with the puppets – created a field that Jill felt comfortable in exploring volatile issues of sexuality and compulsivity symbolized in her play.

Previously, the young woman had never been as direct towards her issues as she was through the puppet play, with its combination of puppetry and being videotaped. Both of these projective devices offer distancing from the centre of self, where the root of gravity is not focused on Jill but rather on the puppets, which in turn point their vectors to the video camera. Under the guise of being playful, Jill was able to touch upon feelings of anger, hatred, fear and loss. As I watched her, as well as interacting in the performances by occasionally providing voices, an eerie feeling crept over my arms and refused to leave me. Afterwards, I discovered that my art therapy supervisor reacted in a similar fashion and was quite alarmed at some of the things that Jill called to attention in her puppet play. Yet the young woman was able to speak through crossed vectors within the assembled scraps of wood in a way that she would not have normally been able to do if she was asked to talk directly.

Puppetry can also provide sources of communication, socialization and connection with people in relatively brief periods of time. One of my former clients, a five-year-old boy, became quite introverted when concentrating on his art process. He had difficulties in communicating verbally with others due to inhibiting environmental factors, possible neurological damage resulting from being born addicted to cocaine, and living in a transitory place. For the most part, he created art by himself and was active in parallel play. From time to time, 'Sammy' would acknowledge my presence and my modelling non-verbally through his art. Seeing a slight developmental progression in his art and intrigued by his meditative play and art, a thought occurred: if there is movement in his art and connection of themes in his play, perhaps his ability to interact and communicate would increase. In order to introduce play and movement, I modelled a simple puppet out of wood and cloth, both materials that he had used before. Also, I constantly had to readjust myself physically, by lowering myself to the ground in order to be in Sammy's plane. After he focused his attention onto the puppet, he leaned to the left and drew a face on the blank piece of wood. Then Sammy quickly created his own puppet out of one block of wood with cloth attached by glue and tape. In subsequent sessions, Sammy appeared more connected to

the puppet that we created together since he included it in the play more and identified it as a witch while he was unable to name the other puppet.

How Sammy felt linked to a puppet or an animal figure was through identifiable visual forms: he automatically gravitated to the figures of Bugs Bunny and the little troll. Again, certain imagery has personal meaning for a particular artist, puppeteer or client. Just as gargoyles and faeries are symbolically important to me, Bugs Bunny carries special meaning to Sammy, as it did for me when I was younger. When co-leading a teddy bear workshop for pregnant teenagers, I soon discovered that the girls were very enthusiastic about making bears, as teddy bears were easily identifiable with babies without the project seeming juvenile and stupid to them.

Many times I sat in the waiting room at the foster care clinic, providing art activities for the children. Once I started to bring puppets, especially Kermit, out to the waiting room, many of the children and their parents gravitated towards the art table. Since Kermit has been a frequent visitor to most of their homes via their television set, he automatically became a friend for several of the children. The quick bonding and intimacy through the interaction of the puppets, however, stimulated some of the children's separation issues. Through my own journey of my water faerie puppet and story, I became aware of my own deep connection with my puppets and the separation anxiety that I usually go through when I complete a puppet. This unique puppet bonding with a foster child can be difficult to disconnect, especially if the child has dealt with many losses. A transitional object of the puppet, whether it is a drawing of the puppet or a small replica, helps dampen the child's anxiety somewhat; it is also equally important to include a ritual of saying good-bye to the puppet and putting it away at the end of each session. This provides someone who has experienced previous loss the opportunity to say good-bye and terminate in a healthy way.

Conclusion

The puppeteer has a special relationship with his/her art media. The American culture has fostered prejudices and preconceived notions of puppetry and the puppeteer. Everything from Witchcraft to a children's entertainment to Pagan roots to being placed in an outcast or persecutory role has been pegged onto the puppeteer and her/his craft. While there may be some truth to these labels, puppeteers and puppetry are much more and have many things to offer our society. Puppetry, in all its multi-facetness has the propensity to heal on many levels. The magic does not have to die when we grow older. In the context of creative arts therapy, puppetry can be used

as a tool to access the symbols of the preconscious and the archetypes of the collective unconscious.

So what is the future of puppetry? International festivals are shooting up around the globe. Puppeteers from all over are tapping into the super highway of internet to connect together. The American Art Therapy Association is sending over North American delegates to Indonesia to study the Javanese culture and the various wayang puppetry. This delegation is not only to introduce art therapy into the region, but also for AATA to learn how to incorporate the arts of puppetry, costuming and performance into the field of creative arts therapy from a cultural and spiritual perspective. By broadening the cultural perspective on the process and communal efforts that goes into visual and performing arts, this viewpoint could enrich the way Western art therapists perceive how clients from a multitude of ethnic and cultural backgrounds relate to the creative process and craft. These are examples of puppetry and the people who make it possible – the puppeteers are making the world smaller through art and performance.

Whether puppetry is used as a theatrical performance-art category of its own or used within the context of therapy, conjuring objects and creatures and making them come to life can indeed be therapeutic to both the performer and the audience. Puppets have the potential to be other-worldly healers in this world, where we may all feel like puppets in the hands of a dominating force during some period of our lives. Puppetry operates on many different levels and in many different ways for artists, intellectuals, the mentally impaired and mainstream populations. What better linkage could there be to interweave a variety of dimensions and alternative universes than through the breath that lays within the ribcage of the puppet.

References

Cole, R.N. (1993) *Lend Them a Hand.* Ontario: Milford.

Currell, D. (1974) *The Complete Book of Puppet Theatre.* London: A & C Black (Publishers) Ltd.

Dupuy, D. and Heller, L. (1988) *Dare to Dream.* Toronto: Key Porter Books Ltd.

Philpott, A.R. (ed) (1977) *Puppets and Therapy.* London: Plays Inc., Educational Puppetry Association.

Schaefer, C.E. and Cangelosi, D.M. (eds) (1993) *Play Therapy Techniques.* New York: Jason Aronson.

Wall, L.V., White, G.A. and Philpott, A.R. (eds) (1965) *The Puppet Book: A Practical Guide to Puppetry in Schools, Training Colleges and Clubs,* 2nd edition. London: Faber and Faber.

Further reading

Adachi, B. (1978) *The Voices and Hands of Bunraku*. New York: Kodansha.

Arnheim, R. (1988) *The Power of the Centre*. Berkeley: University of California Press.

Arnoldi, M.J. (1995) *Playing With Time: Art and Performance in Central Mali*. Bloomington: Indiana University Press.

Baird, B. (1965) *The Art of the Puppet*. New York: Macmillan.

Bohmer, G. (1971) *The Wonderful World of Puppets*. Boston: Plays, Inc.

Boorstin, D.J. (1983) *The Discoverers*. New York: Random House.

Buurman, P. and Wayang Golek (1988) *The Entrancing World of Classical Javanese Puppet Theatre*. New York: Oxford University Press.

Deri, S. (1984) *Symbolization and Creativity*. Madison, CT: International Universities Press.

Diaz, A. (1992) *Freeing the Creative Spirit*. New York: Harper Collins.

Flower, C. and Fortney, A. (1983) *Puppets, Methods and Materials*. Worcester, MA: Davis Publications.

Haff, S. (1992) 'On a visit with puppets.' *American Theatre 9*, 8, December.

Jenkins, P.D. (1980) *The Magic of Puppetry: A Guide for those Working with Young Children*. Englewood Cliffs, New Jersey: Prentice Hall.

Krishnaiah, S.A. (1988) *Karnataka Puppetry*. Regional Resources Centre for Folk Performing Arts, Karnataka, India.

Jurkowski, H. (1988) *Aspects of Puppet Theatre*. London: Puppet Centre Trust.

Landy, R.J. (1991) 'The dramatic basis of role theory.' *The Arts in Psychotherapy 18*, 29–41.

Lane, A. (1994) 'Kafka's heir'. *The New Yorker LXX*, 35, 31 October.

Kominz, L.R. and Levenson, M. (eds) (1990) *The Language of the Puppet*. Pacific Puppetry Centre Press.

Latshaw, G. (1978) *Puppetry: The Ultimate Disguise*. New York: Richard Rosen Press Inc.

London, P. (1989) *No More Secondhand Art, Awakening the Artist Within*. Boston, MA: Shambhala.

McNiff, S. (1992) *Art as Medicine*. Boston, MA: Shambhala.

Magon, J. (1976) *Staging the Puppet Show*. Miami Press.

Mason, B. (1992) *Street Theatre and Other Outdoor Performance*. London: Routledge.

Meschke, M. (1992) *In Search of Aesthetics for the Puppet Theatre*. Janpath, New Delhi: Indira Gandhi National Centre for the Arts.

Oatman, K. (1981) *Breaking Through the Barrier*. Ontario: Ontario Puppetry Association.

Periale, A. (ed) (1994) *Puppetry International*. UNIMA-USA., Inc., American Centre of the Union International de la Marionette.

Robbins, A. (1994) *A Multi-Modal Approach to Creative Art Therapy*. London: Jessica Kingsley Publishers.

Romney, J. (1996) 'Strange quays.' *World Art: The Magazine of Contemporary Art*, 1, 70–75.

Ross, J.F. (1993) 'Out of the mouths of babes, also pigs, dragons...' *Smithsonian*, December.

Scott, A.C. (1984) *The Puppet Theatre of Japan*. Tokyo: Charles E. Tuttle Co.

Segel, H.B. (1995) *Pinocchio's Progeny*. Baltimore, Maryland: John Hopkins University.

Shershow, S.C. (1995) *Puppets and Popular Culture*. New York: Cornell University Press.

Speaight, G. (1990 (1955)) *The History of the English Puppet Theatre*. Southern Illinois University Press.

Taymor, J. and Blumenthal, E. (1995) *Playing With Fire*. New York: Harry N. Abrams.

Tillis, S. (1992) *Toward an Aesthetics of the Puppet: Puppetry as a Theatrical Art*. Westport, Conneticut: Greenwood Press.

Vella, M. and Rickards, H. (1989) *Theatre of the Impossible, Puppet Theatre in Australia*. Roseville, Australia: Craftsman House.

Warren, B. (ed) (1993) *Using the Creative Arts in Therapy*. New York: Routledge.

Resources

Movies and television:

Alice. (Jan Svenkmajer) (1988) New York: Firs and Run/Icarus.

Brother's Quay. (1979–1988) Institute Benjamenta and other short puppet films.

Child's Play. (1988).

The Dark Crystal. (1982) Jim Henson Productions.

Faust. (1995) Jan Svenkmajer.

Lily. (1953).

Marquis Sade. (1990) French.

Meet the Feebles. (1989) Peter Jackson.

The Muppet Movie. (1979) Jim Henson Productions.

The Muppets Take Manhattan. (1984) Jim Henson Productions.

Nightmare Before Christmas. (1993).

Sesame Street. (1969) Jim Henson Productions.

Starevich's Short Films. (1912, 1934).

Performances and Plays by Puppet Artists

J.E. Cross *(The Alchemist, Netherworlds, Marriage of Mother Earth and Father Sky)*

Janie Geiser

James Godwin

Julie Taymor *(The Green Bird)*

Basil Twist

Neville Tranter *(Room 5, Macbeth)*

Earth Celebrations, Bread and Puppet Theatre

Interview References

Karin-Alejandra Arroyo

Steve Kaplin

Matilda Carmichael (puppet)
Professor Freshwater – Mr. Punch (anonymous puppeteers)
L. Rawler – Kernal Jaxon
The Demon King (puppet)
Marianne Tucker – Goldilocks
Michael Gilbert – Gordon
Shae Uisna – Arlecchino
Dan Green – robot, many names
Alice Wallace – Maureen
Claas Hansen – Goblin, 'little fire man
Felicia Young – Earth Celebrations
Janet Morgan – Cernunnos
Also: references to the Jungian theory

The Power of Art and Story
Women Therapists Create Their Own Fairy Tales

Sarah Griffin Banker

Preface

I became intrigued with the therapeutic potential of fairy tale workshops while attending a course in the Jungian interpretation of fairy tales. It was clear that the rich material was laden with possible meanings and symbols, which were shared and discussed. The emphasis was intellectual; our emotional responses were rarely revealed or explored. I know now that when, as I listened, my own personal resonance was activated, the archetypal demon would sometimes grab my psyche, and I would squirm in my seat, pick at my nails, get sleepy, and look at my watch, wishing the session would end.

One evening after class, having been devoured by the demon, I went home and took out some clay. As I worked with it, I became immersed in the world of image. Something happened; I felt relief and became calmer. During our last class, our instructor brought out some paper and crayons and asked us to draw a motif from *Snow White*. These two experiences opened up possibilities for an idea I had had – to combine Jungian interpretation with art therapy techniques in an all-day workshop that explored one fairy tale in depth.

I contacted a friend who is a Jungian analyst, well-versed in fairy tales, and together we organized and led a six-hour workshop for ten people on the Grimm brothers' story, 'The Handless Maiden'. At the workshop we read the tale, discussed the motifs, asked each participant to interact with one of these motifs through art materials, and, from the expressive experience of working with the art materials, to create their own personal fairy tale and

tell it to the group. It proved to be a powerful experience for us all, and I mentioned it at the next meeting of my supervisory group.

Arthur Robbins, our leader, thought a condensed version of my work would be a good opportunity for the group to experience the processing of a fairy tale with art therapy. As therapists working together weekly in a trusting environment, we have a safe place, so I gave a mini-workshop in our hour-and-a-half session. There was resistance from some members to our frustratingly short period of time, and to me as a workshop leader acting as a general in control of troops. Therefore, we used the following two meetings to continue processing our own personal tales and our art work.

I have now given two workshops on the same fairy tale, the population and some of the structure being quite different. One thing, however, was the the same. Each of the participants in both workshops experienced powerful reactions to motifs in the tale. Their reactions made it more vivid for me. When Arthur Robbins asked me to include this workshop experience in a chapter for his new book, I drafted what I wanted to say. Something, however, was wrong: I could not write about these workshops on this particular tale, 'The Handless Maiden', without processing my own power-lessness, the loss of my own hands; once again I was caught in the clutches of the archetypal demon. This time, the demon led me to create my own fairy tale in order to create my contribution to the book.

Introduction

What is the power in fairy tales that makes them useful in therapeutic treatment? When a complex or conflict comes up, what makes the fairy tale viable in working with the psyche? Further, what makes the art therapy experience of the fairy tale a powerful tool for the client in their own journey?

Fairy tales express how we feel. The images in a fairy tale carry archetypal energy, which helps them mirror the psyche. 'Archetypes are inherited elements of the human psyche which reflect common patterns of experience throughout the history of human consciousness' (Mills and Crowley, 1986, p.13). The emotional patterns in fairy tales, which are universal, are structured by the unconscious. The crisis is introduced, the unfolding of the guiding figure is set up, the journey then takes place in an environment for transfor-mation. Through its different motifs, a fairy tale can point to a resolution of a psychic conflict.

Thus, when the client is searching to elaborate on a conflict or trying to understand a complex, a story can be introduced by the therapist and used as a helpful tool. Motifs from the story can organize the client's affect. A

story touches the unconscious, and casts a spell on the client, who becomes more open to fantasy as its motifs inhabit the mind. 'We take our own images and "enter" them into a developmental "programme" that is encoded with the hope – characteristic of folktales – that difficulties can be overcome. According to Bloch, every living symbol which speaks to us contains "archetypally encapsulated hope"' (Kast, 1986, p.13). Personal images related to the archetypal images received from a tale give the client a choice of what they want to deal with. The symbolic processes that we encounter in fairy tales open up ways for solutions that have not yet taken shape to reveal themselves in the individual's imagination. As we put our personal motifs into symbolic form through art, the symbol produced visually gives the motif dimension. This chapter deals with the use of a fairy tale to stimulate a creative process of symbolization with the added benefit of art therapy's power to express these symbols.

The Tale

My colleagues assembled around the room to listen to me read aloud Grimm's fairy tale 'The Handless Maiden'. When I had finished, we discussed the various motifs and characters that stood out. The major motif was the father's cutting off of his daughter's hands to fulfill his contract with the devil; in return, the devil would alleviate the family's poverty. The mother stays so much in the background of the tale that she is not a support for her daughter. The girl had previously saved herself from being taken by the devil by drawing a circle around herself in chalk; the devil could not enter it. She also cried bitter tears, which kept him away. Finally, the furious devil ordered the father to cut off her hands. The girl said to her father, 'Do with me what you will'. The terrible deed was then done, the father saying that he would take care of her for the rest of her life. However, she told him that she must leave to find compassionate people; she had him bind her arms to her back and left his house.

Journeying, tired, hungry, and in distress, she came upon a castle surrounded by a moat. An angel saw her condition and, to rescue her, parted the water in the moat so that she could cross and enter the castle's walled garden. The angel also showed her a pear tree bearing luscious ripe fruit. The girl ate a pear as it hung from the tree, only to be told by the gardener that the pear tree was the property of a young king. Distressed that somebody was eating his pears, the king went into the garden to wait for the culprit. He saw the angel and the beautiful young girl and decided to marry her. As a wedding present he gave her golden hands. However, he was soon forced to leave for seven years. She, now the queen, and now with child, faced the

devil again. He returned to claim her and her child. With the help of the king's mother, she escaped. Deep in the forest she came to a house bearing a sign which said, 'Here all dwell free'. A snow-white maiden welcomed her and asked her to remain. There, her own hands gradually grew back. She named her son 'Sorrowful' and stayed in the house in the forest safely until her husband, the king, returned from his own journey to find her and their child.

The Journey Through a Shift in Expressive Mode

> The hands may almost be said to speak. Do we not use them to demand, promise, summon, dismiss, threaten, supplicate, express aversion or fear, question or deny? Do we not use them to indicate joy, sorrow, hesitation, confessions, penitence, measure quality, number, and time? Have they not the power to excite and prohibit, to express approval, wonder, and shame?
>
> Quintilian

The group discussed the story, embellishing the motifs. When we came to the part where the arms are bound behind the girl's back, we all stood up and put our arms behind our backs to experience this body stance. The bound-up arms behind our backs seemed to move the theorizing into the body space of feeling, and gave us a sense of helplessness and vulnerability. This feeling moved into our bodies, so that we experienced the girl's vulnerability with our own. Leaving home and going out into the unknown world, facing the unknown without protection, were symbolized by this physical handicap. 'The feedback of sensations from the body contributes to mental imagery and the formation of ideas' (Rose, 1986, p.105). It became clear that, lacking a mother or the nurturing feminine to protect her, the heroine would have to find her own way to protect herself. For each woman in the group, the powerlessness of the heroine – for instance, her inability to reach for the pear on the tree – connected with her own experience of powerlessness as a woman at a specific time in her life.

For the next part of the workshop, the group was asked to choose from the art materials. Keeping in mind the motifs of the story, my colleagues began to relate the tale's motifs to their own life experiences to evolve their own story, a fairy tale that symbolically described their lives.

As I watched, I observed an energy and dynamic building and channelling into the clay and paper work as they once again experienced the body contact, this time with the art materials. In his book, *The Power of Form,*

Gilbert J. Rose says that 'The flux of minute actions as well as impulses toward action forms a backdrop of muscle-tonus patternings. These may feed back unconsciously, contributing the quality of motor imagery to an incipient idea, changing it somewhat, or fuelling further motor imagery' (1986, p.105). The connection between the body and the unconscious surprises us and brings about transformations within our psyche over which conscious minds have no control.

When the group was finished with their art work, each woman was asked to tell her story to the group, beginning with 'once upon a time', words which provide some distance; I felt distance might be needed, for the oncoming emotions of the unconscious bring up some very sensitive and private issues. For the storytelling segment, we sat in a circle. Even though as an ongoing group we knew each other, it was very moving to hear autobiographical information that we already knew recast in symbolic form.

It is my belief that the self seeks to balance itself, and that once it is opened to the powers of the unconscious through fairy tales, it can become a guide for those archetypal forays into the psyche which we must all make in order to grow. The self becomes a process of knowing. It keeps creating wholeness within us. As archetypes are processed from the fairy tales, the different images present themselves to the self through art. Getting to know and being true to this self become our own personal journey, as it is for the hero or heroine of a fairy tale.

Imagery from the Journey

In the imagery of 'The Handless Maiden', an ancient archetypal object, the circle, appears frequently. For the young girl in the fairy tale, the chalk circle represents protection. For our group participants, the circle is used not only for protection but also for healing. In moments of psychological danger we draw an imaginary circle around us. Whether for body or soul, the circle serves as a container.

The second container in the tale is the safe-house where our heroine goes to give birth to her son and grow back her hands. The container for the therapists in my supervisory group is the weekly meeting where trust and compassion encircle us.

In the journey of the tale and the supervisory group, the second container becomes a nurturing feminine circle. For the young mother in the tale, it is the healing of her father's betrayal and her mother's absence. For the group, healing takes place individually as our good ever-present 'father' provides a container to hold our sorrow, while we process our parent/child conflicts.

The evolving process of the story–art dynamic finds access to the layering symbols in the unconscious. The experience gives form to an aspect of the unconscious which, when released to consciousness, takes shape in metaphorical language. Therefore, in the evolution of this fairy tale workshop, the metaphorical verbalization gives us tools to work with. The art process itself gives us imagery which informs us through the metaphor, for the power of the image from the art process becomes the healing agent for each individual and for the group as a whole.

Figure 11.1: Fairy tale 1

Fairy Tales

Fairy Tale 1

Once upon a time there was a young girl whose mother died when she was young. She did not know how to say goodbye. The adults around her did not speak about the dead mother. It was too painful. They chopped of the girl's hands and bound her arms behind her back. It wasn't until later that she realized her hands had been cut off. She could not feel them; she didn't think that she had any. Nobody told her they were missing. She didn't recall the pain of her hands being cut off. Growing up, she had periods of great sadness and loneliness. She went out into the world confronting life with a protective, invisible chalk circle following her wherever she went. She was

able to be fed by whatever fell into her circle. When she was a grown woman, she married and had her first child. Her hands began to grow back.

She found a wise woman dressed in blue who had her own chalk circle. She would fly across the river to sit with the wise woman and learn the tools of her trade. The woman in blue gave her a magic eyeglass and told her if she would stay inside the chalk circle, when she held up the eyeglass, she would be able to see the whole world.

Fairy Tale 2

Once upon a time there was a young woman who sacrificed her hands for her soul. She cried and cried. She had strong legs and feet that took her on a journey out into the world. On her journey she met an angel whom she trusted. The angel guided her on her journey until one day they came to a beautiful pear tree. The young woman saw a luscious, ripe pear on the tree and yearned for it. The pear tumbled from the tree. The angel then created a sacred circle around the two of them and the pear. No one could enter the sacred circle. The angel told the young woman that she needed the pear to feed her soul. The young woman bent down and took a bite of the luscious pear, and suddenly discovered she had hands. Her hands had returned to her arms. She felt whole once again and trusted that she would take care of herself in the world.

Fairy Tale 3

Once upon a time there was a young lady who had a wicked mother and no father, and the mother cut off the hands of her daughter. She started to cry, and cried and cried so much that she created an ocean. She went out into the world without hands and put herself into very difficult situations, not acknowledging that she had no hands. But she always managed to surmount her difficulties, even without hands, because she always had an angel with her. One day she met a man, and they married and had a child. Shortly after the birth of the child the man left. She used the child as her helper. She still didn't have any hands, so the child became her hands.

Figure 11.2: Fairy tale 2

Figure 11.3: Fairy tale 3

Fairy Tale 4

Once upon a time there was a tree trunk alone in an enclosed lush garden, reaching up from a circle. The tree trunk became a hand reaching to the sky. The lush garden is within the circle. Outside of the garden is the unknown. Reaching into the unknown from the circle is the tree, which has broken through the ground.

Fairy Tale 5

Once upon a time, a girl, in all her purity, met her shadow and they were wed. She gave birth to her own heart, in all her blood and sorrow.

Fairy Tale 6

I found this a painful and disturbing tale. I can't just start off with 'Once upon a time...' and make up a story. I'm too upset. There are no angels, no magic circles in my life. I tried to find 'it' my whole life but I couldn't. I gave up. No God, no angel, no protector. I have my creative life and energy. My realities are what I can feel and touch and create. I cannot look inside for an angel. The fairy tale is so disturbing because she has an angel. How did that happen? No matter how much I tried and prayed, the angel was not there for me.

Fairy Tale 7

Once upon a time there was a young woman who was always in a hurry. Sometimes she would remember that when she was a little girl, an Angel had been her friend, and was always close by. When she became a woman, the Angel would be hovering around, but hard as the young woman tried, she could not reach her. At the moments when she most needed magic, the Angel would disappear, leaving the young woman abandoned and alone. The woman's mother had always told her, 'Do not get close to anyone; if you do, the Dragons will get you'. She took her mother's words inside her heart, and her heart closed up with fear.

One day, the young woman met a wise old wizard. The wizard asked her, 'Why are you always in a hurry?' She replied, 'If I stand still, the Dragon will get me'. So the wise old wizard took his stick and drew a large circle on the ground. He told her to sit inside the magic circle until she knew how to be still, and quiet; the circle would protect her from the Dragon. So the woman sat in the circle and grew to know herself. Much to her surprise, her Angel came and sat with her.

Figure 11.4: Fairy tale 4

Figure 11.5a: Fairy tale 5

Figure 11.5b: Fairy tale 5

Figure 11.6a: Fairy tale 6

Figure 11.6b: Fairy tale 6

Figure 11.6c: Fairy tale 6

Figure 11.6d: Fairy tale 6

Figure 11.6e: Fairy tale 6

After awhile, the Angel said, 'This circle is getting pretty small'. She handed the woman a stick. The woman took the stick, and the stick made another circle, interlocking the wizard's. This made a figure eight, and the woman stood at the centre. One day, the wizard came and said, 'Why are you out of my circle?' The woman took a big breath and said, 'I drew my own circle, thank you,' and lo and behold, the wizard became a Dragon, big and fierce! The Angel entered the woman's heart, breaking it open as she did. She whispered, 'Touch the Dragon's tongue with your finger'. So the woman reached her finger towards the Dragon's tongue. In touching the tongue of the Dragon, she felt a rush of golden light inside and around her, and knew she was already to go with her life's journey.

Fairy Tale 8

Once upon a time in the land of repetition compulsion... I felt parallels with this fairy tale. The handless maiden left her home because she had to. She married (twice) and again had to leave. Her journey was on different psychic levels. It got rough, and it was hard. She had to trust that what was within could be her hands. That's where the angels came in. They were her hands, until she could grow her own. The intertwined rings felt like the inner connections that we have with people and with journeys which are rough and bumpy. They reflect how we are intertwined. My personal angel has a cowboy boot and seems to know when to kick butt.

Further thoughts about the fairy tale: we all leave our families with handicaps. I had to reframe the angel and devil since they felt too religious and severe. Expecting 'good people' to help would not be part of my fairy tale. Developing independence and skills would be – and going it alone. My real substance could not being to develop until it was 'die or leave'. The sorrow was held, and the new psyche, and hands, are growing from within. If there is an 'aha!' to these comments, it is that, contrary to this rule, it actually has been the good people along the way that I can thank for helping my hands to be created.

The combined structure of a fairy tale with an expressive art experience creates a powerful medium for organizing primary and secondary process thinking. This archetypal story of betrayal, abandonment, and transformation taps into a deep cultural well of consciousness and strongly engages this group. As the story casts its spell, substantial discharge of energy and movement occurs within different levels of consciousness. Many of the participants are intensely drawn by the symbol of the dangers of the outside world.

Figure 11.7: Fairy tale 7

Figure 11.8: Fairy tale 8

In their reporting of the fairy tale, for the most part the group members seemed grounded and centred. It was clear, though, that one of the participants, Therapist 6, was full of fury and rage. The form level deteriorated as she was flooded with primitive affects. Still, there was no question that she was very much involved in her process. Storyteller 5 could fully engage herself in assimilating the process only after she proceeded to work on the visual level.

The fairy tale stimulated images regarding spiritual connections as a means of coping with betrayal and separation. However, there was equal room for finding new solutions in the here and now reality. Storyteller 4 vividly portrays her feeling of being very lost and alone. Yet, her art piece produced an enormous flow of affect to the outside world, crying out for contact.

In the participants' fairy tales we find polarities of hope and despair, openness and defensiveness, and at the same time a fluidity and shifting to different levels of consciousness.

In many of the stories there is a constant search for meaning. We observe the full circle of sensuality, sexuality, life and death, all leading to experiences of transformation. The fairy tale and the visual expression together create a structure for deep emotional engagement with oneself, as well as for finding a bridge that will lead to meaning. In this respect, both mediums offer a dynamic structure that stimulates many of the dimensions of therapeutic presence.

References

Mills, J.C., Crowley, R. and O'Ryan, M. (1986) *Therapeutic Metaphors for Children and the Child Within.* New York: Brunner Mazel Publications.

Kast, V. (1995) *Folktales as Therapy* (translated by D. Whitaker). New York: International Publishing Corporation.

Rose, G.J. (1986) *The Power of Form: A Psychoanalytic Approach to Aesthetic Form.* Madison: International Universities Press Inc.

Dance/Movement and Art Therapies as Primary Expressions of the Self

Arthur Robbins

As creative arts therapists, we are assigned to clinical populations that present primary deficits of the self. These deficits are usually assigned to the broad range of primitive mental states: schizophrenia, borderline, narcissistic, schizoid and paranoid disorders. Within this wide spectrum of patients, we encounter affects of abandonment, rage, sexual trauma, loss, grief and pain that are rarely organized or synthesized as working parts of the self. We also observe primitive defences of withdrawal, denial, ego fragmentation, projection and splitting as well as a retreat into states of grandiosity or self-denial. In these instances, the primary connection of mother and child was either depriving or deficient. For these patients, the pain in making new connections is quite prominent within these disorders. Patients present formidable protections in order to avoid further grief, humiliation, or shame. Their defences are primitive and fierce and defy the usual verbal interventions, for in spite of living on a primary process level, these patients are well defended against any empathic resonance.

The creative arts therapist offers a very special frame to this patient population. On the one hand, the therapist offers a frame or a container that allows the freeing up of visual or kinesthetic imagery. On the other, the therapist still allows sufficient emotional distance from overwhelming pain. Since they live in the land of primary process communication which is governed by right hemisphere neurological connections, these patients require right hemisphere contact. An expressive creative arts therapy connection creates a bridge for a safe exploration of the primitive mother–child

relationship. Thus, these early developmental issues are often best reached through spatial, temporal, or visual forms of non-verbal expression.

The creative arts form serves as a sensory affective expressive experience. It often reflects memory traces and provides inroads to a visual, kinesthetic or auditory experience of a very primitive origin. However, one caution needs to be made: the expressive form in therapy cannot be employed in a mechanical or routine fashion. Even though the primary mode of interaction is non-verbal in nature, each structure emanates from a deep empathic and transferential connection.

Let us take a look at some of the dimensions of art therapeutic expression. The work of *A Multi-Modal Approach to Creative Art Therapy* may serve as an important framework in approaching art from a therapeutic perspective. In that text, I wrote:

> Approaching my patient's art, I often ask myself these questions: How does it feel to live in this picture? What happens to my body? Do I feel tight, or restricted, or free with plenty of space around me to move? Would I like to live in this picture? Does it feel lonely or crowded? Can I enter the picture, or does the artist keep me outside of his or her artistic endeavor? I try to note the movement of my eyes. Do my eyes move in the picture; do they bounce to many different, scattered places, or do I get lost in one particular area or another of the picture? In our diagnosis, we attempt to translate the story that is told by the structure of the patient's pictorial expression, as well as the content. (Robbins, 1994, p.116)

Extrapolating from Rudolph Arnheim's system of composition, we can apply this frame to object relations theory. In that text, *The Power of the Centre* (1988), Arnheim discusses two basic compositional systems that potentially organize our perceptual experience of self and other. We may be drawn by a central focus or we may be aware of the full organizational grid of the piece. First, the balancing centre of an art form can be described as the focus and organization where our eyes are drawn to in any particular work of art. The second, equal force, of horizontal and vertical lines is analogous to a grid that organizes the external pull of our eyes to the exterior of the art piece. The play of the outside and inside organization of our perceptual energies create a story of our object relations. In *A Multi-Modal Approach to Creative Art Therapy*, I addressed this dual energy in art. There, I wrote:

> Looking more closely at the art work, we can observe the story of self and object and their relationship to one another. Does the structure box in the energy so the very essence of the self is squeezed and

smothered? By contrast, preoccupation with the centre (more or less ignoring the outside) betrays very little internalization of the other. The structure of horizontal and vertical lines may mirror, hold or contain the centre. On the other hand, the structure may impair, invade or overpower the centre. (Robbins, 1994, p.116)

Each art form presents its own idiosyncratic rhythm and play of inside and outside energies. Ehrenzweig (1967) amplifies what I consider to be a core aspect of the true self. His description is very similar to Arnheim's conception of the centre. A perceptual centre represents our core of energy and provides the foundation for self that constantly attempts to organize impressions and experiences into some type of cohesive unity. We also see in an art form the eternalization of a self object that represents the outside energy of an art piece. What is the relationship of figure and ground? How is the art piece held? Is there truly a relationship that moves back and forth from inside to outside? In the most ideal art forms, there is ongoing movement as well between primary and secondary process. One can view a flow of energy and form. Thus, the centre can be characterized as unbound energy, timelessness, and shifting perceptions that later take on linear definition and organization. Ego rhythm becomes an aspect of our selfhood that gives each of our 'selves' a means by which to continually grow and be reborn. The art piece reflects a multitude of stories of what happens to the energy of the self as it moves in and out with new symbolic connections and self definitions. However, this rhythm is not obvious to all patients. For some patients, this rhythm holds little meaning. Still others have lost their ability to listen to the deep internal messages that are represented in their art form.

Art expression offers a byway into an expressive tactile sensation. For many patients, art expression may be the only way that they can be connected to a very early affective experience. For others, assuming that the therapist does not impose a stereotypic interpretation, colours can reunite patients with a feeling that leads to symbol formation. Thus, we are constantly experiencing the flow of the visual and kinesthetic energy; the art form provides the possibilities of new shapes and meaning. We also can observe defences in our therapeutic work with art or movement. They appear when the energy of flow and form becomes artificial and disengaged from any authentic self-object mirroring. In an art form, we can observe stereotypical expressions, preservative, meaningless, or defended communications. The art expression may range from rigidity to chaos. Ideally, there is an unconscious search for a smooth flow that creates a holistic experience of figure and ground.

At best, these descriptions are approximations of our sensory motor experiences, for we are attempting to give verbal articulation to a non-verbal form of expression. We, in turn, bring our own subjectivity to these experiences and rely on the idea that there is such a thing as non-objective truth.

Returning to the main thesis, a creative arts therapy frame provides a temporal, spatial container for processing. Each patient provides a variety of forms of vulnerability as well as accessibility. Patients interacting through a non-verbal medium avoid the exposure of a self that may be vulnerable to shame and humiliation. In each instance, therapists must find a key to a patient's primary form of communication. The kinesthetic expression and immediacy of dance and movement is freeing and effective with some. By contrast, art offers a less immediate experience and some find a visual organization an important means of building symbol formation. Ideally, the medium of expression becomes an extension of the mirroring process. In many instances patients move back and forth from art to movement and dance.

The best of therapeutic circumstances build containing functions through the particular structure of the art form. For example, the phrasing structure of dance therapy provides a container for affects. The dance therapist, through gradations of movement, creates new organizations of sensory affect states that become organized in these new-found containers. Through these phrases and the interaction with patients, new self objects are internalized. The internalization of different forms of affect regulation then becomes the central experience of movement, art, or music therapy.[1]

The art processing moves along visual as well as sensory motor lines. Many patients hold distortions of the mother's face that neither mirrors nor organizes an affective experience of the self. Through a particular non-verbal medium, therapists offer patients a more expressive mirror that provides distance, containment, and structure. Both forms of expression, art and movement, are essentially body expressions of a sensory affective engagement of self. Hopefully therapists provide an important means of reordering an infant–mother child bonding that often has a very chaotic interpersonal as well as neurological connection.

As for how to best reach each patient, there is no sequential or temporal structure to follow. Therapists must discover – through the non-verbal cues

1. I am indebted to Laurel Thompson for her helpful suggestions regarding dance/movement processing.

that come from their patients – the best guides to initiate primitive forms of communication. There are some rough structures to follow:

(1) The fluidity or rigidity of the defensive apparatus of a patient to a particular kind of stimulation, for example, are the boundaries either overly permeable or so rigid as to block all incoming stimulation, and will the inherent properties of a particular medium reinforce or undermine this particular condition? One example is the use of finger paints with a borderline patient. In this case, use of the medium can reinforce a regressive pull towards fusion.

(2) The level of object relatedness associated with any given patient's ego state. Care must be taken here in that this can shift quickly.

(3) The inherent properties of a modality such as form, movement, affect stimulation, use of space, and cognitive involvement lend differing structures to the therapist–patient interaction.

(4) The patient's unique response to properties such as those listed in 3.

(5) The therapist's skill in offering a holding environment using any given medium. (Robbins, 1987, p.41)

The core issue for choosing any given modality for a patient is determined by the internalization of early non-verbal sensory experiences that he or she laid down as a memory chase during the formative years. The therapist must clearly weigh several complicated factors in formulating a position. As different pathological introjects are externalized through non-verbal expression, a given medium may stimulate or cool down a particular therapeutic process. Thus, in many respects, therapists must use their judgment to provide a safe frame for affect regulation. Some mediums are more stimulating than others; some are more direct and temporal, others give pause for reflection. All of these are considerations for providing a safe container for the organization of affects.

The following description is a continuation of our fairy tale chapter. Some personal comments are in order, to understand the basis of some of my interventions with this supervisee. As a young man, I loved to dance and move. My movements on the dance floor often surprised my friends and colleagues, for I often appeared somewhat on the shy, reflective side. Still, the memories of meeting my wife on the dance floor and our pleasure in movement with each other stays with me. I've never attended a dance or movement class, though it is significant that my wife began her career as a modern dancer. Later in my professional work, for a brief period of time, I

conducted classes in advanced clinical techniques with dance and movement students. The professional terminology of a movement therapist was already a familiar one. A good deal of this perspective I have transposed, in energy terms, to an understanding of an art experience. In spite of my lack of training as a dance therapist, I actively attend to the body communications of my patients as well as my supervisees.

In the previous chapter, the members of the group describe their processing in the fairy tale workshop. In the session following this workshop the missing member returns and stays quietly on the sidelines while further processing takes place regarding the group's involvement with the fairy tales. However, toward the end of the session, one of the members draws our attention to the quiet space and downcast presence of the supervisee. The group encourages her to offer her own fairy tale. She is also encouraged to work with clay. The following is both the fairy tale as well as a brief description of her clay piece and her response to the group's support to become part of the previous fairy tale workshop.

> Once upon a time there was a creature. It was said that this creature resembled a stingray. She had a lovely thin body and supple wings. Oddly, she had two heads. One day when the stingray was swimming in the deep waters she began to feel lost and very lonely. She tried to find her way. She called out and she cried which often helped her. She tried to catch her breath as she groped along her way. Neither of her two heads were any help. They argued, 'STOP–GO–STAY–NO! GO THIS WAY–NO, THAT WAY–I DON'T KNOW!'

> Suddenly, the stingray heard voices responding to her cry.

> 'Find your magical path,' cooed a voice. The stingray followed the voice faithfully but still felt lost. Another voice led her toward a reflection. Alas she saw a glimpse of herself. 'I have no stinger!' she gasped. She swam away quickly. As she swam the stingray used the power of her wings and body to propel her through the waters.

The supervisee writes the following comments regarding her participation in this group:

> I am a member who was absent from the fairy tale group. I was present in a couple of groups when the fairy tale session was discussed. At the session that this tale of the stingray was created, the group members were talking about the possibility of their work being published in the supervisor's book. I felt disconnected from the event and the process. Feeling disconnected is a theme I have struggled with

throughout my life and at times in this group. I wondered if my missing the group was a larger metaphor as I have contemplated returning to the group in the fall. I struggled to reveal to the group how I felt as I cried through the tale of the stingray.

The day after the group meeting, I swam in a pool. As I swam I thought about the stingray. I felt a connection between the energy line that runs vertically through my body and out of the top of my head and the missing stinger. I realized as I swam that I have been out of touch with this energy line which provides a link to feeling vital, centred, balanced and whole.

The clay representation of the stingray was smashed and destroyed at the close of the group. I did this for two reasons. First, I felt that I had internalized the image. Second, I had brought these feelings up and created this story in the last ten minutes of the session. My work was not fully processed and I did not believe that it was going to be photographed and included with the other pieces.

I decided to invite the supervisee to an individual session. My intuition led me to think such a meeting might be to our mutual advantage. When she arrived, I immediately asked her how she felt about being invited to an individual session. She assured me that she felt honoured and flattered. I asked her why she had destroyed her clay art piece and she easily replied that she never expected the work to be photographed or used. In fact, she really didn't see how her story was part of the original workshop. I wondered out loud, 'Did you destroy the clay piece because you were angry at the group?' She explained that there simply was not enough space or place for her to have any impact on what happened after the workshop.

As she was talking, I was aware of my countertransference response, for I felt protective and somewhat taken in by her sad, seductive eyes. It was all too easy to feel paternal, like a good daddy, with this supervisee. I was aware of this reaction and its power over me and tried to maintain a centred presence; I neither wanted to be infantilizing or patronizing with this supervisee, nor impress her with my cleverness. I encouraged her to take over the space in the room and be in charge of the session. I had no idea as to how we would proceed. She told me that her head was buzzing and that her body felt tense and restricted. Ostensibly, she seemed relaxed and I shared my own response to her. She replied that she was stuck and glued to the chair. She added that she was frightened of judgment.

With this information, I asked her to take back this judge inside of her and describe its presence and personage so that we could learn more about

the impact of this force. Was it male or female? She thought for a while and reported that it was a male judge. 'How would you sit,' I said, 'if you were this judge?' She changed her entire body stance. She held her head high with her chin jutted out and she threw a superior glance toward me. She looked down upon me and crossed her legs. She became rather imposing and aloof. 'That's the kind of judge that's inside of me.'

When I encouraged her to reflect more about this judge, she spontaneously commented that it reminded her of someone in the group. She described this group member as rather analytic, thoughtful, somewhat superior, and removed in her interaction with her peers. She immediately took on the facial grimace of her colleague. She smiled to herself, for this member also had a male presence about her.

'I need some mirroring about me,' she said. So, I sat in my chair opposite her, placed my head downward. I felt a tension and sadness in my face and felt small and insignificant. I literally crept inside of myself. She smiled and asked, 'Oh is that how I look?' Then she noted the slight smile across my lips. 'What is that smile all about?' she wondered. I said that I felt that this stance was merely a pose or a ruse. I wasn't really as frightened or scared as I made out. In fact, it was my secret power that had some control of others through tears and helplessness. She thought for a while and remembered that she was both in awe and tense around her father. This same stuckness now existed in her throat. She remembered how her tears and sweetness were a means of having influence and impact over him.

I wondered out loud if she still felt frozen to the chair. She thought for a while and said 'I still feel somewhat stuck. I realize I do have certain options here. You are not my father and certainly you are a much more open person.' With a good deal of will, she got up and walked back and forth in the room. I asked her if she wanted me to stand up or remain in the chair. She replied rather thoughtfully, that she preferred my sitting where I was. She felt uncomfortable and somewhat at loose ends and not knowing what to do with herself.

I brought to her attention that she was standing behind the chair. This surprised her and she described this chair as a very rooted, firm chair and she was aware that it covered the lower half of her body. Then, another image came to her mind. It was the image of another group member. She described to me through body communication how this fellow colleague appeared. This member is rooted to the ground and projected a sense of 'I am a presence, I am somewhat formidable and I am no pushover. I know who I am.' She started to own this picture in her own body and was surprised how much fun it was to feel so rooted in this newfound experience. Her chin was

raised, her feet were planted on the ground. She was connected more to both her head and body and there was a strong non-verbal communication that I immediately reflected back to her. She could take or leave me; she was who she was. She relaxed a little more, took much more space up in the room, and proceeded to return to her chair to face me.

She reflected upon her relationship with her father. The helplessness, the use of tears and impotency, were a means of gaining power and some control. She also associated to her professional experiences where she at times found herself in tears, particularly with male attendants whom she had little control or influence over. She described one experience where she felt her only choice was to walk out full of tears and impotency from being in the same room with them. 'This seems so automatic,' she said, 'that I am not sure what to do about it.' I commented that it was perhaps automatic now but indeed she did have choices. These automatic devices, I commented, really had no relevance to her current life experience.

'You know,' she said, 'in the past I wondered whether I should go into movement therapy.' Perhaps, I reflected back, we were having a piece of movement right now, even though we were not going through a traditional movement therapy session. She wondered aloud whether she should share this experience with her peers in the group. I assured her that this was her decision and we discussed briefly how this material from this session would be used. We agreed that it could be used as part of the new chapter, and she would have final say as to what I would write and withhold.

I suspect that some of my colleagues would describe this not truly as a dance or movement therapy session, even if it does take place in a supervisory framework. Yet, I made note that there was a variety of interactions along such issues as mirroring, containment, and non-verbal action and reaction to one another. If anything, there was a good deal of synthesis of verbal and non-verbal communication. Our body postures were certainly mirroring one another. I was aware of both her vertical and horizontal energy and how, over the course of the session, she seemed to be literally moving upwards and to reflect upon this experience.

Certainly, I would not describe myself as a movement therapist, yet this lack of training does not interfere with my ability to respond to the non-verbal rhythms of energy, movement, space, and form. There was a good deal of shaping between us, and through this experience some meaning seemed to emerge. In the traditional sense of the word, I would not describe this as a dance therapy session. It does not have the structure that ideally goes on in a typical dance therapy framework. Yet, movement and meaning did take place, along with a shift in energy and organization.

Movement and art are two forms of expression that meet and join one another on a sensory, kinesthetic level. One may present an argument that one form is dramatically different from another. In the personal experience of each medium, art, music and dance are very separate, yet each of them contains and frames sensory motor and spatial experiences. In an art form we can build organizations on one another so that there is an evolution of space and time, similar to a movement therapy session. The choice, then, as to our particular medium depends on the talent and character structure of both participants. The end goal remains the same: to provide a transitional space that can shape and reshape the ongoing therapeutic evolution that opens up the affective, sensory motor pathways of self and other.

References

Arnheim, R. (1988) *The Power of the Center.* Berkeley: University of California Press.

Ehrenzweig, A. (1967) *The Hidden Order of Art.* Berkeley: University of California Press.

Robbins, A. (1987) *The Artist as Therapist.* New York: Human Sciences Press.

Robbins, A. (1994) *A Multi-Modal Approach to Creative Art Therapy.* London: Jessica Kingsley Publishers.

PART VI

A Final Note

A Final Note

Good treatment management requires an engagement that produces thera-peutic presence in the therapist–patient dialogue. If we are not centred or grounded with our patients, if we cannot organize the rawness of primary process thinking into a secondary process frame, then the therapeutic structure may be artificial at best. It is the shifting and moving back and forth to different levels of consciousness that forms the therapeutic work-place, where change can occur. Thus, if we are not open and available to both the inside and outside worlds, there is little space for new assimilations and accommodations in life. Regardless of our therapeutic model or particular expressive modality, the challenge of all therapy is to discover the road that reaches deep into the essence of the patient's existence. There are no easy game plans or recipes for this to be accomplished. Our basic resource is in ourselves: our ability to constantly and creatively plumb the world of the known and unknown to find ways of making contact that will surprise as well as guide us. Seen in this context, treatment can be both fulfilling and exciting. Without these possibilities, we are left to rely on a stale frame, but with them we can expect something fresh, original and alive to happen between the patient and ourselves.

The Contributors

Benedikte Barth Scheiby is a Supervisor in Music Therapy for Beth Abraham Health Services in New York and adjunct Faculty Member at New York University, New York.

Sarah Griffin Banker is Art Therapist and supervisor of the Creative Arts Department in Therapeutic Activities at the Hebrew Home for the Aged at Riverdale, New York.

Vivien Marcow Speiser works in the Creative Arts Therapy Department of the Faculty Leslie College, Cambridge, Massachusetts.

Billie A. Pivnick is a Clinical Psychologist on the Faculty of the Postgraduate Center for Mental Health/Child and Adolescent Analytic Program, and Visiting Associate Professor in the Clinical Psychology Program at Columbia University. She was a Recipient of the Institute for Psychoanalytic Training and Research's Stanley Berger Award for her contribution to the field of psychoanalysis.

Arthur Robbins Ed.D., A.T.R. is Professor of Art Therapies at the Pratt Institute, Brooklyn, New York, and the Founding Director of the Institute for Expressive Analysis. He also serves on the Faculty of the Training Institute of the National Psychological Association for Psychoanalysis in New York.

Laura Robbins-Milne is an Instructor in Clinical Pediatrics at Columbia Presbyterian Medical School, New York.

Melissa Robbins is a Staff Psychotherapist at the Women's Mental Health Collective, Somerville, Massachusetts, and Group Therapy Coordinator in the Behavioral Medicine Program, Harvard Medical School at the Cambridge Hospital, Massachusetts.

Michael Robbins is a Psychotherapist in private practice in affiliation with the Center for Body Oriented Psychotherapy, Somerville, Massachusetts, and a visiting Faculty Member at Pratt Institute, New York.

Sandra Robbins is a Psychic Healer. She is also on the part-time Faculty at Pratt Institute, Brooklyn, New York.

Felisa Weiss is an Art Therapist at the Kingsbrook Jewish Medical Center in New York.

Subject Index

References in italic indicate figures.

Author Index